ALBERS AND MOHOLY-NAGY
FROM THE BAUHAUS TO THE NEW WORLD

First published 2006 by order of the Tate Trustees
by Tate Publishing, a division of
Tate Enterprises Ltd,
Millbank, London SW1P 4RG
www.tate.org.uk/publishing

© Tate 2006

On the occasion of the exhibition
*Albers and Moholy-Nagy: From the Bauhaus to the
New World*

Tate Modern, London
9 March – 4 June 2006

Kunsthalle Bielefeld, Germany
25 June – 1 Oct 2006

Whitney Museum of American Art, New York
2 Nov 2006 – 21 Jan 2007

Exhibition sponsored by

British Library Cataloguing in Publication Data
A catalogue record for this book is available from the
British Library

ISBN 10: 1-85437-691-8 (hbk)
ISBN 13: 978-185437-691-6 (hbk)
ISBN 10: 1-85437-638-1 (pbk)
ISBN 13: 978-185437-638-1 (pbk)

Designed by Atelier Works
Reproduction by Dawkins Colour, London
Printed by Mondadori, Verona

Front cover (top) László Moholy-Nagy, *A19* 1927
(detail of pl.14, p.19)
Front cover (bottom) Josef Albers, *Repetition Against
Blue* 1943 (detail of pl.93, p.129)
Frontispiece (left) *Portrait of Josef Albers in Ascona* 1930
(Photographer unknown)
Frontispiece (right) Lucia Moholy, *László Moholy-Nagy*
1926 (detail of fig.1, p.10)

Editor's Note
All titles have been translated into English. In
instances where there is a gap in meaning due to
linguistic incompatibility the translated English
title is followed by the German original.

ALBERS AND MOHOLY-NAGY
FROM THE BAUHAUS TO THE NEW WORLD

Edited by Achim Borchardt-Hume
Tate Publishing

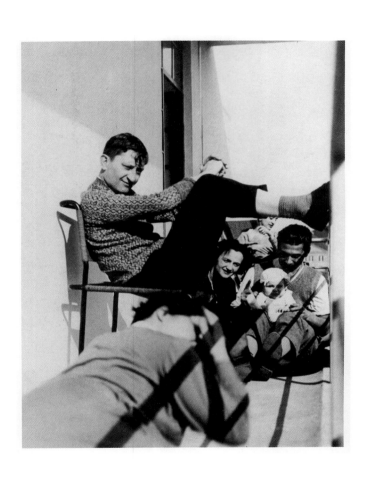

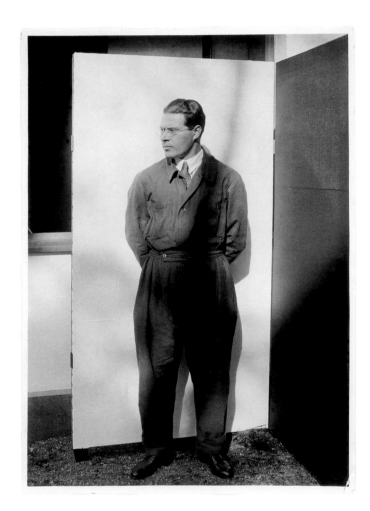

Sponsor's Foreword

BMW has a long tradition of working with the arts in the UK and we are pleased to be continuing this in our new relationship with Tate Modern. As sponsor of *Albers and Moholy-Nagy: From the Bauhaus to the New World*, BMW (UK) Ltd is delighted to support Tate Modern in mounting yet another fascinating exhibition.

This exhibition is of particular relevance to BMW as it shows many of the historical design and creative influences that were prevalent when BMW began designing, engineering, and producing its first motorcycles and cars in Germany.

As a company that has championed creativity, BMW has reinvigorated automotive car and motorcycle design in the new millennium. BMW's appreciation of car design as an art form – whether sculptural or graphic – has also influenced its relationship with the arts. The famous *Art Cars* by the likes of Andy Warhol and David Hockney and 2005's award-winning BMW manufacturing plant by London-based architect Zaha Hadid are two such examples of successful relationships.

BMW believes that education and training are fundamental and I am pleased to have consolidated our sponsorship by supporting the production of an introductory film for Tate Modern. The film brings together leading artists and experts to offer a unique insight into many of the works on display.

Jim O'Donnell
Managing Director, BMW (UK) Ltd

Foreword

Albers and Moholy-Nagy: From the Bauhaus to the New World offers audiences a unique opportunity to experience a posthumous dialogue between two pioneers of twentieth-century art. It is particularly important for us in being the first exhibition at Tate Modern dedicated to early Modernist abstraction. Bringing together more than two hundred works it demonstrates the lasting influence of Josef Albers and László Moholy-Nagy on the development of twentieth-century art and visual culture on both sides of the Atlantic.

This exhibition would not have been possible without the vital support of those entrusted with caring for the artists' estates. We are deeply grateful to Hattula Moholy-Nagy and her sons Andreas L. Hug and Daniel C. Hug for patiently answering countless queries and for allowing us access to previously unpublished material. Nicholas Fox Weber, Director of The Josef and Anni Albers Foundation, ably assisted by Oliver Barker, has been unwavering in his commitment to this project from the outset and these few words do the generosity of his support little justice. They join the ranks of the many private owners as well as Directors and Trustees of museums across Europe and the United States who have parted with important works from their collections to make this unique juxtaposition possible.

The exceptionally ambitious nature of this exhibition was matched by the generosity of its sponsor, BMW. This is the first Tate exhibition supported by BMW and we could not have hoped for a more sensitive partner, for which particular thanks are due to Uwe Ellinghaus, Marketing Director and Paul Andrews, General Manager Marketing Services. We warmly thank BMW for extending their support to parts of the Education programme surrounding this exhibition. We are also most grateful to the Department for Culture, Media and Sport for granting government indemnity to the exhibition.

We are delighted that following its presentation at Tate Modern the exhibition will travel to Kunsthalle Bielefeld in Germany and the Whitney Museum of American Art in New York. I thank my fellow Directors Thomas Kellein and Adam D. Weinberg for the enthusiasm with which they spontaneously embraced this opportunity for collaboration.

Achim Borchardt-Hume, Curator at Tate Modern, has made an intelligent and visually exciting selection of works and has driven this exhibition towards realisation with great energy and flair, aided with singular professionalism by Maeve Polkinhorn, Assistant Curator.

Albers and Moholy-Nagy, each in his own way, consistently broke new ground creating works that are as visually exciting as they are intellectually engaging. It is our ambition for this exhibition to do the same so that the oeuvre of these two great artists may continue to be an inspiration to us all.

Vicente Todolí
Director, Tate Modern

Curator's Acknowledgements

Albers and Moholy-Nagy: From the Bauhaus to the New World traces the journey of these two visionary artists from Weimar Germany to post-War America. In so doing, it follows not just the personal journeys of two remarkable individuals, but the collective ideas and dreams of a generation: from the utopian belief in a new social order rising phoenix-like from the ashes of World War I to the cataclysmic dystopia of Nazi Germany, World War II and the dawn of the Nuclear age. A dystopia both men faced with courage and defiant optimism.

I have been fortunate enough to share my journey of curating this exhibition with a number of extraordinary travel companions. I am greatly indebted to Hattula Moholy-Nagy as well as Andreas L. Hug, Daniel C. Hug and Roger G. Schneggenburger for their tireless support. Nicholas Fox Weber, Director of the Josef and Anni Albers Foundation, like the best of travel guides 'opened my eyes', to paraphrase Albers's famous dictum, for which I shall always remain grateful. I much relied on the expediency and diligence of Oliver Barker, Executive Administrator. Additional thanks are due to Brenda Danilowitz, Chief Curator, and Molly Wheeler, Archivist.

David Juda of Annely Juda Fine Art kindly facilitated contact with a number of private collectors lending works by Moholy to this exhibition as did Peter McGill and Lauren Panzo of Pace McGill Gallery, Hendrik Berinson of Galerie Berinson, Margit Bernard of Stars GmbH and Susanne Orlando of Galerie Orlando. I am also grateful to Leslie Waddington and Alan Cristea for their advice concerning works by Albers.

My thanks go to Thomas Kellein, Director and Björn Egging, Curator at Kunsthalle Bielefeld and to Donna De Salvo, Associate Director and Carter Foster, Curator of Drawings at the Whitney Museum of American Art, for the time and attention they have dedicated to the presentation of this project at their respective venues.

Among the many individuals who encouraged me along the way with their interest and advice I would like to mention especially Anita and Günter Beckers, Lilly Dubowitz, Lloyd Engelbrecht, Woodie Flowers, Florian Neusüss and Renate Heyne as well as Peter Nisbet, Daimler Benz Curator at the Busch Reisinger Museum, and Nan Rosenthal, Senior Consultant at the Metropolitan Museum of Art.

Every exhibition is a team effort and I am particularly grateful to Maeve Polkinhorn, Assistant Curator and Rebecca Fortey, Project Editor. Claudia Colia, Jacob Dabrowski and Ben Woodcock, Exhibition Interns, provided vital administrative support. To them and the many other exceptional staff at Tate without whom it would not have been possible to realise this exhibition and publication in their current shape I offer my unreserved collegial gratitude.

My final thanks go to Laura, Saskia, Thomas and Mattias.

Achim Borchardt-Hume

1
Josef Albers
Rhenish Legend 1921
Assemblage, glass and copper
49.5 x 44.5 cm
The Metropolitan Museum of Art, Gift of the artist,
1972

2
Josef Albers
Fensterbild 1921
Glass, wire, painted metal, nails, mesh, imitation
pearls and ink on wood
54.1 x 54.1 cm
Hirshhorn Museum and Sculpture Garden,
Smithsonian Institution, Washington, DC, Gift of
the Joseph H. Hirshhorn Foundation, 1972

3
Josef Albers
*Park c.*1924
Glass, wire, metal and paint in a wooden frame
49.5 x 38 cm
The Josef and Anni Albers Foundation

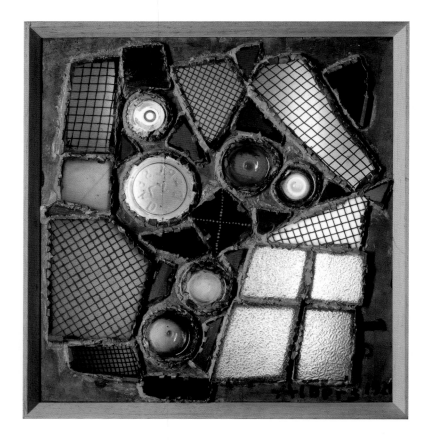
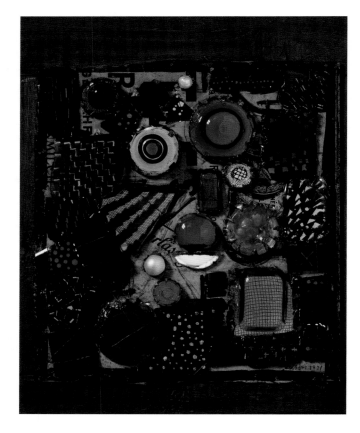

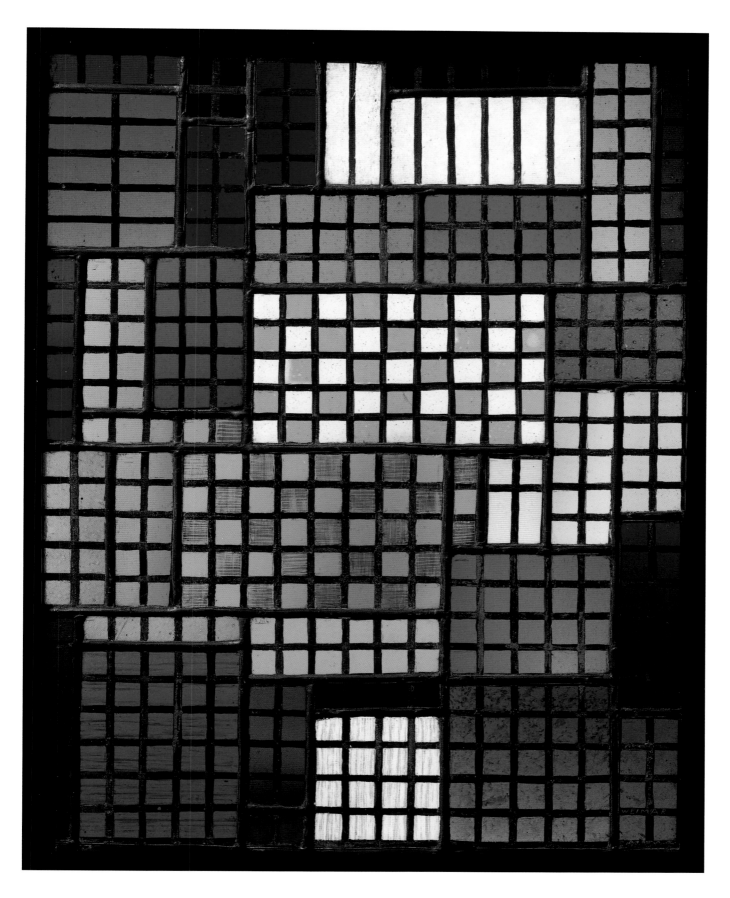

4
László Moholy-Nagy
Photogram with Spiral Shape 1922
Photogram
13.7 x 8.7 cm
Dana and James Tananbaum Collection

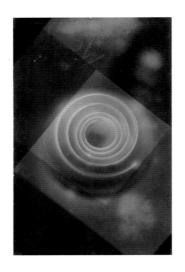

5
László Moholy-Nagy
Untitled 1922
Photogram
14 x 9 cm
Musée national d'art moderne, Centre Pompidou,
Paris

6
László Moholy-Nagy
Untitled 1922
Photogram
18.7 x 13.6 cm
Musée national d'art moderne, Centre Pompidou,
Paris

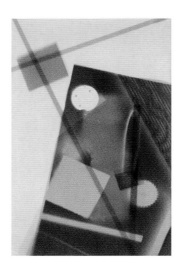

7
László Moholy-Nagy
Black Quarter Circle with Red Stripes 1921
Oil on canvas
99.6 x 80.1 cm
Private Collection

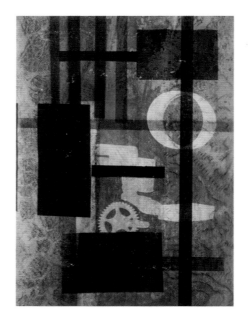

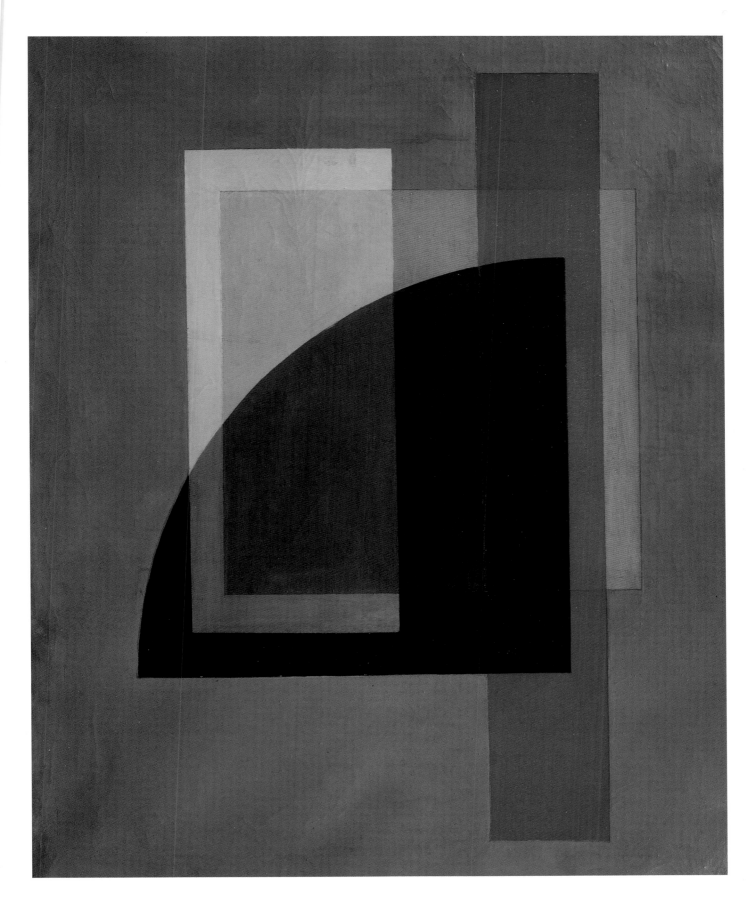

8
László Moholy-Nagy
The Big Wheel 1920–1
Oil on canvas
96.2 x 76.3 cm
Collection Van Abbemuseum, Eindhoven

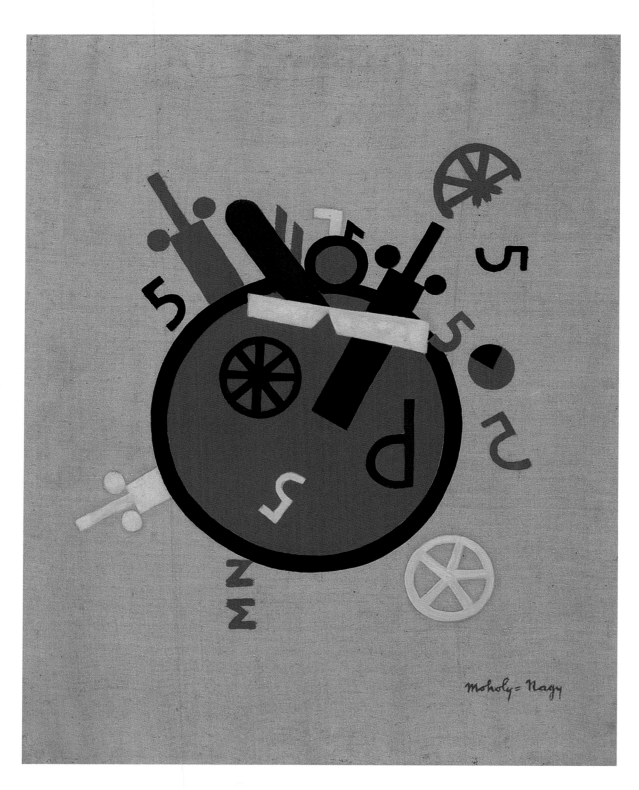

9
László Moholy-Nagy
K XVII 1923
Oil on canvas
95 x 75 cm
Kunsthalle Bielefeld

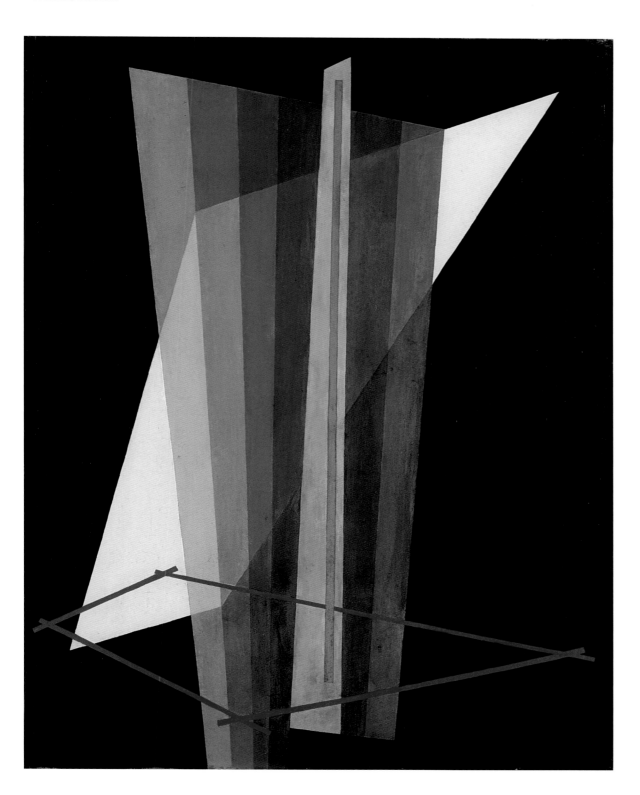

10
László Moholy-Nagy
Composition Q IV 1923
Oil on canvas
76 x 96 cm
Collection Angela Thomas Schmid

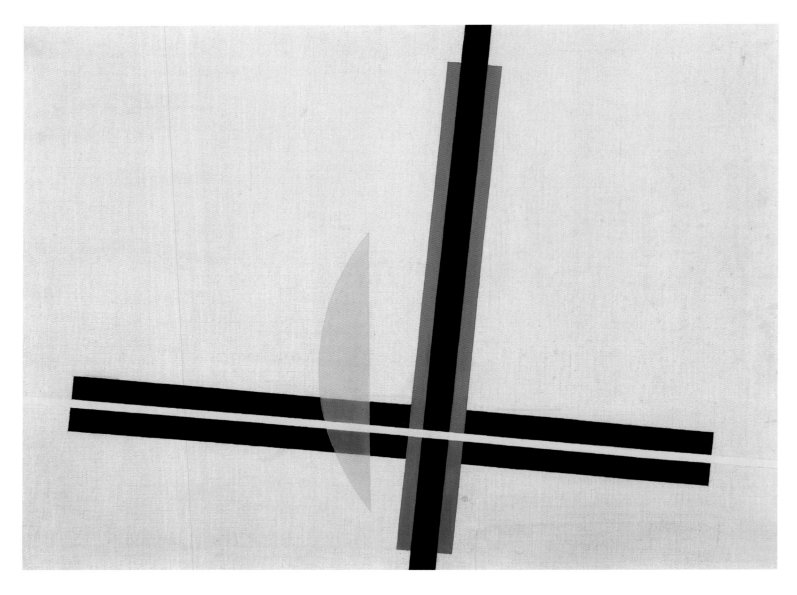

11
László Moholy-Nagy
K VII 1922
Oil on canvas
115.3 x 135.9 cm
Tate. Purchased 1961

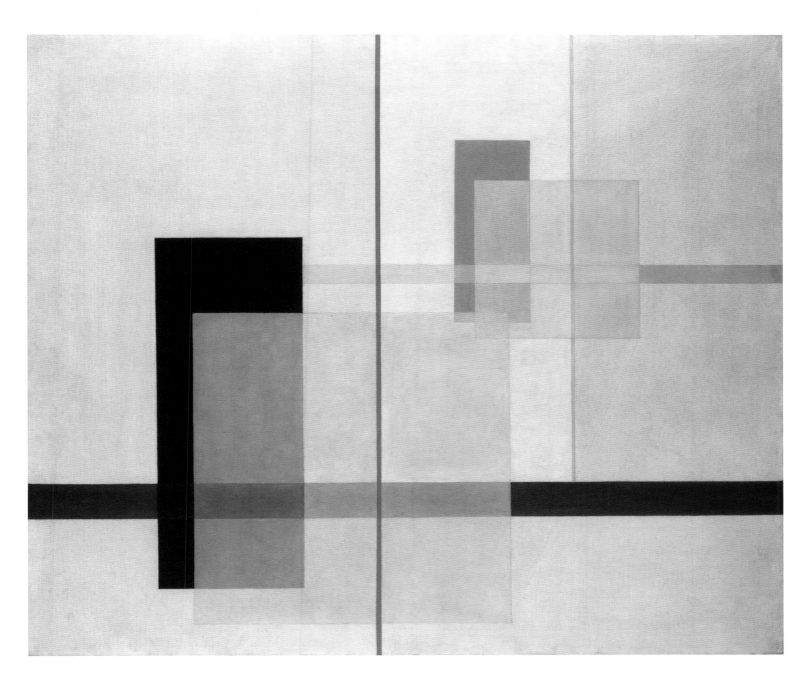

12
László Moholy-Nagy
G8 1926
Oil on Galalith and cardboard
42.7 x 52 cm
Private Collection

13
László Moholy-Nagy
Composition 1925–7
Ink on paper under red partially-painted perspex
38.5 x 49 cm
Private Collection

14
László Moholy-Nagy
A 19 1927
Oil on canvas
80 x 96 cm
Collection Hattula Moholy-Nagy

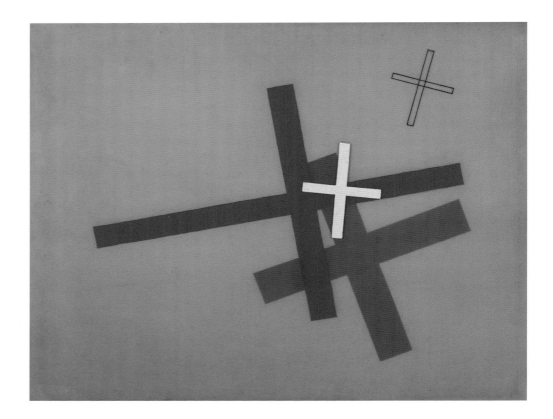

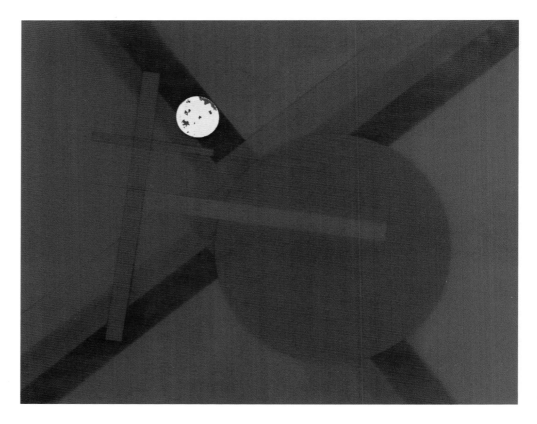

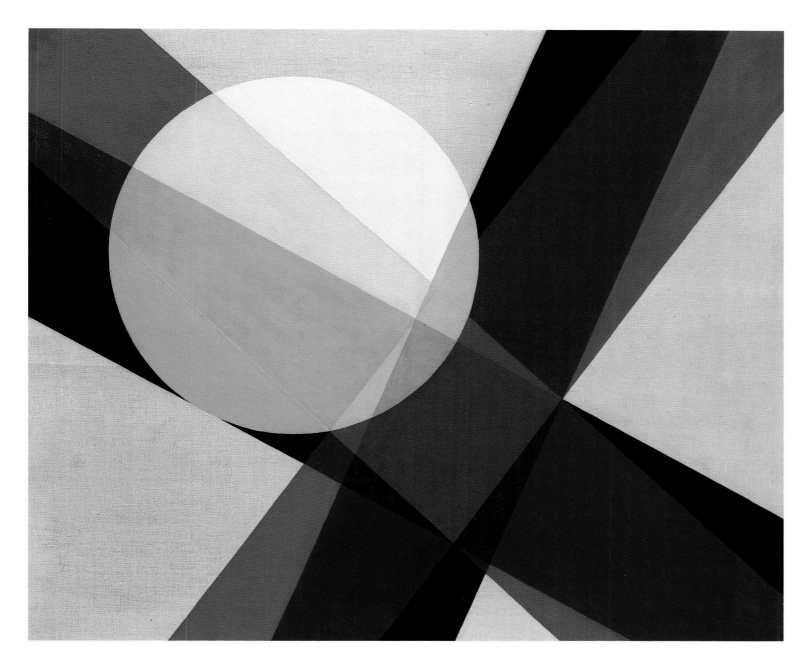

15 (below)
Josef Albers
*Skyscrapers A c.*1929
Sandblasted opaque flashed glass
34.9 x 34.9 cm
Private Collection

16 (top right)
Josef Albers
*Skyscrapers on Transparent Yellow c.*1929
Sandblasted flashed glass with black paint
35.2 x 34.9 cm
The Josef and Anni Albers Foundation

17 (below right)
Josef Albers
*Skyscrapers B c.*1929
Sandblasted flashed glass
36.2 x 36.2 cm
Hirshhorn Museum and Sculpture Garden,
Smithsonian Institution, Washington, DC, Gift of
the Joseph H. Hirshhorn Foundation, 1974

18 (opposite page)
László Moholy-Nagy
Telephone Picture EM1 1922
Porcelain enamel on steel
94 x 60 cm
Viktor and Marianne Langen Collection

19
Josef Albers
*Goldrosa c.*1926
Sandblasted flashed glass with black paint
44.6 x 31.4 cm
The Josef and Anni Albers Foundation

20
Josef Albers
*Upward c.*1926
Sandblasted flashed glass with black paint
44.6 x 31.4 cm
The Josef and Anni Albers Foundation

21
Josef Albers
Tectonic Group 1925
Sandblasted flashed glass with black paint
29 x 45 cm
Collection Angela Thomas Schmid

22
Josef Albers
Armchair for Hans Ludwig and Marguerite Oeser, Berlin
1926 (executed 1928)
Mahogany, beech, maple, sprung and padded
upholstery, grey woollen covering and nickel-plated
screws
75 x 61.6 x 67 cm
Bauhaus-Archiv, Berlin

23
Josef Albers
Set of Four Stacking Tables c.1927
Ash veneer, black lacquer and painted glass
39.2 x 41.9 x 40 cm
47.3 x 48 x 40 cm
55.4 x 53.3 x 40 cm
62.6 x 60.1 x 40.3 cm
The Josef and Anni Albers Foundation

24
Josef Albers
Study for Lettering 1926
Pencil, black ink and collage on tracing paper
21 x 30 cm
The Josef and Anni Albers Foundation

25
Josef Albers
Study for Glass Construction 'Six and Three' c.1931
Pencil, India ink, and gouache on wove graph paper
52.1 x 26 cm
The Josef and Anni Albers Foundation

26
Josef Albers
Study for Glass Construction 'Six and Three' c.1931
Pencil, red pencil and red ink on paper
61.6 x 40.9 cm
The Josef and Anni Albers Foundation

27
Josef Albers
Six and Three 1931
Sandblasted opaque flashed glass
56 x 35.5 cm
The Josef and Anni Albers Foundation

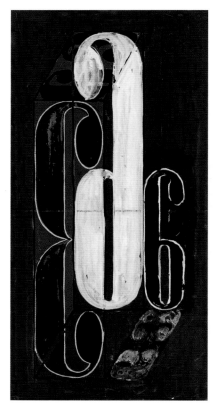

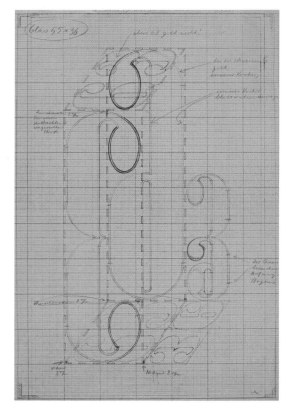

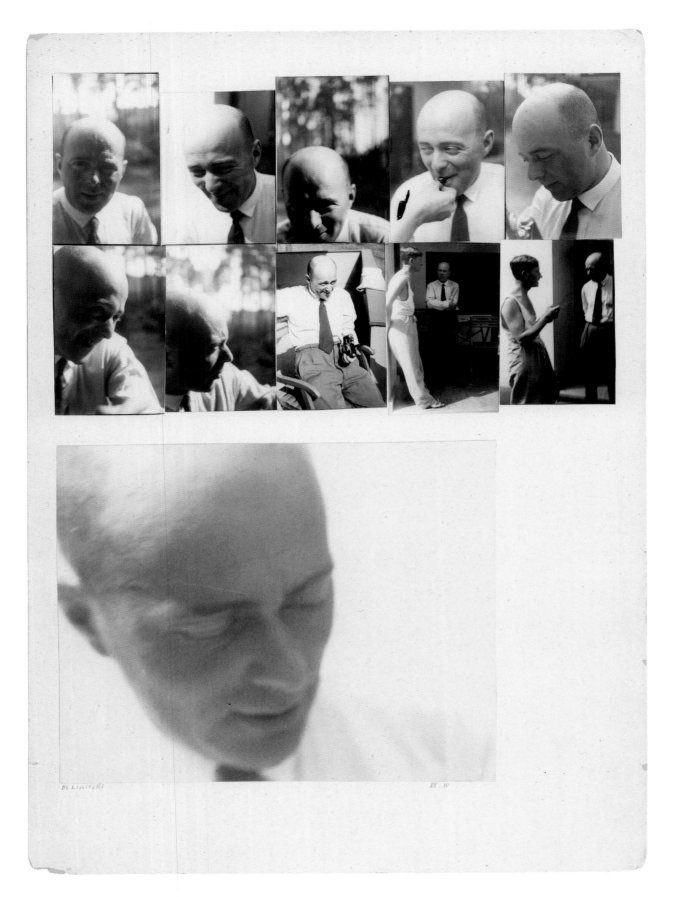

28
Josef Albers
El Lissitzky at the Bauhaus 1928–30
Gelatin silver print
41.8 x 29.7 cm
The Metropolitan Museum of Art, Ford Motor
Company Collection, Gift of Ford Motor Company
and John C. Waddell, 1987

29
László Moholy-Nagy
Oskar Schlemmer in Ascona 1927
Gelatin silver print
16.8 x 12.4 cm
Galerie Berinson, Berlin/ Ubu Gallery, New York

30
László Moholy-Nagy
Ascona (Schlemmer Girls on Balcony) 1926
Gelatin silver print
39.8 x 29.9 cm
Galerie Berinson, Berlin/ Ubu Gallery, New York

31
Josef Albers
Coat of Arms for the City of Bottrop 1924
Gouache on paper
24.5 x 17.5 cm
Josef Albers Museum, Bottrop

32
Josef Albers
Three Designs for a Flag for the Bauhaus Exhibition
1923
Opaque white, watercolour and pencil on paper
23.1 x 15.1 cm
Bauhaus-Archiv, Berlin

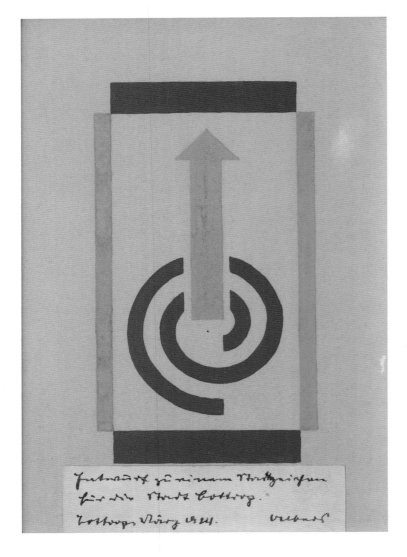

33
László Moholy-Nagy
Malerei, Fotografie, Film 1925
Painting, Photography, Film
(Bauhausbücher, vol.8)
Cover

34
Kasimir Malevich/ László Moholy-Nagy
Die gegenstandslose Welt 1927
The Non-Objective World
(Bauhausbücher, vol.11)
Cover

35
László Moholy-Nagy
Von Material zu Architektur 1929
From Material to Architecture
(Bauhausbücher, vol.14)
Cover

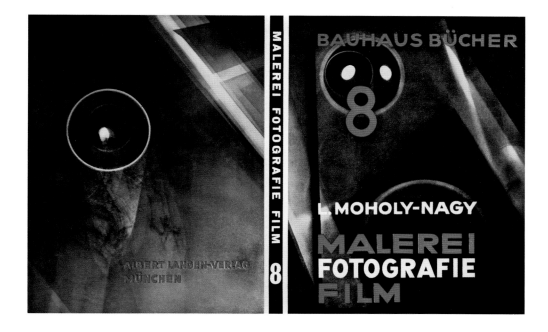

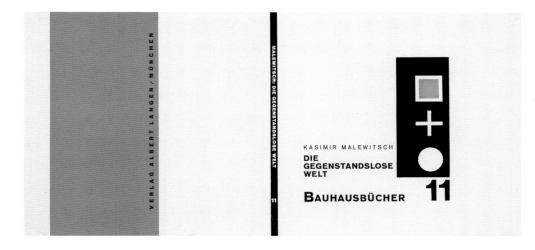

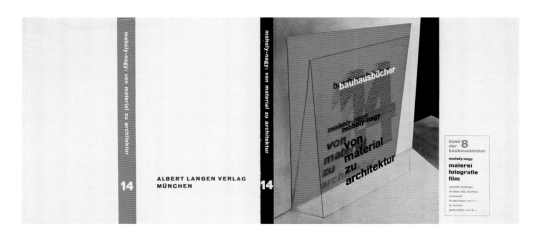

36
László Moholy-Nagy
A 20 1927
Oil on canvas
80 x 95.5 cm
Private Collection, courtesy Annely Juda Fine Art,
London

37
László Moholy-Nagy
Photogram No. II 1929
Silver gelatin print (enlargement after 1922
photogram)
95.5 x 68.5 cm
Galerie Berinson, Berlin/ Ubu Gallery, New York

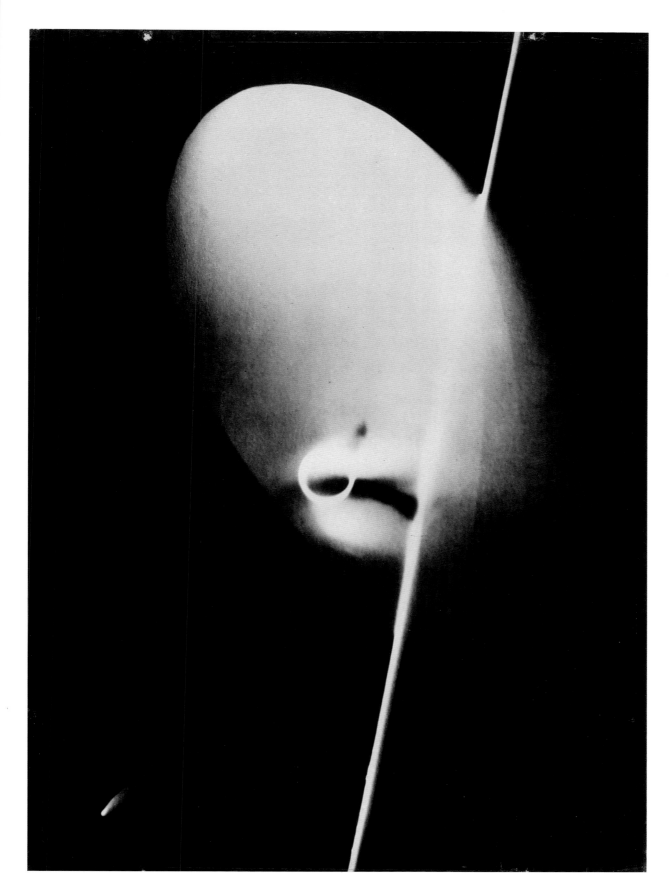

38
László Moholy-Nagy
Untitled (Three Untitled Photograms) 1922
Gelatin silver prints
Each 19 x 12 cm
Private Collection, courtesy Pace/MacGill,
New York

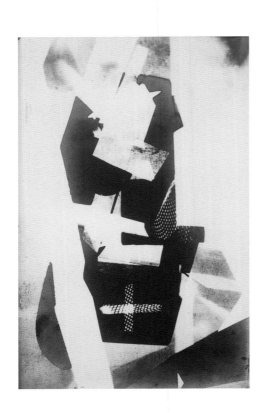 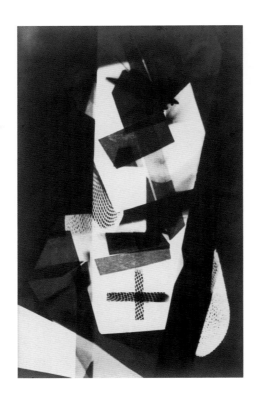 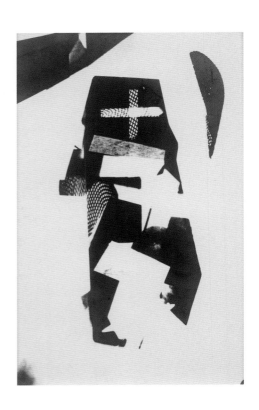

39
László Moholy-Nagy
*Negative c.*1927
Gelatin silver print
29.7 x 21.4 cm
Private Collection, courtesy Pace/MacGill,
New York

40
László Moholy-Nagy
*Negative Cat c.*1926
Gelatin silver print
28.4 x 23 cm
The Art Institute of Chicago, Julien Levy Collection,
Special Photography Acquisition Fund

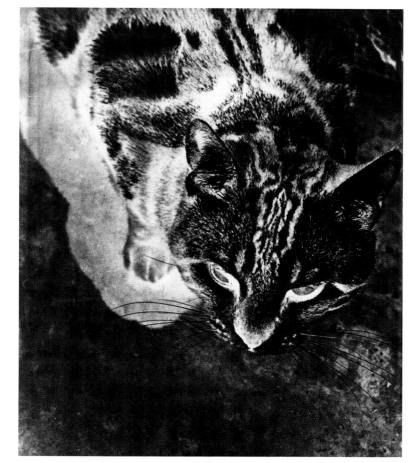

41
László Moholy-Nagy
The Diving Board 1931 or earlier
Gelatin silver print
28.3 x 20.7 cm
The Museum of Modern Art, New York.
Anonymous gift

42
László Moholy-Nagy
Dessau c.1926–8
Gelatin silver print
24.9 x 18.6 cm
Museum Folkwang, Essen

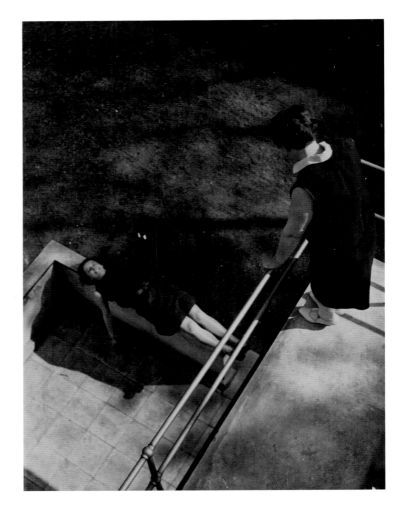

43
László Moholy-Nagy
Ascona 1926
Gelatin silver print
36.7 x 27.7 cm
The Museum of Modern Art, New York.
Anonymous gift

44
László Moholy-Nagy
Rothenburg 1926–8
39.5 x 29.5 cm
James Hyman, London

45 (top)
László Moholy-Nagy
*Joseph and Potiphar's Family c.*1926
Gelatin silver print of a photomontage
(photoplastic)
11.7 x 17.5 cm
The J. Paul Getty Museum, Los Angeles

46 (centre left)
László Moholy-Nagy
How Do I Keep Young and Beautiful? 1920s
Gelatin silver print of a photomontage
(photoplastic)
17.4 x 12.5 cm
Collection Hattula Moholy-Nagy

47 (below)
László Moholy-Nagy
Sport Makes Appetite 1927
Gelatin silver print of a photomontage
(photoplastic)
20.3 x 27.9 cm
IVAM, Instituto Valenciano de Arte Moderno,
Generalitat Valenciana

48 (centre right)
László Moholy-Nagy
Jealousy 1924–7
Gelatin silver print of a photomontage
(photoplastic)
17.4 x 12.5 cm
Collection Hattula Moholy-Nagy

49 (opposite page)
László Moholy-Nagy
Between Heaven and Earth 1923–7
Collage with photogram and pencil on paper
65 x 50 cm
Galerie Berinson, Berlin/ Ubu Gallery, New York

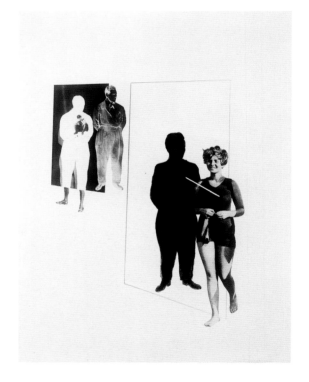

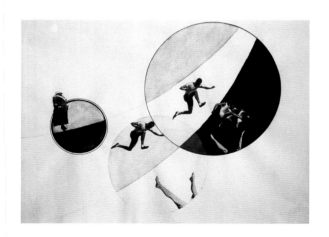

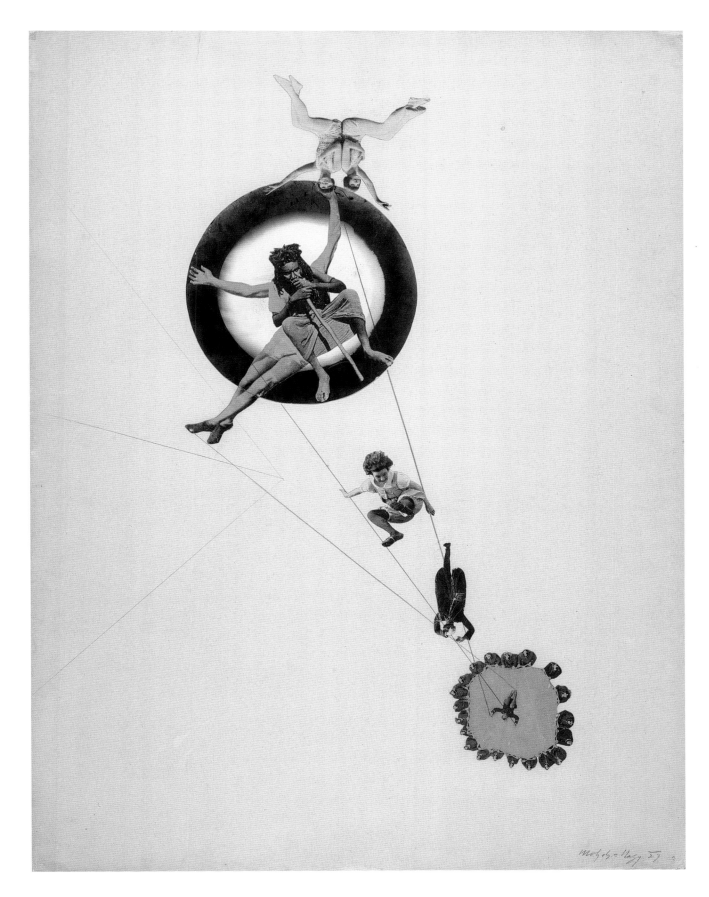

50
László Moholy-Nagy
Pneumatik 1926
Drawing and collage on paper
52.5 x 41.1 cm
Louisiana Museum of Modern Art, Humlebaek,
Denmark. Donation: The Josef and Celia Ascher
Collection, New York

51
László Moholy-Nagy
The Eccentrics 1927
Die Eigenbrötler
Photomontage
64.4 x 49.7 cm
Museum Folkwang, Essen

52
László Moholy-Nagy
Birthmark (Salome) c.1926
Muttermal (Salome)
Photo collage mounted onto cardboard
63 x 48 cm
Bauhaus-Archiv, Berlin

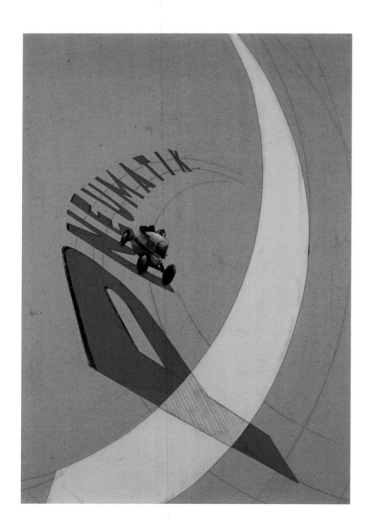

53
Josef Albers
Beaker 1929
Sandblasted opaque flashed glass
29 x 37 cm
Private Collection

54
Josef Albers
Cables 1931
Sandblasted opaque flashed glass
40 x 50 cm
Tate. Presented by The Josef and Anni Albers
Foundation 2006

55
Josef Albers
Study for 'Pergola' 1929
Pencil and ink on graph paper
31.1 x 50.8 cm
The Josef and Anni Albers Foundation

56
Josef Albers
Study for Pergola 1929
Gouache and pencil on paper
44.5 x 58 cm
Bauhaus Dessau Foundation, Germany

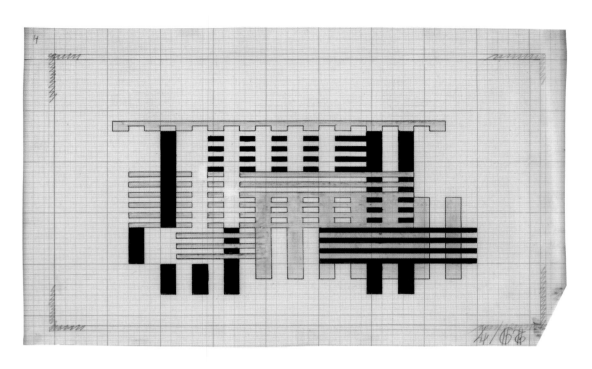

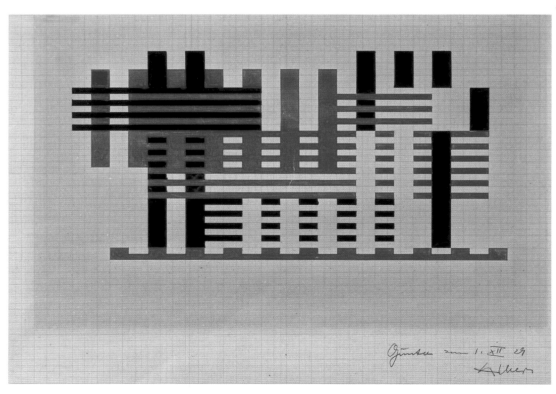

57
Josef Albers
Pergola 1929
Sandblasted opaque flashed glass with black paint
27 x 45.6 cm
The Josef and Anni Albers Foundation

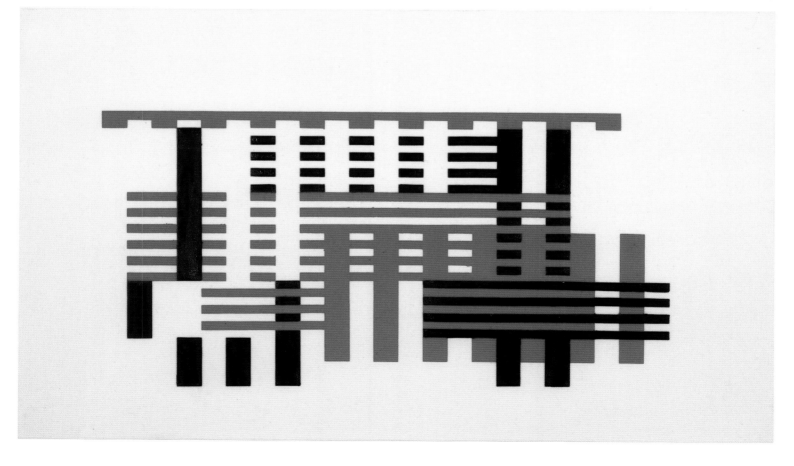

58
Josef Albers
Glove Stretchers 1928
Sandblasted opaque flashed glass
39.4 x 52.7 cm
Musée national d'art moderne, Centre Pompidou,
Paris. Donation of The Josef and Anni Albers
Foundation 2001

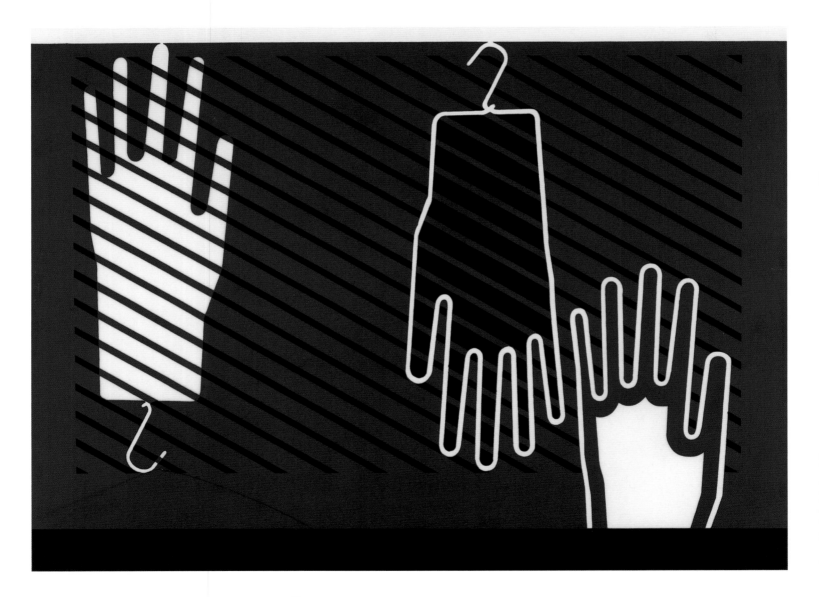

59
Josef Albers
Flying 1931
Sandblasted opaque flashed glass mounted on
cardboard
30.2 x 35 cm
Staatsgalerie Stuttgart

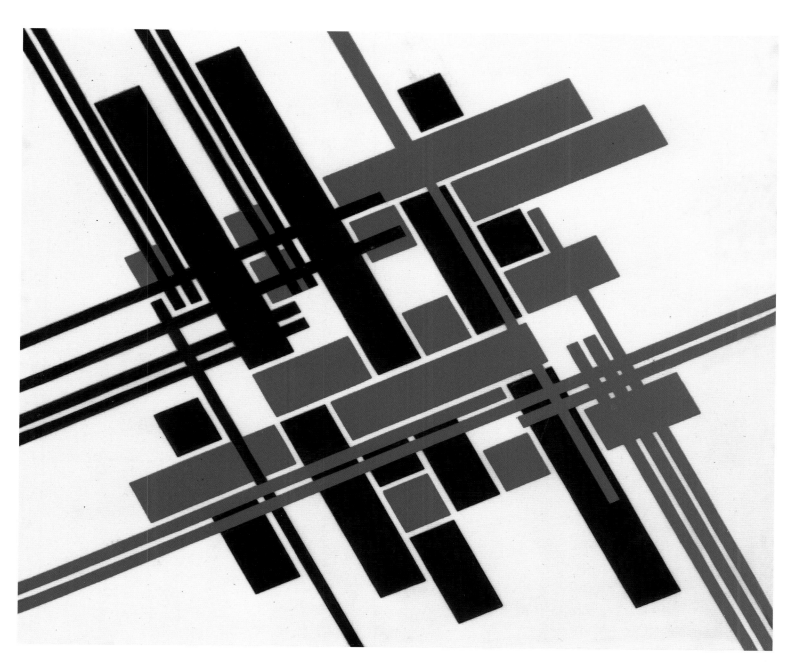

60
Josef Albers
Untitled (Bullfight San Sebastian) n.d.
6 photographs mounted onto cardboard
29.7 x 41.7 cm
The Josef and Anni Albers Foundation

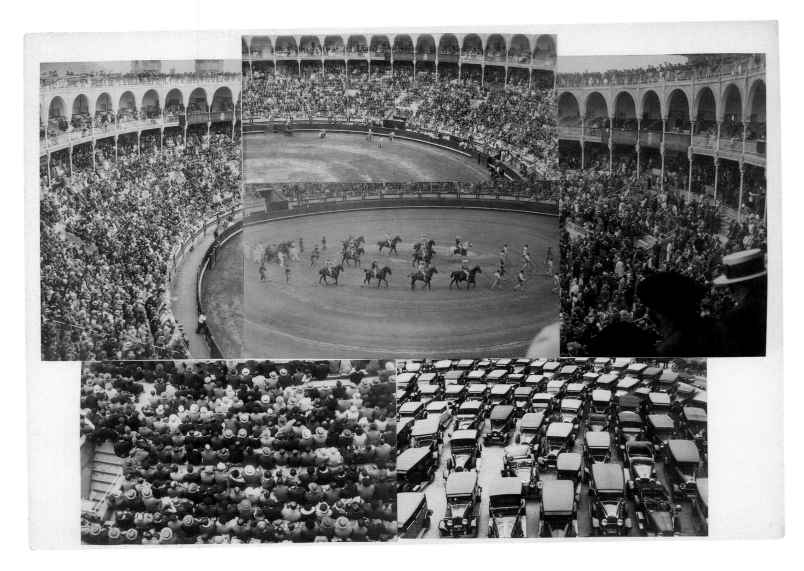

61
Josef Albers
Steps 1931
Sandblasted opaque flashed glass
41.5 x 54.5 cm
Private Collection

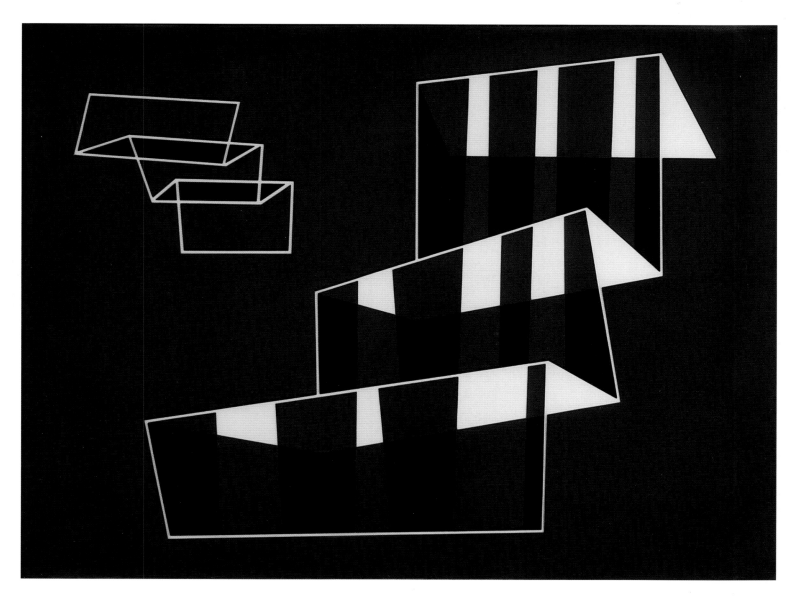

62
Josef Albers
Sport on Bathing Beach, Biarritz n.d.
Photograph mounted on cardboard
23 x 17.1 cm
The Josef and Anni Albers Foundation

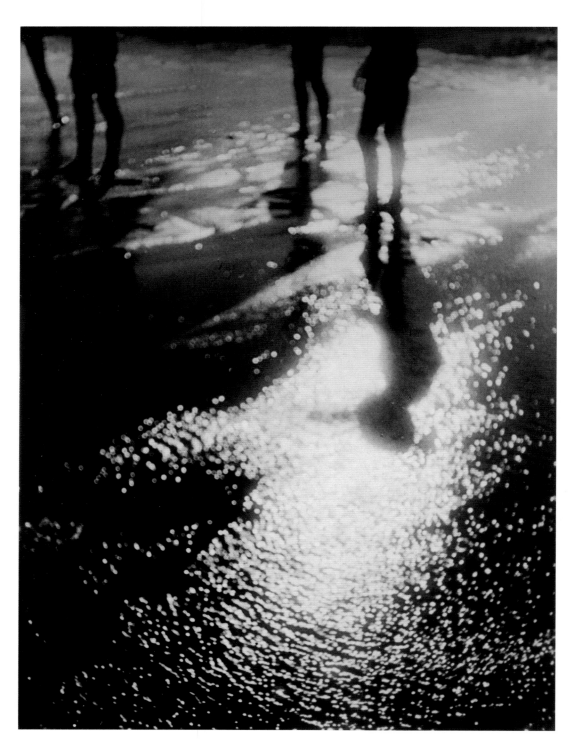

63
Josef Albers
Untitled n.d.
Gelatin silver print
23.2 x 15.9 cm
The Josef and Anni Albers Foundation

64
Josef Albers
Very Thin Ice n.d.
Gelatin silver print
22.9 x 15 cm
The Josef and Anni Albers Foundation

65
László Moholy-Nagy
Sketch for Score of 'Mechanical Eccentricity' 1924–5
Partiturskizze Mechanische Exzentrik
Collage, ink and watercolour on card
140 x 17.8 cm
Collection of the Theatre Studies Department,
University of Cologne

66
Stefan Sebök
*Construction Drawing for László Moholy-Nagy's Light
Prop for an Electric Stage* 1930
Pencil on tracing paper
42 x 61.5 cm
Bauhaus-Archiv, Berlin

67
László Moholy-Nagy
Light Prop for an Electric Stage
1928–30 (replica 1970)
Metal, plastic and wood
151 x 70 x 70 cm
Collection Van Abbemuseum, Eindhoven

68 (overleaf)
László Moholy-Nagy
Stills from *Light Play: Black-White-Grey* 1930
5 min 30 sec
16 mm black and white film, silent
Courtesy Hattula Moholy-Nagy

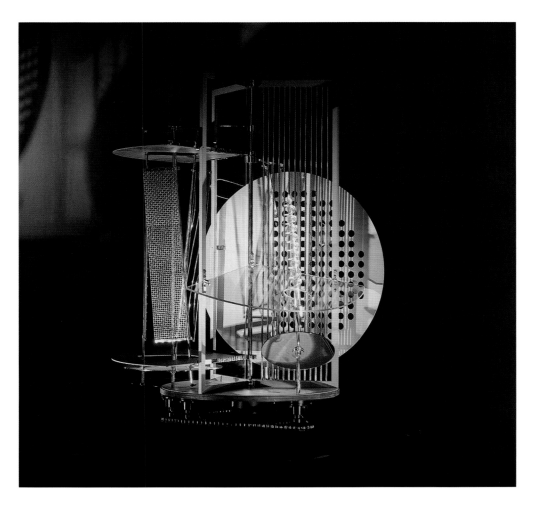

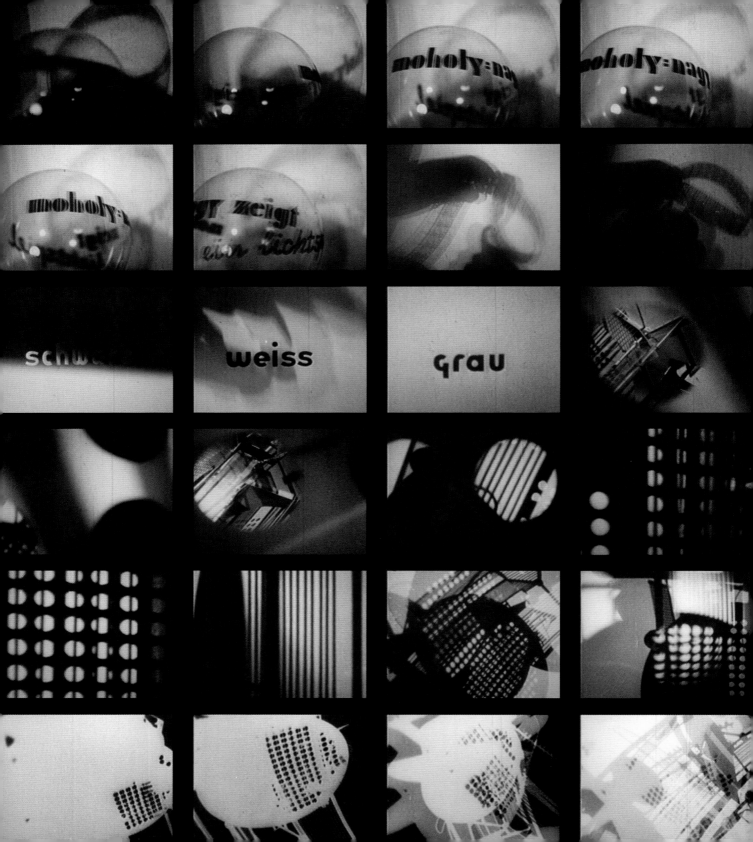

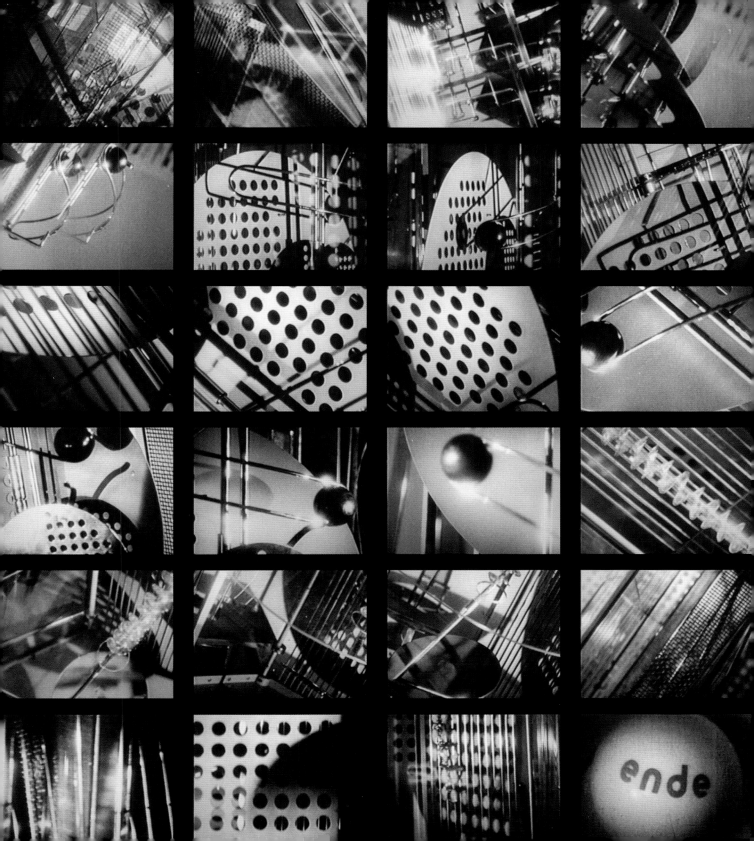

69
Josef Albers
Sea 1933
Woodcut
(Printed at Ullstein Press, Berlin)
35.6 x 44.8 cm
The Josef and Anni Albers Foundation

70
Josef Albers
Easterly 1933
Cork relief
(Printed at Ullstein Press, Berlin)
21.6 x 31.1 cm
The Josef and Anni Albers Foundation

71
Josef Albers
Study for 'Aquarium' c.1934
Brush and ink on wove paper
20.8 x 29.5 cm
The Josef and Anni Albers Foundation

72
László Moholy-Nagy
Imperial Airways Map of Empire and European Air Routes April 1936
Colour Lithograph
99.4 x 63.5 cm
British Airways Archive and Museum Collection, Hounslow

73
László Moholy-Nagy
Space Modulator Experiment, Aluminium 5 1931–5
Aluminium and Rhodoid
86 x 71 cm
Private Collection, Germany

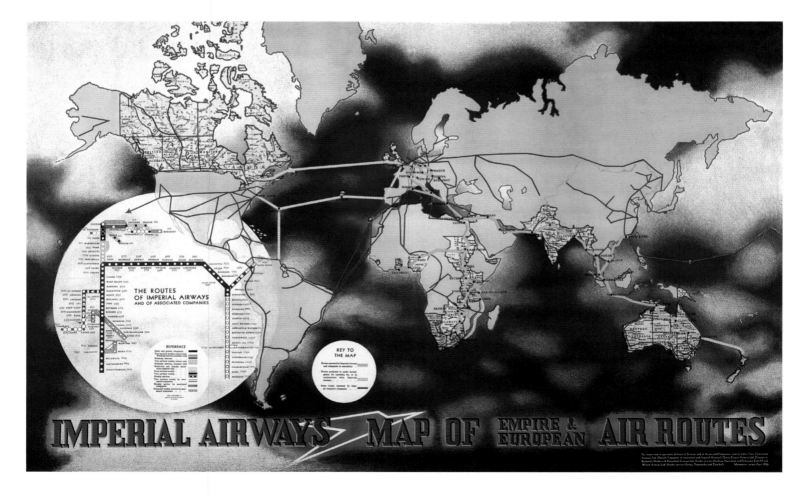

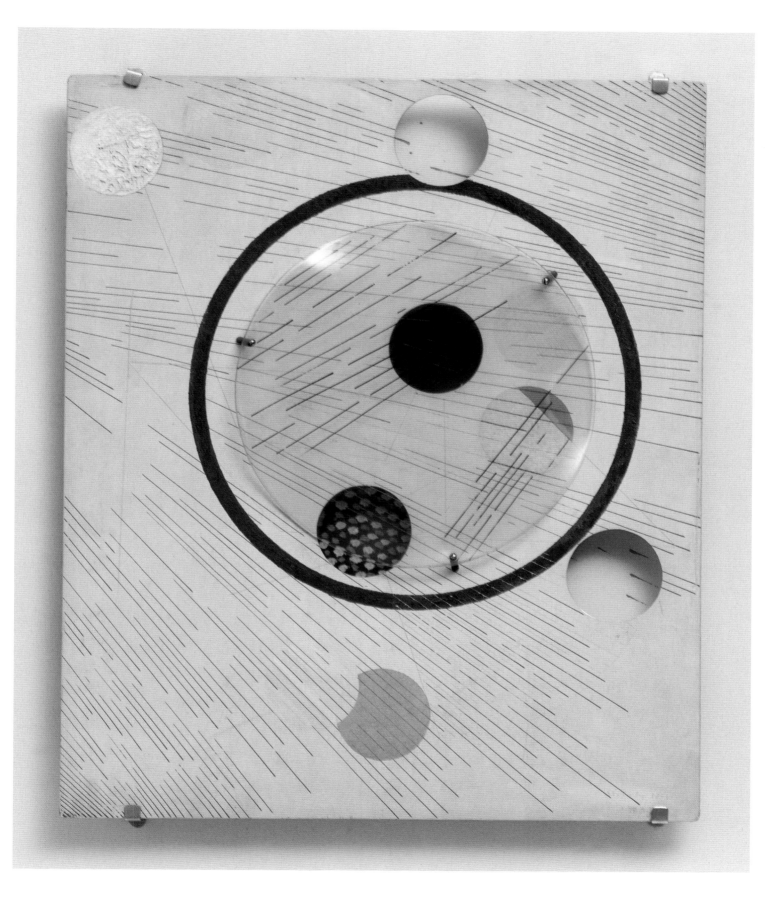

74
László Moholy-Nagy
Composition TP5 1930
Oil and engraving on Galalith
28.1 x 20.1 cm
Collection Angela Thomas Schmid

75
László Moholy-Nagy
Tp 2 1930
Oil and incised line on blue Trolitan
61.5 x 144.3 cm
Solomon R. Guggenheim Museum, New York.
Gift, Solomon R. Guggenheim

76
László Moholy-Nagy
G 11 1934
Oil and tempera on Galalith
32 x 46 cm
Private Collection, Germany

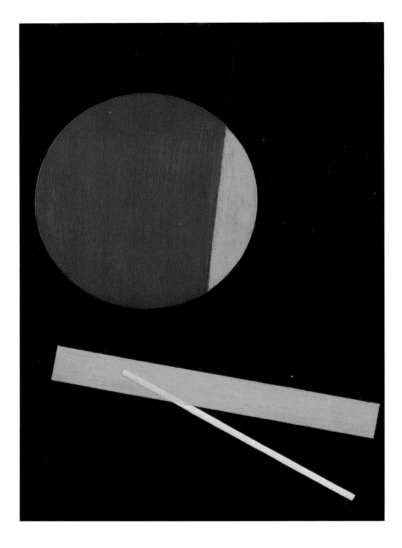

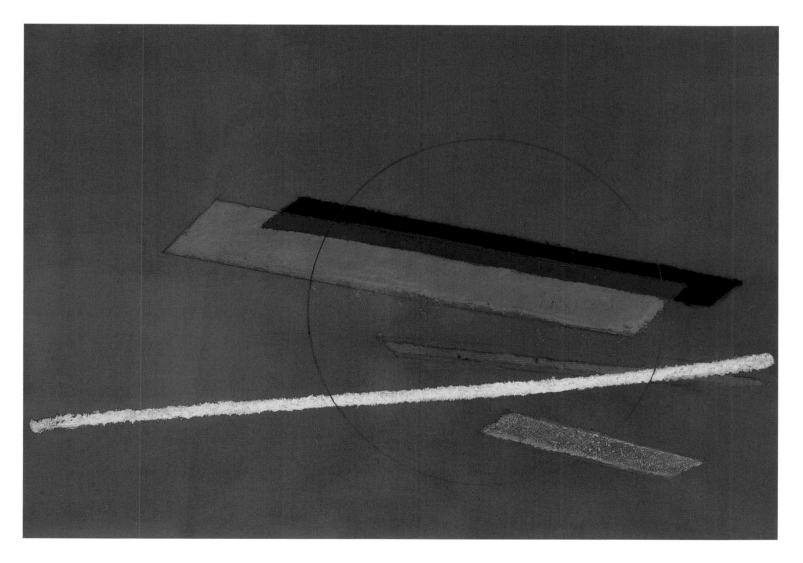

77
László Moholy-Nagy
Untitled (Dusk on the Playing Fields of Eton) 1930s
Gelatin silver print
22 x 27 cm
Collection Hattula Moholy-Nagy

78
László Moholy-Nagy
Untitled 1930s
Gelatin silver print
21.3 x 16.5 cm
Collection Hattula Moholy-Nagy

79
László Moholy-Nagy
Construction AL6 1933–4
Oil on aluminium
60 x 50 cm
IVAM, Instituto Valenciano de Arte Moderno,
Generalitat Valenciana

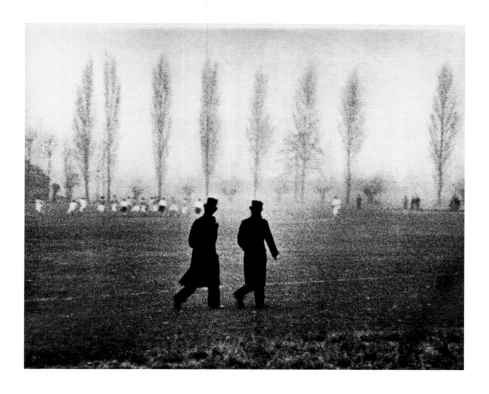

80
László Moholy-Nagy
*Poster for London Transport: Quickly Away, Thanks to
Pneumatic Doors* 1937
Colour lithograph
101.3 x 63.3 cm
Victoria and Albert Museum, London

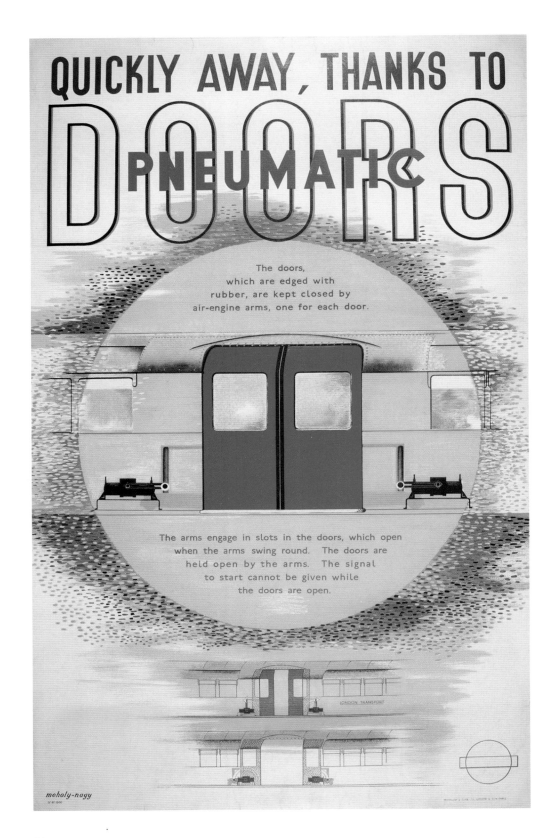

TWO BAUHAUS HISTORIES

Achim Borchardt-Hume

fig.1
Photograph of László Moholy-Nagy
by Lucia Moholy,1926
Bauhaus-Archiv, Berlin

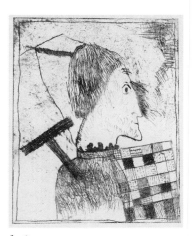

fig.2
Marcel Breuer
Portrait of Josef Albers 1921–2
Etching on paper
14 x 11.5 cm
The Josef and Anni Albers Foundation

On 13 February 1923, Walter Gropius, founder and Director of the Staatliches Bauhaus in Weimar, announced the appointment of two new Members of teaching staff: Josef Albers, who had been a student at the school for the previous three years, and László Moholy-Nagy, who had been introduced to Gropius only the year before at Herwarth Walden's famous Der Sturm gallery.[1] The atmosphere at Germany's most celebrated art and design school, as Albers himself later recalled, was dominated by the creative rivalries of its teachers, among them artists and architects of such stature as Wassily Kandinsky, Paul Klee, Lyonel Feininger, Oskar Schlemmer and Mies van der Rohe. Albers and Moholy turned out to be no exception to this rule.

Two portraits from the mid-1920s give a flavour of the artists' divergent temperaments. The first, a photograph by his wife Lucia, shows the bespectacled Moholy sporting the scarlet overall of a racing-car mechanic atop a starched white shirt with tie, every bit the modern, technocratic intellectual (fig.1). The second, a caricature by his friend, the designer Marcel Breuer likens Albers – bearing an early glass piece like a coat of arms or a theological treatise, his hair cropped into a monk's tonsure – to the fifteenth-century Florentine radical Savonarola (fig.2). In a superficial way, these two images suggest the twin facets of the Bauhaus with which Albers and Moholy (not always by their own volition) became commonly associated: Albers, the introvert teacher and craftsman; Moholy, the extrovert multi-media artist and propagandist. Questioning this dichotomy offers new insights not only into their work, but also exposes the fictitious nature of a monolithic Bauhaus narrative.

Albers joined the ranks of the modernist avant garde comparatively late in life. Born in 1888 in Bottrop, Westphalia, he had initially trained and worked as a primary-school teacher before enrolling at the Royal Art School in Berlin. His teaching qualifications spared him from being drafted into the German army; he spent most of World War I in his native Bottrop, frequenting evening classes at the School of Applied Arts in nearby Essen. With the war over, he went to Munich to study with the salon painter Franz von Stuck, a somewhat anachronistic choice (two of Albers's future fellow-Bauhauslers, Kandinsky and Klee, had studied with Von Stuck twenty years earlier). Dispirited by the stealth of academic teaching Albers responded enthusiastically to the wake-up call of the Bauhaus manifesto. He described his impromptu decision to leave Munich for Weimar as follows: 'I was 32, but I went to the Bauhaus. Threw all my old things out of the window, started once more from the bottom. That was the best step I made in life.'[2]

Around the same time that Albers travelled from Bavaria to Weimar, the young Moholy, his junior by seven years, arrived in Berlin as an exile from his native

Hungary. He had little formal artistic education, having studied law when he was called to arms by the Austro-Hungarian army. His earliest creative experiments were in poetry rather than the visual arts, and writing would always remain an important activity. It was the shock of the war experience that first propelled him to become an artist. In a quest for a new beginning, he joined a group of intellectuals gathered around the avant-garde journal *MA* (Today). However, accused of being bourgeois and counter-revolutionary, *MA* was soon closed down by the Communist Soviets of post-revolutionary Hungary. In the wake of political turmoil and anti-Jewish sentiments, Moholy, together with many other Hungarian intellectuals, emigrated first to Vienna and then to Berlin, the Mecca of the Eastern European avant garde, where he quickly befriended other artists such as the Constructivist El Lissitzky and the Dadaists Kurt Schwitters and Hans Arp.

A NEW BEGINNING

In 1920, separated by the 220 kilometre distance between Berlin and Weimar, Albers and Moholy independently took a decisive turn in their careers, abandoning mimetic representation in favour of a rigorously abstract idiom. It is important to note that neither did so through an engagement with the formal innovations of the early modernist movements such as Cubism, or because of influences outside the traditional art-historical canon – non-European or folk art, theosophy or the like – as many artists a generation before had done.[3] Rather than a gradual development, their move into abstraction was sudden and wholehearted, intended to mark a rupture with the past, collective as much as personal.

Yet Albers and Moholy arrived at this nexus in their careers by very different means: Albers on a largely empirical route via early Bauhaus teaching and through his intense engagement with materials; Moholy through embracing the avant-garde ideas of Dada and Constructivism. The similar yet different beginnings of these two artists anticipated the ways in which their careers for the next three decades were to develop along parallel paths yet never quite overlap.

Albers's first abstract works were collages made from roughly cut shards of coloured glass (fig.3). These betray a rawness and physicality few would associate with his later, more controlled, work (with the noticeable exception of his early American paintings, his 'second new beginning'). Albers later recalled trawling the streets of Weimar, equipped with knapsack and hammer, on the hunt for broken bottles and windows. Apart from offering a glimpse into the economic reality of the early Bauhaus years, Albers's account also suggests his new interest in the avant-garde ambition of eradicating the boundaries between art and life.[4] It has been suggested that these *Scherbenbilder* (Shard pictures) were influenced by the teachings of Johannes Itten, the then head of the preliminary course, and his promotion of the strategies of collage and assemblage, as well as earlier lessons by the Dutch glass-artist Johan Thorn-Prikker, with whom Albers had studied in Essen.[5] However, with their focus on light and transparency as the artistic means of a new age the *Scherbenbilder* also connect with the wider Bauhaus ideals, especially those of early modernist architecture as promoted by Gropius.

Albers's artistic development over the next decade would largely continue to be driven by his intense engagement with materials. When asked about the influence of contemporary avant-garde ideas on his work, Albers flatly replied:

fig.3
Josef Albers
Rhenish Legend 1921
(pl.1, p.10)

Everything was in the air in Weimar: the Futurists, the Constructivists; God knows what was there. Van Doesburg opened a shop across the street. Wanted to set himself up as the anti-Christ. We had right away a clash ... That cruel insistence on just straight lines and right angles. It was for me just mechanical decoration.[6]

Yet, the fact that by the mid-1920s Albers's style to a large degree had become just that – straight lines and right angles – contradicts this protestation to creative self-sufficiency. Instead it suggests that Albers was assimilating a formal repertoire, while avoiding its theoretical underpinning, which via the concurrent changes in the Bauhaus-aesthetic overall can be traced back to Constructivism and De Stijl.

In contrast, Moholy's move into abstraction was motivated by the fervent desire to be part of an artistic and social avant garde. Dada's irreverence, which aimed to offend middle-class notions of good taste, taught Moholy to refuse the limitations of traditional definitions of art, and to appreciate the artistic potential of mundane subject matter such as railway bridges, machines and mathematical numbers, and the value of humour and irony as creative strategies. From Constructivism, on the other hand, Moholy borrowed the principle that art should be pure, creating relationships amongst its compositional constituents that were void of any representational references. 'To be an artist is to surrender to the elements that give form', he proclaimed.[7] Moholy's idiosyncratic type of Constructivism was characterised by its emphasis on transparency and light. Built from opaque areas of colour, the geometric shapes in Moholy's paintings seemingly float on top of each other. Though there is pictorial depth in paintings such as *Construction Z I* 1922–3 (fig.4), there is no spatial 'illusion'. Overlapping translucent planes explored in a wide range of different media remained a recurrent theme in Moholy's art throughout his career.

ARTS, CRAFTS AND INDUSTRY

The evolution of the Bauhaus reflected that of Weimar Germany as a whole. The arts-and-crafts ideal of the economically depressed post-war years soon made way for an alignment with the rising demands of industry, the first Bauhaus exhibition in 1923 under the title 'Art and Technology. A New Unity' marking the pivotal turning point. Many of the first generation of Bauhaus teachers resisted this paradigmatic shift, and Albers and Moholy stand for two distinct positions within this historic moment, the former highlighting continuities, the latter programmatic change.

The original Bauhaus manifesto had invoked the communality of the craftsmen working on medieval cathedrals as a model for a new symbiosis between arts and crafts. Albers's attraction to this ideal had been foreshadowed by his earlier enrolment in the Essen School for Arts and Crafts. However, as a newly appointed member of staff he could ignore neither the growing criticism of the Bauhaus's programme as outdated nor the mounting pressure for the school to produce marketable products. The two different directions in which Albers's early glass collages evolved soon after 1923 reflect this dilemma.

Being put in charge of the stained-glass workshop, Albers initially fulfilled the early Bauhaus ideal of the artist-craftsman by designing large-scale architectural commissions including windows for the Director's Office in Weimar (fig.5), Gropius's Haus Sommerfeld and the Ullstein Publishing House in Berlin.[8] When modernist architecture and its rejection of ornament made such windows obsolete (the stained-

fig.4
László Moholy-Nagy
Construction Z I 1922–3
Oil on canvas
75 x 96.5 cm
Bauhaus-Archiv, Berlin

fig.5
Stained glass window designed by Josef Albers for the Director's Office in Weimar c.1922 (destroyed)

fig.6
Josef Albers
Fruit Bowl 1923
Silver-plated metal, glass and wood
9.2 x 42.5 x 42.5 cm
The Museum of Modern Art, New
York. Gift of Walter Gropius, 1958

fig.7
Josef Albers
Tea Glass 1926
Heat resistant glass, porcelain, nickled
steel, Ebonite
5.7 x 11.5 x 11.5 cm
Bauhaus-Archiv, Berlin

fig.8
László Moholy-Nagy
G8 1926
(pl.12, p.18)

glass workshop was abandoned following the Bauhaus's move to its new Gropius-designed dwellings in Dessau in 1925), Albers embarked on an innovative series of sandblasted glass pieces that mimic the format of easel paintings. The prevalence of geometric grids and right angles, and the potential for serial production – made with a stencil the pieces could theoretically be replicated – indicate Albers's new-found kinship with the architecture and design discourse of the period.

Yet, at the same time, they retain an element of craft. Adapted from a process originally invented to reduce the cost of engraving gravestones, the precise sandblasting draws at least as much attention to the skill of the craftsman as to the semi-industrial technique itself. One exceptionally important influence on Albers throughout these formative years was the weaver Anni Albers, whom he had married in 1925 and whose geometrically patterned fabrics bear striking parallels to his glass works.

Albers's elegant designs for a number of objects, including a set of nestling tables, various armchairs, a fruit bowl and a tea cup, all suffer from a tension between wishing to embrace the democratisation of serial (ideally mass) production without wanting to sacrifice the quality of individual craftsmanship (see figs.6 and 7). Years later he wrote: 'Industry has replaced hand tools with machines, craftsmen with workmen, individual production with mass production. The result is a doom for the crafts, though industry, so far, has done little to replace the best qualities of the crafts.'[9] However, rather than being specific to Albers, this tension was symptomatic of the mismatch between the Bauhaus utopia of good design for all and the efficiency requirements of a capitalist market place.

For Moholy, technology had superseded craft as the principal paradigm for the modern artist.[10] In 1922, the year that Constructivism triumphed at the *Grosse Deutsche Kunstausstellung* and Moholy had his first major solo exhibition at Der Sturm, he wrote: 'Everyone is equal before the machine. I can use it, so can you.'[11] The same year, he famously ordered five enamel paintings from a sign factory, three of them bearing the same motif of a vertical bar and two elongated crosses increasing in size. He later recounted how he had instructed the sign painter to execute these 'paintings' with the help of graph paper and an industrial colour chart, and how he had done it by telephone, eliminating any personal contact whatsoever.[12] To underscore the paintings' anti-individualism, he titled them, as he would most of his work from hereon in, with a combination of letters and numbers, reminiscent of scientific formulas. However truthful (or not) Moholy's account of the *Telephone Paintings* was, it is symptomatic of his eagerness to attune his art to the machine-aesthetics of the modern age.

Upon arriving at the Bauhaus, Moholy was put in charge of the Metal Workshop. Despite his experience in this area being limited to some early sculpture experiments in bent and welded metal (see fig.31, p.82), under his tutelage this became the first workshop to achieve the goal of affordable and economically viable Bauhaus design. His use of opaque plastics in three-dimensional compositions such as *G8* 1926 (fig.8) was another indicator of his continuous ambition to re-align the technical and artistic innovations of his day. The high point of this ambition, however, was *Light Prop for an Electric Stage* 1928–30 (see pl.67, p.53 and fig.9). Though it was executed after he had left the Bauhaus, his first ideas for the project dated back to his time at the school, if not before.[13] A mechanism constructed of polished metal, sheets of glass and transparent screens arranged around pivoting metal rods, this early kinetic sculpture

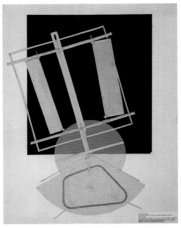

fig.9
László Moholy-Nagy
Light Prop for an Electric Stage 1928–30
Collage on paper
65 x 49.8 cm
Collection of the Theatre Studies
Department, University of Cologne

fig.10
Cover of Kasimir Malevich,
Die gegenstandslose Welt (1927),
(pl.24, p.31)

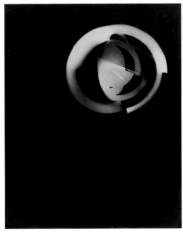

fig.11
László Moholy-Nagy
Untitled 1925–8
Photogram
39.9 x 30 cm
Museum Folkwang, Essen

conflates and transcends common definitions of machine and work of art. The host of unanswered questions and different interpretations as to the intentions behind its creation and its original display aside, what is of interest in the present context is Moholy's radical revision of the role of the artist. Separating the acts of conceptualisation and execution, the technical development and supervision of construction was entrusted to the young architect Stefan Sebök (pl.66, p.53). Ten years later, one of the artist's Chicago students rightly observed that: 'Moholy-Nagy has an entirely different idea of the definition of "craftsman", not the craftsman who produces with his hand, but the person who oversees and directs the process of production … This conception of the craftsman is a consequential enlargement on ideas attuned to industrial production.'[14]

The efficiency of industrial production also served as benchmark for another new activity that Moholy developed while at the Bauhaus: graphic design. 'Printed matter today', he wrote, 'will have to correspond to the most modern machines; that is, it must be based on *clarity*, *conciseness* and *precision*'.[15] Between 1925 and 1930 Moholy, together with Gropius, edited a series of fourteen books with contributions by Kandinsky, Schlemmer, Klee, Piet Mondrian, Kasimir Malevich and Gropius, which disseminated Bauhaus ideology far beyond Weimar and Dessau. Largely designed by Moholy, the Bauhaus books, as they came quickly to be known, represent a landmark achievement in twentieth-century publishing (see fig.10). As a graphic designer, Moholy saw efficient communication through words as one of the fundamental challenges in a society that he recognised as being increasingly visually driven. His response to this challenge was to draw on the aesthetic principles of Constructivism. Through changes in font weight, the interplay of text and empty surround, and the use of thick bars instead of underlining, Moholy created an unprecedented synthesis between the written word as bearer of content and its visual qualities as a sign printed on the page.

Yet, despite all his enthusiasm for technological progress it should not be forgotten that throughout his Bauhaus years (and thereafter) Moholy defined himself first and foremost as a painter. Just as Albers veered between craft and industry, so Moholy, while advocating new roles for the artist in industrialised society, was reluctant to abandon established models completely.

MASTERS AND STUDENTS

Upon their appointment, Albers and Moholy were jointly entrusted with giving a new direction to the *Vorkurs* (or preliminary course), which was obligatory for all newly enrolled Bauhaus students.[16] Intended to undo the errors of academic education, this one-year long course became the most lasting innovation of Bauhaus education.

This is not the place for a detailed analysis of Albers's and Moholy's pedagogical theory and practice.[17] Suffice to say that both aimed to liberate the creative potential of their students in the firm belief that becoming an artist was not a question of genius but of unlocking a positive universal force. As Moholy put it: 'Everyone is talented. Every healthy man has a deep capacity for bringing to development the creative energies found in his nature.'[18] Both artists saw their principal task as sharpening their students' perceptiveness – to become more 'aware' – be it to the qualities of a particular material or the pressing questions of their time. Like modern scientists working in a University laboratory, they understood teaching as a collective research

fig.12
Konrad Püschel (class of László Moholy-Nagy)
Study on the Terms 'Structure, Facture, Texture' 1926/7
Tempera and Indian ink on paper, mounted on card
58 x 44.5 cm
Bauhaus Dessau Foundation, Germany

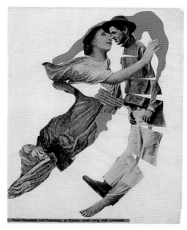

fig.13
Karl Marx (class of Josef Albers)
Paolo Malatesta and Francesca da Rimini – Two Eternal Lovers 1932/3
Photomontage
58 x 44.5 cm
Bauhaus Dessau Foundation, Germany

endeavour rather than as the transmission of a fixed canon of knowledge. 'Learning is better than teaching', Albers was fond of saying, 'because it is more intense: the more is being taught, the less can be learned'.[19]

Nuances in the deployment of terms such as 'texture', 'structure' or 'facture', and in the use of typical Bauhaus student exercises such as 'material studies' aside, one is hard-pressed to detect major differences in Albers's and Moholy's methodology and pedagogical aims.[20] Instead, their differences principally concerned the rhetoric through which Bauhaus teaching (and their respective contributions to its evolution) was propagated to the outside world. For Albers the emphasis was always on direct interaction between teacher and student. Eyewitnesses describe him as a tireless educator: critical, encouraging, always deeply involved. The same was true of Moholy, with the caveat that his eyes were always set on horizons beyond the confines of the classroom, the printed word being his medium of choice to realise this ambition.

The product of a prolific author, Moholy's writings should be seen as an extension of his artistic project, on a par with photography, montage, film or design, rather than simply analytical explanations. This is also true of his account of Bauhaus education, *Von Material zu Architektur* (From Material to Architecture), volume fourteen in the series of Bauhaus books. Combining source material from the Vorkurs with a wide array of contextual references, the book expanded its subject matter from a teaching manual to an exploration of visual culture in Weimar Germany. In contrast, Albers in his description of the *Vorkurs*, published one year earlier, had stuck far more closely to the course's actual curriculum. Little wonder then that he vociferously contested Moholy's account as non-representative of Bauhaus education.[21]

When Albers and Moholy settled in the United States in 1933 and 1937 respectively, each took his distinct version of the Bauhaus's pedagogical blueprint with him. At the experimental Black Mountain College, Albers continued the tradition of student-led education: 'Let us be younger with our students … The pupil and his growing into his world are more important than the teacher and his background.'[22] His principal ambition as a teacher was to sensitise his students – among them such protagonists of post-War North American art as Robert Rauschenberg and Eva Hesse – 'to open eyes', as he famously declared when he first arrived. Although colour had not been a topic on the Bauhaus curriculum since the school's move to Dessau in 1925, it now became one of Albers's principal concerns. His major pedagogical opus, *Interaction of Color* (1963), authored during his time at Yale University some years later, represents one of the few serious analytical attempts by any twentieth-century artist to revise and extend inherited colour theories (see pl.122, p.152).

Where Albers tended to be intensive, Moholy was expansive. At the New Bauhaus (subsequently the School of Design in Chicago and from 1944 onwards the Institute of Design in Chicago), he primarily focused on ascertaining an aesthetically and socially responsible position for the creative individual, with the pedagogical emphasis shifting from educating artists to educating designers. His major publications, *The New Vision* (1938), an extended version of *Von Material zu Architektur*, and the posthumously published *Vision in Motion* (1947) were informed by an unusually broad understanding of contemporary visual culture and his rejection of traditional value distinctions between art, design, photography and mass media. Gropius, for one, described the latter as 'so lucid and clear that I believe it will become a bible in our field.'[23] Both books exerted a lasting influence on students and professionals across varying creative disciplines.[24]

fig.14
Double-page spread from Lajos
Kassák/ László Moholy-Nagy,
Buch neuer Künstler (1922)

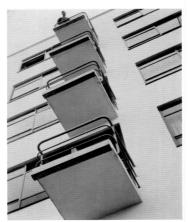

fig.15
László Moholy-Nagy
Bauhaus Balconies 1926
Gelatin silver print
49.5 x 39.3 cm
George Eastman House

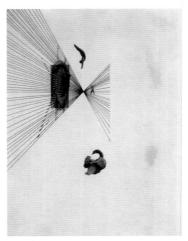

fig.16
László Moholy-Nagy
Leda and the Swan 1925
Gelatin silver print of a photomontage
16 x 12 cm
Collection Hattula Moholy-Nagy

THE NEW VISION

> You will be delighted with Moholy's photography [book, i.e. *Malerei, Fotografie, Film* (Painting, Photography, Film)] ... But will you agree with the author or the book of photographs when he wipes the slate clean of anything that might be called painting? That is the crucial question at the Bauhaus, and in part of the art world as well ... Moholy is so aggressive on this score that he sees, like a soldier, only the enemy (painting) and his victory (photography) ... He had his photographs enlarged, and I must admit they are very beautiful ... Does painting still have a raison d'être in the face of such photographic achievements?[25]

Even though photography did not form part of the Bauhaus curriculum until 1928, Oskar Schlemmer's alarmed question indicates how hotly contested the medium was throughout the mid-1920s. Much of this was due to Moholy.

Moholy's first experiments in photography dated back to his years in Hungary, where he had been introduced to the medium by Erzsi Landau, who had her own photography studio in Budapest. Furthermore, his wife, Lucia, whose iconic shots of the Dessau Bauhaus continue to determine our image of the school, was a successful photographer in her own right. As an avid reader of magazines, Moholy was keenly aware of the opportunities afforded by the rapidly increasing circulation of photographic images. Those *MA* issues edited by Moholy, for instance, showed a marked shift in balance between text and reproductions in favour of the latter, as did *Buch neuer Künstler* (Book of new artists) (1922), one of the earliest anthologies of modern art Moholy edited together with Lajos Kassák.

There are three distinct categories in Moholy's photographic oeuvre. Firstly, he experimented with cameraless photographs or 'photograms' (see fig.11) – abstract compositions created by exposing specially coated paper to light of varying intensity (he often had his photograms re-photographed, which has caused considerable confusion between the different photographic processes employed). Secondly, he made photographs characterised by dramatic diagonals, bird and worm perspectives and often printed as both positive and negative images (see fig.15). Finally, he created photomontages, or 'photoplastics', as he called them, which combine found images and additional compositional elements into a new photographic image (fig.16).[26] Despite obvious semantic differences, the three categories shared a preoccupation with the medium's parameters, particularly photography's imitative nature, its relationship to painting, and the question of 'Production-Reproduction', as was the title of one of his earliest articles on the subject. Moholy had identified as one of photography's strengths its potential to satisfy the hunger for new visual experiences, a hunger he viewed as endemic to human nature and a 'natural' propellant towards progress: 'It is a specifically human characteristic that man's functional apparatuses can never be saturated; they crave ever new impressions following each new reception ... From this perspective, creative activities are useful only if they produce new, so far unknown relations.'[27] In his article, Moholy elaborated specifically on visual innovations afforded by cameraless photography. Not only would his photograms directly feed into his painting to create a formal language no longer tied to a specific medium but, as unique photographic images that had ceased to record the visible world, they questioned the very definition of photography as a reproductive medium.

Much of Moholy's writing of the 1920s was dedicated to various aspects of

fig.17
László Moholy-Nagy
Untitled 1925–8
Photogram
18.3 x 24.1 cm
Museum Folkwang, Essen

fig.18
László Moholy-Nagy
Untitled 1930s
(pl.78, p.62)

fig.19
Josef Albers
Paris, Eiffel Tower 1929
2 photographs mounted on cardboard
29.7 x 41.7 cm
The Josef and Anni Albers Foundation

photography, making him the principal spokesman for what soon became known as 'The New Vision'. His *Malerei, Fotografie, Film* (Painting, Photography, Film), volume eight of the Bauhaus books, marked a landmark moment in the debate around the interrelation between the media of painting, photography and film, and especially the recognition of the latter two as art forms on a par with the former. Much of the book's formidable argument rested on a visual anthology composed by Moholy that aside from reproductions of his own and other artist-photographers' images included film stills, press pictures and anonymous images taken from scientific magazines. *Malerei, Fotografie, Film* propagated photography as a revolutionary extension of human sight, compensating for the shortcomings of retinal perception: modern technology in the service of humanity to catch a better glimpse of a brave new world.[28]

Moholy's publishing projects from the mid-1930s, such as his visuals for Mary Benedetta's *The Street Markets of London* (1936) or John Betjeman's *An Oxford University Chest* (1938), showed a markedly more documentary approach to photography, with the extreme angles of his earlier images replaced by a pointedly neutral perspective (fig.36, p.88). In parallel he experimented with colour photography, much of it for commercial purposes, advertising the likes of Venesta furniture, Viyella cloth and Hero jam. Always keen to put the latest technological innovations to creative use, in 1937, when 35mm Kodachrome film first became available, Moholy embarked on a series of slides whose renewed aesthetic departure – from fluid abstract compositions to Surrealist tableaux – showed his untiring fascination with the medium (pl.106, p.141).

Though Albers did not become active as a photographer until after Moholy had left the Bauhaus, the work he subsequently produced revealed a markedly more ambiguous relationship with the medium. His photography was largely a private experiment, with images neither shown nor published during his lifetime. He approached photography from the perspective of a humanist, primarily interested not in the medium's syntax, but its relation to the complexity of human sight. Albers recognised visual perception as not just a physiological but also a psychological process, the interaction between the two determining how the mind 'interprets' the retinal image. Widely recognised as central to the understanding of his late work, especially the *Homage to the Square* series 1950–76 (see pls.114–19, pp.148–151), Albers's first systematic exploration of this dynamic coincides with his early photography.

Albers remained especially sceptical of photographic truthfulness. In a rare pronouncement on this issue, an unpublished lecture from his time at Black Mountain College, he wrote: 'There is a saying "a photo, or a lens, never lies", and a policeman for instance has good reasons to believe it … But if that saying means that a photo shows the things as they are, as they look to us, then the saying that "a photo never lies" is a lie.'[29] Many of Albers's photographs are characterised by a tension between first appearance and actuality: the apparently positive and negative images of a bare-branched tree on second glance reveal themselves as a pair of positive prints, one shot at night-time, the other on a frosty winter morning (pls.63–4, p.51). Frequently, Albers mounted variations of a particular shot onto board. Subverting the make-believe authority of the photographic image, in Albers's photographs the moment of truth resides not so much in any one shot but in the negative 'unseen' space in between. Demanding the active participation of the viewer to fill this space – by, for instance, translating two dramatic shots of the Eiffel Tower's iron structure into an

imaginary ascent (fig.19) – for Albers the human eye always remained the master with the camera its humble servant.

ETHICS AND AESTHETICS

When probed about the formalism of his work, Albers, in an interview of 1960, declared: 'I consider ethics and aesthetics to be one.'[30] The question of art's continuous relevance in times of radical social and political change had also been at the forefront of the young Moholy's mind. When first considering becoming an artist, he wrote: 'During the war, but more strongly even now, I feel my responsibility toward society. My conscience asks incessantly: is it right to become a painter in times of social revolution? May I claim for myself the privilege of art when all men are needed to solve the problems of sheer survival?' His answer to this self-posed question was remarkably similar to Albers's position in that Moholy equated the ethical integrity of the maker with that of his work: 'I know now that if I unfold my best talents in the way suited best to them – if I try to grasp the meaning of this, my life, sincerely and thoroughly – then I'm doing right in becoming a painter … I can give *life* as a painter.'[31]

Moholy instinctively embraced the leftist-orientated notion of art as a contributing force to social reform. His position at this point was close to that of other avant-garde artists such as Van Doesburg and El Lissitzky who defined 'art, just as much as science and technology [as] a method for organizing life in general.'[32] However, Moholy soon became frustrated with the rhetorical rivalries amongst his peers, especially their paranoid protestations to 'originality', and criticised their self-centred debate as bourgeois and elitist. This criticism coincided with his taking up position at the Bauhaus, whose principal ambition was to further social progress by making good design affordable to a wider public. This utopian dimension of the Bauhaus ethos also played an important part in Albers's artistic formation. In one of his rare statements from the early Bauhaus years he wrote: 'We believe, that our attempts are on the right path to educate creative human beings, and that our desire for the simplest and clearest forms will make mankind more united, life more real, that is more essential.'[33]

This 'essentialism' was reflected in the formal reductionism of both artists' work. Albers and Moholy were united in their rejection of excessive individualism. Rather than expressing the sentiments of its maker, their art was first and foremost intended to provide an 'enlightening' experience for the viewer. They wanted their art to be immediate and inclusive, intelligible without any art-historical knowledge or academic education. Above all, they wanted it to be of its time. As Moholy put it: 'Art crystallizes the emotions of an age; art is mirror and voice. The art of our times has to be fundamental, precise, all-inclusive.'[34]

This preoccupation with extending the reach of art also motivated both artists' – albeit tentative – experiments in subverting the unique object status of the work of art, one of the paradigms setting it apart from serially manufactured products. Both Moholy's enamelled *Telephone Paintings* and Albers's flashed glass pieces at least implied the possibility of replication. Once cost had been reduced through larger editions, they would circumvent, said Albers, 'the snobbish interest in the unique work'.[35] Similarly, photography's extended reach was one of the key reasons for Moholy to promote it as the medium of the future. Walter Benjamin quoted Moholy as saying: 'The limits of photography cannot be determined … Technology is, of course, the pathbreaker here. It is not the person ignorant of writing but the one

ignorant of photography who will be the illiterate of the future.'[36] To contribute to a holistic education of mankind by training people to become visually discerning remained primary objectives for both Albers and Moholy, throughout their careers.

The lines were more blurred when it came to political activism. In keeping with his character, Albers kept the same distance from left-wing politics as he had done from the avant-garde movements associated with it such as Constructivism. Moholy's position, on the other hand, was more ambiguous. As a preamble, one should not forget that his first experience of party politics – the closure of *MA* – had led to life-long geographical displacement. Subsequently, Moholy, the 'Hungarian' artist in exile, was far more vociferous on the subject than Moholy, the 'German internationalist' living in Weimar. To the Hungarian-speaking part of the world Moholy may well have appeared not just an aesthetic but also a political radical when he criticised De Stijl, for instance, thus: 'we make a distinction between the aestheticism of bourgeois Constructivists and the kind of constructive art that springs from communist ideology'.[37] In Weimar Germany, on the other hand, as a prominent Member of the Bauhaus (which was repeatedly accused of harbouring Communist subversives), he had to tread far more carefully, seeking reassurances, for instance, that a Worker's Club in Leipzig at which he was due to appear was not 'too' Socialist.[38]

fig.20
László Moholy-Nagy
The Eccentrics 1927
(pl.51, p.40)

The closest Moholy came to open political commentary was in his photoplastics, whose visual puns and subversive humour are permeated by the spirit of Dada. *Militarism* 1925–7, also titled *Propaganda Poster*, is an acerbic critique of imperialist warfare and the colonial division of the world to which the petite-bourgeoisie of the young Weimar Republic turned a blind eye, a theme that is further explored in large scale montages such as *The Eccentrics* (Die Eigenbrötler) 1927 (fig.20) and *Birthmark (Salome) c.*1926 (pl.52, p.41), also known as *Mother Europe Tends to her Colonies*. However, ultimately it was always art that for Moholy stood in the foreground. When Gropius resigned as Director of the Bauhaus in early 1928 to be succeeded by the Communist architect Hannes Meyer, Moholy vociferously criticised the latter's focus on questions of production to the detriment of artistic quality. In his letter of resignation, he wrote:

> We are now in danger of becoming what we as revolutionaries opposed: a vocational training school which evaluates only the final achievement and overlooks the development of the whole man. For him there remains no time, no money, no space, no concession … It remains to be seen how efficient will be the decision to work only for efficient results. Perhaps there will be a new fruitful period. Perhaps it is the beginning of the end.[39]

TROUBLE IN UTOPIA

fig.21
Front cover of László Moholy-Nagy,
the new bauhaus (1937)
Collection Hattula Moholy-Nagy

Moholy returned from Dessau to Berlin, where he remained until the surging Nazi-terror forced him to leave Germany. Following a brief spell in the Netherlands he moved to London, which thanks to the influx of Europe's émigré intelligentsia, briefly developed into a melting pot for modernist ideas. Moholy reconnected with Gropius and when the latter left for the US in 1937, it was not long before he invited Moholy to come to Chicago.[40] The New Bauhaus was guided by Moholy's attempt to resuscitate the Bauhaus's utopian dream of making the world a better place through good design. The support of leaders of US industry such as Walter P. Paepcke, Director of the Container Corporation of America, notwithstanding, the school had to battle endless financial and organisational difficulties. However, the biggest obstacle

lay in the double-edged sword of its very allegiance with Corporate America. While, on the one hand, this allowed Moholy's ideas to penetrate a much wider arena of popular culture, on the other, it ran the risk of reducing them to mere style. Moholy himself was plagued by doubts to this effect, reflecting on what he called the 'nightmarish' celebration of the Container Corporation's landmark exhibition *Modern Art in Advertising* in 1945: 'The provocative statement is constantly annulled by checkbook and cocktail party. Am I on the same way?'[41]

Albers, on the other hand, remained at the Bauhaus until its closure by the Nazi authorities in 1933, making him the artist with the longest affiliation with the school (from 1920 as a student to becoming Assistant Director under Mies van der Rohe, following the school from Weimar to Dessau and finally Berlin). Soon afterwards, at the invitation of Ted Dreier, the philanthropist founder of the liberal Black Mountain College, Albers and Anni crossed the Atlantic Ocean en route to North Carolina.[42] Their arrival did not go unnoticed in the East Coast press, which enthusiastically welcomed the arrival of 'A Teacher from the Bauhaus'.[43]

Albers was the first Bauhaus artist to arrive in the US, four years ahead of Gropius and Moholy, with whom he largely avoided contact. Apart from a brief letter exchange, in which Albers once more contested Moholy's depiction of Bauhaus education, each artist embarked on his separate journey of translating the experiences of Weimar modernism into a wholly different cultural situation.

Other contributions to this catalogue deal in more detail with the migration of Bauhaus ideas from Europe to the US in the wake of Albers's and Moholy's emigration. Here, the concluding focus will be on the dilemma faced by both artists in their attempts to sustain a visual language based on utopian ideals in a highly dystopian moment, personal (geographical displacement and, in the case of Moholy, terminal illness) as well as historical (World War II, the nuclear bomb and Cold War politics).

While Albers, as a newly arrived teacher at Black Mountain College, continued the Bauhaus tradition of holistic education, as an artist he quickly became his own man. Abandoning the school's interdisciplinary ethos, for the first time since his Munich days he took up a paintbrush. His paintings' unprecedented formal looseness and chromatic exuberance express his enjoyment of the North Carolina landscape and of his new situation. Regular visits to Mexico and the discovery of Mayan art and architecture offered him a fresh framework of reference within which to explore this new fascination with colour. The results were paintings such as *To Mitla* 1940 (pl.87, p.123), and his later series of *Variants* 1948–52 (pls.112–13, p.146–7), which was inspired by Mexican adobe architecture.

However, the late 1930s saw the beginning of a second, markedly more severe, research strand into form and line as constructional devices for what might best be described as 'spatial ambiguity'. In *Equal and Unequal* 1939 (pl.92, p.128), for instance, two monochrome shapes float on an unarticulated, flat background. Following trained thought patterns, eye and mind attempt to read the black forms as either identical or symmetrical only to discover a number of small but significant differences. A present to Anni (who kept the painting in her bedroom, see fig.23) it is tempting to interpret *Equal and Unequal* not just as an exercise in visual perception but as a reflection on the complexities of marital life. One might go even further and see its atmosphere of instability as a metaphor for a profound sense of unease with the world, as would be befitting for an artist who had witnessed the destruction of cultural

fig.22
Josef Albers
Variant, '4 Central Warm Colors Surrounded by 2 Blues' 1948
Oil on Masonite
63.5 x 88.9 cm
The Josef and Anni Albers Foundation

fig.23
Anni Albers's bedroom with *Equal and Unequal* hanging on the back wall

values in his homeland and who rescued his wife's Jewish family from Nazi persecution.

This reading is supported by a comparison of Albers's work from the late 1930s and early 1940s – especially the *Biconjugate* series – with that from the Bauhaus period. Whereas the geometry of the glass pieces shared the avant garde's confident communication of a social utopia through a visual Esperanto, the perceptual instability of the later work suggests the replacement of such hopes by feelings of doubt and scepticism.

This is even more pronounced in the series of *Structural Constellations,* machine-engraved line drawings of extraordinary perceptual complexity, which Albers first developed in 1949. The polished Vinylite plates contain a seemingly indefinite space, across which levitate the central configurations. While the change in weight of their outlines and the differences in surface treatment create an impression of volume and depth, this has nothing in common with the illusionary space of Renaissance perspective. Where the latter placed the viewer in a position of comfortable certainty, looking at a painting like a master surveying his lands from an opened window, the articulation of space in *Structural Constellations* achieves the exact opposite: it destabilises, questions, withholds reassurances.

The same can be said of the pictorial space in Moholy's paintings of the late 1930s and 1940s. Whereas his Constructivist compositions of the 1920s had replaced the illusionary depth of traditional painting with a series of planes that gradually recede parallel to the picture surface, later paintings such as *CH X* 1939 (pl.97, p.133) draw the viewer into a vertiginous visual fall. Much of Moholy's work from this period is characterised by a desire to destabilise the viewer's position, be it through integrating the play of moving light and shadows in his paintings on Perspex such as *Ch 4* 1941 or through playing with the conventions of linear perspective in a painting on canvas of the same title. While this desire has frequently been interpreted as a nostalgic persistence to capture the dynamism of the modern age, it can also be read as expression of the quintessential late modernist vantage point: one of unsettling uncertainty. This also applies to Moholy's Perspex and steel sculptures, yet another string to his bow. Often suspended in space, gently rotating, their contorted surfaces reflecting the ambient light, these sculptures eschew a fixed, pre-determined standpoint. And even his photograms from this period display an unprecedented sense of no longer being earthbound, the objects involved in their creation barely making contact with the light-sensitive support.

A life-long advocate of technological progress, Moholy was deeply traumatised by the dawn of the atomic age.[44] The depth of his shock at the destruction of Hiroshima and Nagasaki (one should not forget that it was the horror of World War I that had first propelled him to become an artist) may explain why, as someone who had all his life propagated an art reduced to its constituent elements, he returned for the first time in twenty-five years to a semi-representational mode in paintings with descriptive titles such as *Nuclear I, CH* 1945 (fig.24)

Moholy felt the threat of destruction all the more acutely as he himself was staring death in the face, spending an increasing amount of time bed-bound in hospital (see fig.25). He embarked on a series of drawings whose two prevailing subjects – the nuclear bomb, often represented as an explosion of colour, and his leukaemia, depicted as an abstracted network of blood streams transporting differently coloured cells –

fig.24
László Moholy-Nagy
Nuclear I, CH 1945
(pl.111, p.145)

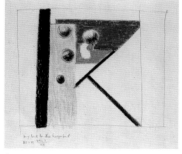

fig.25
László Moholy-Nagy
My Bed in the Hospital 1945
Pencil and crayon on paper
18 x 20.5 cm
Collection Hattula Moholy-Nagy

established a correlation between collective and personal crisis. The rapid pencil stroke and vibrant sense of colour testify to his unbending spirit of optimism, going so far as to describe his leukaemia as the Institute of Design's saving grace, since it brought him sympathy from the school's nagging financial supporters.[45] Moholy died in November 1946 at the age of fifty-one.

Four years later, in 1950, Albers embarked on what would become his signature series, the *Homage to the Square*. Each painting consisted of three to four squares set inside each other, gravitating towards the lower edge, and the series' primary concern was with the visceral nature of colour perception. Yet, it is telling that the series' title, rather than alluding to colour, references the dominant shape, the word *Homage* suggesting Albers's reverence for the square's formal authority free from any representational associations. Unrelated to either Kasimir Malevich's Suprematist square or Mondrian's grid, both of which were based on a belief in social progress and transcendental redemption, Albers's *Homage* annihilates anything beyond itself. It neither reveals the psychology of its maker (Albers applied readily available paints straight from the tube to the back of masonite boards to deny the 'artist's touch') nor leaves the viewer with a retinal afterimage. The *Homage* exists only in the here and now of visual experience. Turning conventional colour teaching on its head – purple next to brown, a painting composed entirely of clashing grey, black and light blue – the early examples of the series are visual assaults, attempting to mark what art historian Miklós Peternák has called, 'the zero point of a new origin'.[46]

Albers began the first *Homage* at the age of sixty-three. Working at an obsessive pace, by the time of his death in 1976 he had completed more than a thousand variations on the theme. Between the early *Homages* (pls.114–17, pp.148–9) and their later relatives there is a marked shift towards the sublime (pls.118–19, pp.150–1). Rather than colours grinding against one another, the later paintings tend to be constructed as tonal symphonies, fugue-like variations of subtle colour combinations. They increasingly demand a viewing mode of prolonged contemplation and solitary attention. 'When you really understand that each colour is changed by a changed environment', Albers elaborated, 'you eventually find that you have learned about life as well as about colour'.[47] If these paintings contained any message regarding the improvement of the world, it was that this depended on a process of continuous self-edification. By now, the time for the avant-garde utopia of a collective social revolution was over.

MECHANO-FACTURE: DADA/CONSTRUCTIVISM AND THE BAUHAUS

Michael White

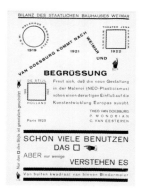

fig.26
Bilanz des Staatlichen Bauhauses Weimar
Balance sheet of the Weimar Bauhaus
from *Mécano*, no.4/5 (white), 1923

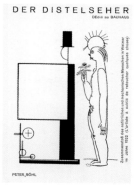

fig.27
Karl Peter Röhl
Der Distelseher (The thistle visionary)
'Confrontation of the natural and
mechanical people in Weimar in the
year 1922 (the artist forgot to retouch
some things)'
from *Mécano*, no.2 (blue), 1922

Josef Albers and László Moholy-Nagy both made a shift towards geometric abstract art in the early 1920s, coupled with an explicit rejection of the Expressionist idiom they had each adopted during World War I. In fact, they both shared an interest in the outright eradication of the presence of the artist's hand in the making of the object. This tendency in their work is commonly linked to their experiences at the Bauhaus and the reorientation of its teaching programme inaugurated by Walter Gropius's 1923 lecture 'Art and Technology: A New Unity'. It has also been common to mention the De Stijl artist Theo van Doesburg, who was in Weimar from 1921–2, as a key influence on these transformations: the move to geometric abstraction, the overturning of expression and the emphasis on mechanical production processes.[1] There is not space in this essay to tackle the historiography of the Bauhaus as a whole; the discussion will therefore be limited to the complex triangle Van Doesburg – Moholy – Albers, but an attempt will be made to reconsider the patterns of influence currently assumed and the ambitions of these important figures in the context of the institution.[2] Where it is now common to imagine a shift at the Bauhaus that exchanged subjectivity, emotion and irrationality for objectivity, sobriety and rationality, what is often present in the work of these artists is an attempt to synthesise these opposing categories.

The impact made by Van Doesburg on the Bauhaus is problematic to reconstruct, mainly because of the way in which he mythologised it. A case in point is the declaration he made on the back cover of the fourth issue of *Mécano*, the Dada journal he edited, published in early 1923 (fig.26). Here Van Doesburg credited his arrival in Weimar with tipping the balance from the circle to the square, from the curve to the straight line, from mysticism to reason, poles represented by Gropius's own architectural projects. A previous issue had carried a drawing by a Bauhaus student, Karl Peter Röhl, titled *Der Distelseher* (The thistle visionary) 1922 (fig.27) showing the 'confrontation between the natural and mechanical people in Weimar in the year 1922'. The confrontation in question is between caricatured portraits of Johannes Itten (at that time responsible for the preliminary course), represented 'expressionistically' as a naked figure carrying a thistle with the sun bursting behind his head like a halo, and Van Doesburg, figured as a semi-robot in a top hat. The implication of the drawing is that one stands for sentimentality, the other for reason, one for mysticism, the other for materialism, one for nature, the other for the machine, and that the latter will triumph over the former.

We do not need to look far to see how Van Doesburg's propaganda has been readily deployed in the histories of Albers's and Moholy's careers. A good example is Werner Haftmann's standard account of twentieth-century painting, which claims that when

79

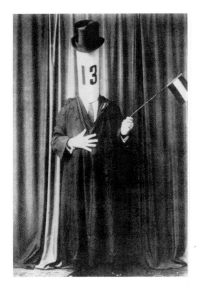

fig.28
Theo van Doesburg at the Bauhaus
Lent Ball, 4 March 1922

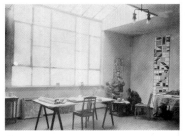

fig.29
Theo van Doesburg, Nelly van
Doesburg and Jarry Scheibe in Van
Doesburg's studio in Weimar, 1922

they took over the foundation course from Itten in 1923, 'in the wake of the international Stijl movement, [the Bauhaus] came to be increasingly dominated by a functionalism that regarded art as nothing more than an experimental form of "industrial design".'[3] Perhaps the clearest indication of the perpetuation of this profound misinterpretation can be found in Krisztina Passuth's monograph on Moholy. Describing his activities in 1923–4, she tells us that, 'although in fact he was at this time painting very fine pictures, in theory he had abandoned painting and the fine arts in general.'[4] It is interesting to note that on the one recorded occasion on which Van Doesburg appeared at the Bauhaus in a top hat, he was in his Dadaist costume for Lent Ball on 4 March 1922 (fig.28). Perhaps the mechanical man was not necessarily the rational man after all.

A third image of Van Doesburg in Weimar can help us back onto the right path. It is a photograph of the artist, together with Nelly van Doesburg and a Bauhaus student, in the studio in Weimar that he occupied from the spring of 1921 to the summer of 1922 (fig.29). Van Doesburg is standing in the far corner of the room in front of his painting *Composition in Grey (Rag-Time)* 1918–19, reading the January 1922 edition of *MA*, an avant-garde Hungarian journal with which Moholy was at the time associated. On the left-hand wall is a design for a large stained-glass window (a project completed in April 1922). On the table below is a pile of sketchbooks, magazines (including copies of *De Stijl*) and a palette. A trestle table is laid out in the foreground for drawing; Van Doesburg spent most of his time during these years working on colour schemes and stained glass for buildings. Behind the table, propped against the wall are a canvas and a couple of panels of stained glass. There is little evidence here of anything we might call industrial design.

One notable feature of the studio was its plainness. Röhl painted his studio in Weimar white in imitation. Given its closer proximity to the Bauhaus building, Van Doesburg co-opted Röhl's atelier for a De Stijl course he put on for Bauhaus students between March and July 1922. Exact details of what Van Doesburg taught the large group he attracted to his course do not survive.[5] From the few reminiscences we have and the objects produced by those who fell under Van Doesburg's spell, it would seem that colour theory and architectural decoration were the major components. It was during this time that Van Doesburg began to formulate his own colour theory, which he described in a letter as 'colour not as the experience of light or an optical medium, but as creative material'.[6] Werner Graeff, who attended Van Doesburg's classes recalled that 'If Itten discovered that everyone preferred his own individual colour scale, Van Doesburg and Mondrian taught a universally valid, objective range – yellow/red/blue + white/grey/black.'[7]

The experience of working in stained glass and producing colour designs for buildings led Van Doesburg to develop a 'constructive' concept of colour that at first sight appears to be a rejection of the subjectivist colour theory stemming from Goethe.[8] However, there was nothing at all scientific about Van Doesburg's colour theory. Colour as 'creative material' had little to do with the physical composition of light or the analysis of pigment. It was based on the perception of contrast and dissonance rather than harmony. As a theory, it was both extremely materialist and simultaneously intangible. The objectivity of colour could be found in its transferability, what Graeff referred to as its 'universally valid' nature, but it could only be experienced in practice, in the dynamic effects produced by placing one colour against another, actually very similar to Goethe's conception. Van Doesburg then

fig.30
Congress of Dadaists and
Constructivists, Weimar,
September 1922
Collection of the Netherlands
Architecture Institute, Rotterdam /
Collection Van Eesteren-Fluck en Van
Louizen Foundation, The Hague

focussed his attention on the ways in which colour could articulate architectural space precisely because it of its destabilising properties. It was the opposite of functional.

Van Doesburg's De Stijl course and his colour theory are important strands in the confluence of ideas that linked together Dada and Constructivist groups in the early 1920s. The presence of magazines in his studio points to the significant role he played as a conduit for the international exchange of information and images. His move from the Netherlands to Germany was part of a concerted effort to internationalise De Stijl. The high moments of this enterprise were the formation of the Constructivist International at the Congress of International Progressive Artists in Düsseldorf in March 1922, followed by the Congress of Dadaists and Constructivists in Weimar in September 1922 (in which Moholy participated) (fig.30). The ambition of the Constructivist International had been presaged in October 1921 by the publication in *De Stijl* of a 'Call to Elementary Art' signed by the Dadaists Hans Arp and Raoul Hausmann, and the Constructivists, Moholy and Ivan Puni, which called for 'art as something pure, liberated from utility and beauty, something elementary within the individual'. [9]

Van Doesburg and Moholy were thus well acquainted before the latter's arrival at the Bauhaus in 1923. Moholy reciprocated Van Doesburg's publication of his writings in *De Stijl* by forwarding reproductions of De Stijl works for inclusion in *MA*. Perhaps the most significant indication of mutual esteem was the prominent place given to De Stijl painters and architects in the *Buch neuer Künstler* (Book of new artists) by Moholy and Lajos Kassák, published in 1922 in response to the Düsseldorf congress. This book, which functioned something like a visual manifesto, collected together around 100 images of painting, sculpture and architecture charting a path from Futurism, Expressionism and Cubism to Constructivism, interspersed with photographs of planes, pylons and modernist architecture. However, the declaration written by Kassák as a foreword to the presentation of images called not for utilitarian design but for collectivity. Intriguingly *Buch neuer Künstler* has at its climax reproductions of designs for abstract film by Hans Richter and Viking Eggeling, the medium that was seen as having the best chance of responding to the changing conditions of visual modernity while engaging with the human senses in a primal way.

Moholy's pursuit of the preservation of aesthetic qualities in new materials can be witnessed in numerous works of the period. Interesting examples are the so-called *Telephone Pictures* of 1922. Whether or not he actually ordered these paintings over the telephone, as legend has it, is a question that will never be answered.[10] It is certain, though, that he had a number of objects produced for him by an enamel paint factory, three of which have come to be known as the *Telephone Pictures*. At the time, Moholy simply called these three objects EM1, 2 and 3, standing for *Email* (enamel). The conception of the works was that they should be shown together and that the three identical compositions of different sizes would reveal the alterations in colour saturation according to scale. The accuracy of application and exact replication of surface that the factory was able to produce turned this demonstration of the uncertainties in visual perception (that the exact same colour could appear different depending on the size of the image) into a semi-scientific experiment.

The *Telephone Pictures* are of interest as much for what they are made from as for how they were made. Moholy was experimenting at the time with distinct qualities of surface using unusual materials. The attraction of enamel paint on a metal support to Moholy was its reflectivity, a quality that would normally be a distinct disadvantage to

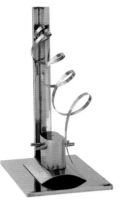

fig.31
László Moholy-Nagy
Nickel Sculpture 1921
Nickel and iron
Height: 35.6 cm
The Museum of Modern Art, New
York

an artist. They should be seen alongside his photograms as experiments with the effects of light on surfaces and for judging whether new materials and new media could maintain a sense of *faktura*, a term used widely in Constructivist criticism, literally meaning 'texture'.[11] It is also known that Moholy was interested in precisely the same esoteric philosophies as Itten, such as Mazdaism and Theosophy, in which the perceptual experience of light and colour was believed to open the way to higher knowledge.[12]

Surface and light are also important to another work of the same moment, *Nickel Sculpture* of 1921 (fig.31), an object that can be interpreted at one level as a simple exercise in the use of particular metals. Thin nickel sheet is contrasted with a substantial L-shaped iron bar, and the various components have been subjected to a number of different processes: cut, bent, polished, welded and drilled. The aspect of the metal that appears to have been most attractive to Moholy, though, was its shine. Thus the ends of the rods are reflected on the sides of the box to create an illusion of floating in space, the convex sheet distorts the straightness of the upright column and the spiral strip flickers to confuse its inside and outside. The fundamental contrast is between the static upright column, which gives a monumental character to the small object, and the dynamic, spatial aspect of the spiral. It is difficult to look at this object and not see it as related to the *Light Prop*, Moholy's kinetic work of 1928–30, which used projected and reflected light, shadows and movement to explore the boundaries of sculpture, architecture and film.[13]

The rich context of international exchange that characterises the relationship between Van Doesburg and Moholy was less present in the case of Albers, who was later somewhat dismissive of the Dutchman's activities in Weimar.[14] While attempts have been made to link Albers and De Stijl, the transformation that takes place in his work after 1923 cannot be understood in the form of a single influence.[15] It is also clear that the change cannot be accounted for within a crude notion of a shift away from art to industrial design, and in fact it bears an interesting parallel to the Dada/Constructivist context sketched out above.

Albers was an experienced glass-maker before he went to the Bauhaus. He had made his first stained-glass window in 1917 for a church in his hometown of Bottrop. At the time he was studying in Essen with Johan Thorn Prikker, an artist who was vigorously promoting stained glass as a modern material capable of embodying religious and social conviction.[16]At the Bauhaus, having taken Itten's preliminary course, Albers began making assemblages from found pieces of glass roughly inserted into a metal sheet. It was on the strength of these works that he was promoted to journeyman, put in charge of reorganising the stained-glass workshop, and was commissioned by Gropius to produce windows for a number of his buildings. The glass assemblages, which so impressed Gropius, are indeed astonishing objects. What is perhaps most striking about them is how textural they are. Stained glass, because of where it is installed, is normally seen from a distance and its material qualities are frequently invisible. Our view of Albers's assemblages, formed from chunks and shards of broken glass, many taken from discarded objects such as broken bottles, is close up and to hand. The glass used is often far from flat and shiny; we see ridges, humps, bubbles, cracks and splinters. The combination of the degraded and the beautiful achieved here is reminiscent of Hans Arp or Kurt Schwitters (who both attended the Congress of Dadaists and Constructivists in Weimar in 1922). While Albers later made light boxes for some of these works, they are not generally dependent on the notion of being

fig.32
Josef Albers
Bundled 1925
Sandblasted flashed glass with black paint
32.4 x 31.4 cm
The Josef and Anni Albers Foundation

windows; reflection as well as transparency is an important aspect of them and Albers also began incorporating opaque glass, pearls and other related materials (pls.1–3, pp.10–11)

Albers's experiments in glass construction led him to a similar point to that of Van Doesburg in conceiving colour as material.[17] He was also well aware of the importance of the relationship between glass and architecture. The teaching plan that Albers drew up for the stained-glass workshop at the Bauhaus in 1922–3 devoted as much space to the connection between glass and architecture as to the making of windows themselves.[18] An important commission for Albers in 1923 was the design of stained-glass windows for the stairwell of the Grassi Museum in Leipzig. Here, he carefully integrated his composition with the scale and sense of the surrounding architecture, creating ladders of coloured strips. Shortly afterwards, he began to produce works made from a single piece of sandblasted flashed glass, which have a unique colour-relief effect. Many of these works have direct architectural reference not just in form but in title, such as *Factory*, *Skyscrapers*, *Pillars*, *Walls and Screens* or *City*. Several featured as illustrations in Arthur Korn's seminal study *Glas im Bau und als Gebrauchs-Gegenstand* (Glass in building and object of use) of 1929, the text of which combined reference to the glorious history of glass as a medium of mystical experience and the practical possibilities of contemporary architecture.[19] Colour played a key role here in bridging the constructive and the aesthetic. It is probably not accidental that Albers used just black, white and red for the initial flashed-glass pieces, this being Goethe's triad, the mother, father and child of all colour.

Albers's use of glass, like Moholy's use of enamel, Perspex or metal, tends to imply the absence of the human hand. These objects appear to be at the opposite end of the spectrum to the rough, worked surface of an Expressionist painting. However, as the pedagogic exercises they later devised for the preliminary course reveal, both men were intrigued by the subject of texture and the connections between the haptic and optic senses. In the only text that Albers wrote at the time concerning his flashed-glass works, he connected them specifically to an interest in *Materie* (matter rather than simply material).[20] Where material exercises at the Bauhaus had direct, pragmatic ends in mind, the study of *Materie* was open-ended. For both Albers and Moholy, it involved the intense examination of the connections between structure, facture and texture primarily through exercises in juxtaposition. The common link from Albers's assemblages of the early 1920s to the sandblasted works is the mutual interplay between rough and smooth, opacity and translucency, reflection and dullness. In the case of Moholy, there is a direct correspondence between the effects of light on reflective surfaces and the capturing of light on photographic paper, which leaves a physical trace and touch. Although they took on quite different form, these activities are not radically distinct from Van Doesburg's theory of colour as creative material and its perception through contrast. The pedagogic rationale behind these theories was commonly the expansion of the powers of perception, with a deep romantic undercurrent.[21]

The quick and faulty analogy that has too often been made between geometric abstraction and a technocratic rationality needs redress and there is no better means to do so than by seeing the artistic output of Albers and Moholy together. We should also continue to build on Jeannine Fiedler's and Peter Feierabend's timely judgement that:

> The 'light mysticism' of someone like Moholy-Nagy, for instance, Gropius's philosophies of space, Schlemmer's solemn idealism, or the poetry of nature in

Klee's playful Romanticism – these are thematic constants [at the Bauhaus] which were more substantial than the formal change, typical of the period, from the jaggedness of woodcuts to the smooth surfaces of steel furniture.[22]

It is no accident that the authors hit on texture here as the key signifying element of Bauhaus production. The move towards mechanical production processes did not spell the end to qualities of facture in the artwork but the opening of a new range of possibilities for the senses.

MOHOLY-NAGY: THE TRANSITIONAL YEARS

Terence A. Senter

Opening László Moholy-Nagy's one-man exhibition at the London Gallery on 31 December 1936, Walter Gropius), acknowledging the substantial mutual benefits Moholy and the Bauhaus had enjoyed, spoke of him as a leading artist whose whole activity strove to prepare for a 'new vision' and a new conception of space in painting. Most of his British listeners would have known little of Moholy's socialist credo and vocabulary centring on the 'new life' in the 'new world' of post-war German reconstruction. But even before joining the Bauhaus,[1] he had co-produced a conspectus of new signs of the times in art and technology, and written guidelines for a journal to synthesise fresh research in all vital fields, aimed, he said, at knowing everything within reason.[2] Building from elementary beginnings founded on light, and exploring the inherent, expressive properties of materials and media, he developed interrelated, experimental painting, sculpture, photography (camera, photogram, and photoplastic), film, theatre design, product design, typography and exhibition design, and frequently published his evolving views. He substantiated the Bauhaus ideal of integration, and used his position there to propagandise and innovate in all his fields of activity.

Events that had brought Moholy, Gropius and Marcel Breuer to live in England began with their resignations in 1928 from the Bauhaus, and their establishment in private practice in Berlin. For Moholy, the following nine freelance years in Germany, in Holland, and then in insular England, fully tested his mission and integrity.

Typically, at the Bauhaus he had taught alongside a technical master, and consistently in his private practice, he employed technically proficient assistants to execute his designs. Max Gebhard, for instance, realised his ideas for Erwin Piscator's stage production *The Merchant of Berlin* (1928) and his commercial graphics, followed by György Kepes in 1930.[3] Kepes, his colleague well into the American period (1937–46), helped him to film his experimental *Light Play: Black-White-Grey* 1930 using his definitive, exploratory *Light Prop* 1928–30, conceived by Moholy, technically drafted by Stefan Sebök, and sponsored by the AEG Theatre Department for the Werkbund exhibition in Paris of 1930.[4] Moholy remained aloof as a creative, philosophical business manager, seeking such commissions as could advance his research. His managerial demeanour amused his first English client and friend, the science reporter, J.G. Crowther, when Kepes wholly assembled and photographed the arrangement for the book-jacket design he had commissioned from the artist.[5]

In Germany Moholy gave occasional lectures on the Bauhaus, and in Budapest, short courses at Sándor Bortnyik's little Bauhaus-like Mühely.[6] With increasing Nazi persecution and anti-Bauhaus acts, as well as Hitler's election in February 1933,

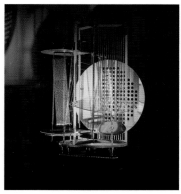

fig.33
László Moholy-Nagy
Light Prop for an Electric Stage (Space-Light Modulator) 1928–30
(replica 1970)
(pl.67, p.53)

Moholy accepted an invitation to work in Amsterdam from a long-standing patron, the half-Jewish Ludwig Katz, former Advertising Manager of Schottlaender (publishers of the textile periodical *Der Konfektionär*), who had fled penniless to Holland. Katz's wide business contacts facilitated his establishment of Pallas Studio with the Haarlem publisher, De Spaarnestad, to launch *International Textiles* on 15 December 1933, with Moholy as Art Director.[7] Nevertheless, Moholy retained his Berlin office, manned by Kepes, and by August 1933, was already considering emigrating to England. A move, he told the key English modernist reporter, Philip Morton Shand, at the CIAM (Congrès Internationaux d'Architecture Moderne) Athens Congress, would depend on a reconnaissance of London in November during a visit to an exhibition of his graphic work organised by the distinguished designer, Edward McKnight Kauffer.[8] In the event, he made three preliminary visits before full removal to London in mid-May 1935, after his stay in Amsterdam.

In many lengthy planning conferences, the demanding Moholy dictated the total format of *International Textiles*,[9] and brought to bear his wide range of elementary graphic devices and their agile permutation to direct the reader's mind through forceful, clear, legible and fresh layouts (see fig.34). He relished the publisher's new typeface, an important feature in regulating the tri-lingual text. His constant questioning of the page space and sequence, supported by judicious, visual contrasts, demonstrated how his commercial graphics were extensions to, rather than imitations of, his paintings and typophotos, but were similarly aimed at public enlightenment. With this periodical, published twice a month and read in over thirty-five countries, Moholy achieved his widest dissemination of the new typography, though anonymously.

fig.34
Opening from *International Textiles*,
12 March 1934

Heralding Moholy's initial London visit in November 1933, the *Listener* provided his first general public platform with Shand's translation of his iconoclastic article *How Photography Revolutionises Vision*.[10] Moholy helped his friend Alvar Aalto to arrange his bent-wood furniture exhibition at Fortnum and Mason's Piccadilly store, organised by Shand under the auspices of the *Architectural Review*, and attended the opening with Crowther. He also delivered a painting he had made for Crowther, ordered in 1930.[11] Moholy took exception to the fact that the exhibition promised by McKnight Kauffer went unstaged, apparently due to re-scheduling problems, but the two did not meet. However, among artists, he saw Ben Nicholson and arranged for him to meet Piet Mondrian, whom he often visited in Paris. He also called on Barbara Hepworth and apparently inspired her to make photograms. (He had possibly first met Nicholson and Hepworth in Paris at Easter 1933 through Jean Hélion of Abstraction-Création.)[12] In London, he was probably also introduced to their advocate, Herbert Read, though whether he knew Henry Moore this early is unknown. Gropius encouraged a meeting with the Elmhirsts, creators of Dartington Hall, which he likened to the Bauhaus, but no outcome is on record. Probably for business as well as social reasons, he saw Elsbeth Juda, wife of his Berlin friend, Hans, now prospective head of *International Textiles*'s London office. Moholy had sold a copy of *Light Play: Black-White-Grey* to the documentary film innovator John Grierson about a year earlier, and had successfully shown it at the London Film Society. Consequently, during his English visit, he completed editing his film of the CIAM Athens Congress, and left it, along with his experimental *Sound ABC* 1932, for the Society to screen just after his departure. On 22 November, he concluded: 'positive things till now not many, but negotiations. m sh's [Morton Shand's] friendship grows.'[13]

In June 1934, he described his first months in Amsterdam as 'quiet and peaceful', yet by April, he had become despondent with the general creative climate and depressed at the short time available for his art projects.[14] Contractual complications, the enormous pressure of work involving Pallas Studio's design agency and Spaarnestad's other magazines, and rushed management consultations left him dejected, as if going daily 'to the scaffold'.[15] To justify his employment, he studied Kodak's dye-transfer method of colour printing on a brief, second London visit of August 1934, helped by his ex-wife, the photographer, Lucia Moholy, a recent English immigrant. The intricate technique excited him, but his initial results in Holland proved fugitive and annoyingly expensive to Spaarnestad, who also disliked his modern design.[16] Nevertheless, he achieved subtle, limpid colour for the Christmas 1934 special, *Kerstboek Panorama*, and for an *International Textiles* cover that distinguished itself from the customary drabness, and was positive enough for him to include as a sample in an international group exhibition staged in Amsterdam by his friend, the Bauhäusler, Paul Citroen, at his Bauhaus-style college.[17]

In October 1934, Goebbels's Chamber of Culture summoned Moholy to submit three of his paintings personally for censorship, but probably his foreign location and movements made non-compliance feasible.[18] By October, he decided on emigration to England, supported by his partner, Sibyl, who now foresaw an imminent German catastrophe.[19]

Moholy's last eight months in Holland were fruitful, with a small one-man exhibition of paintings at Willem Wagenaar's little Kunstzaal in central Utrecht (22 September – 15 October, 1934), and paintings and three-dimensional works at the Stedelijk Museum in Amsterdam (24 November – 9 December 1934). The latter show was arranged by his friend, the designer Willem Sandberg through VANK, the Dutch Society of Arts and Crafts.[20] The peak of his commercial activity in Holland was his large exhibition design for the Dutch Artificial Silk Manufacturers at the Utrecht Spring Fair of 1935.[21] Commissioned via Pallas Studio, this first combined showing was necessitated by difficult international market conditions, so Moholy designed a variety of intrinsic, spatial structures capable of projecting nearly 800 fabrics, from giant fashion plates, to looms, table tops and wavy screens. Its success prompted the manufacturers to commission a further, smaller stand for the Brussels World's Fair, a job that delayed Moholy's emigration to England by a few days, causing some concern for his welfare among those awaiting him in London.[22]

During Moholy's last preliminary London visit of January 1935, he married Sibyl and saw Gropius, who had been living for three months at Lawn Road Flats in Hampstead, owned by his patron, the modernist entrepreneur, Jack Pritchard. At the Judas's flat, Moholy produced a coloured photographic advertisement for an *International Textiles* cover.[23] The prospect of establishing an English Bauhaus was frequently in the minds of Gropius and Moholy. Gropius's approach to Roger Fry, Richard Carline, Henry Moore and the Surrealist Norman Dawson in 1934 was unproductive, but he continued his attempts through Charles Hobson of London Press Exchange, and the Elmhirsts. Arising from the January visit, was Read's idea to instate Moholy as a provisional council member for an industrially conscious new Artists' Unit including Moore, Paul Nash, and Wells Coates, and formed to service commissions in the Bauhaus vein, though the Unit had faltered by the time of his arrival in May.[24]

On settling in London, an eager Moholy held several meetings with Pritchard, Nicholson, Naum Gabo, Leslie Martin and others, about opening a Bauhaus.[25] Later,

Martin recalled that basically Moholy wanted to transplant the German Bauhaus. Martin, though, favoured a gradual adaptation to English conditions by infiltrating an established art school.[26] Many supporters felt that Moholy had already lost a chance of helping to modernise the Royal College of Art and making it relevant to British industry when Gropius was passed over for principal in favour of the academic painter, Percy Jowett, in March 1935.[27] Beyond a few specialists, particularly in graphic design, little was known of the Bauhaus in England. Pritchard told Gropius that England was 'isolated' from the Continent.[28] Read, inspired by Gropius and Moholy, began to commend modernist product design in his book *Art and Industry*, and persuaded Gropius to write *The New Architecture and The Bauhaus* (1935) to make his 'experiences familiar to the British public'.[29] Even as Moholy was about to move to England, he completed the book and jacket designs, thus, appropriately, this definitive treatise became his opening work of the English period.

Barely able to speak English and unacquainted with English ways, he had little choice in the commercial work he undertook to make a living, and gathered many diverse, concurrent orders. A contract with his friend, Dr Erich Schott of Schott & Gen. Jenaerglas, provided funds and free camera equipment.[30] Living firstly at Pritchard's flats, he then moved with Sibyl and their daughter Hattula to Golders Green. Pritchard, who provided and sought commissions for him, was surprised how relatively quickly he established himself. By summer 1935, he found a patron in the wealthy documentary filmmaker John Mathias, possibly through Pritchard's colleague Julian Huxley, and was working closely with him and lobster fishermen at Littlehampton on *Lobsters* 1936. This film, adopting Grierson's conventions, reached cinemas during Moholy's English period. Hans Juda assigned him the tinier of *International Textiles*'s two little rooms in the Strand, where Moholy managed a new branch of Pallas Studio's design agency, though few commissions arrived beyond a cover for *Shelf Appeal*.[31]

fig.35
Special effects models, designed by László Moholy-Nagy for London Film Productions' *Things to Come*, 1936, inspected by technicians at Worton Hall Studios, Isleworth, during filming

fig.36
"Pick me out two soft roes"' she says
From Mary Benedetta, *The Street Markets of London* (1936), photography by László Moholy-Nagy

Accompanying Gropius one day to his work site for London Film Productions' new laboratories at Denham Studios, Moholy renewed his acquaintanceship with Vincent Korda stemming, apparently, from Bortnyik's Mühely. The Kordas were already backing *Lobsters*, and Vincent wanted a designer for the transition sequence from 1936 to 2036 of H.G. Wells's *Things to Come* (1936), currently in production. Vincent had already designed the considerable, futuristic town sequence after Le Corbusier had refused the commission, and Wells objected to Fernand Léger's Purist submissions. On seeing *Light Play: Black-White-Grey*, the head of special effects, Ned Mann, wanted similar imagery for Wells' film, hence Moholy was engaged on his only commercial feature film, providing opportunities for experiment (fig.35).[32] Moholy gained photographic commissions via Shand's colleagues at the *Architectural Review*. The assistant editor, J.M. Richards, accompanied him to photograph thirteen seaside resorts for a forthcoming article that Moholy would also design, while the former assistant editor, John Betjeman, introduced him to the publisher, Harry Paroissien, of John Miles Ltd. Paroissien commissioned photographs for three books on quintessential English class themes: London street markets, Eton College and Oxford University, with vivid, unconventional results (fig.36).[33] Read persuaded his friend, Marcus Brumwell, head of Stuarts' Advertising, to offer him work. For his most important ensuing client, Imperial Airways, he designed a striking exhibition booklet sporting the majority of his graphic devices, the first of three exhibitions (fig.37), as well as other graphic work to commend the social impact of advanced technology.[34]

fig.37 a/b
László Moholy-Nagy
Empire's Airmail Programmes 1937
Booklets
Each 26.7 x 19.4 cm
British Airways Archive and Museum
Collection, Hounslow

fig.38
László Moholy-Nagy
Light Painting 1937
Acetate, metal and paint on board
50 x 51 cm
IVAM, Instituto Valenciano de Arte
Moderno, Generalitat Valenciana

Moholy's key life-saver was the designer Ashley Havinden, who procured him a well-paid display directorship at Simpson's new menswear store in Piccadilly, responsible for show-windows and interior presentation (fig.39).[35] Kepes became the chief designer, and Harry Blacker, art director.[35] Espousing simplicity, Moholy employed his interests in plywood and Rhodoid plastic triggered by Pritchard's Isokon Furniture Company and Vincent Korda's designs for *Things to Come*, respectively. Unprecedented plywood screens with focusing cut-outs (varied as dioramas in Imperial Airways's exhibition train), and transparent free-standing price labels resulted. His strict Constructivist layouts and visual analogues, new to England, brought the desired publicity, as did his topical in-store exhibitions, including those on the theme of aviation (incorporating a real Flying Flea), boating and television transmission.

Bernard Fergusson, author of *Eton Portrait* (1937), as well as Blacker, observed Moholy's priority to be painting, or, according to Richards, work on 'a rather higher level' than bread-and-butter photography.[36] Even so, he had a one-man exhibition at the Royal Photographic Society in April 1936. Moholy moved within loosely overlapping artistic, architectural and scientific communities. He belonged to MARS (Modern Architectural Research Group) and associated with artists around Nicholson and John Piper. He exhibited with these English artists at the Artists' International Association in London, at Leicester Art Gallery, and in *Abstract and Concrete* at Oxford, Liverpool, Newcastle, Cambridge and London. He also maintained his Continental links with, for instance, Abstraction-Création, CIAM, Czech artists and Jan Tschichold, Max Ernst and Hans Arp, who visited him in London. Much to his relief, his cherished *Light Prop* arrived safely from Nazi Germany for his one-man exhibition at the London Gallery.[37] He spoke in the international monograph *Telehor* (1936) of continuing as a painter only for want of financial backing to advance this kinetic work.[38] Painting on Rhodoid, though, presented an opportunity to explore projection and the recording of coloured light with possibilities for improving colour cinematography. Moholy used free sample books to construct interacting colour arrangements for photographing as Dufaycolor transparencies, and printing by the inexpensive, automated English Vivex process.[39] Rhodoid also permitted the consistent development of the *Light Prop* and earlier transparent paintings with light playing through the flat or moulded surface, though its chemistry still caused long-term discoloration. Actual movement was possible in the celluloid leaves of his *Painting with Spiral Binding* 1937.

The charismatic Moholy was welcomed both socially to Britain and as a support for the abstract artists, but his distinctive English contribution, in Myfanwy Piper's view,[40] his credo, alienated him from all but the most cosmopolitan figures. McKnight Kauffer revived an early objection to his mission as plagiarism, an accusation that Moholy believed was damaging his commercial chances.[41] Gabo resented Moholy for allegedly stealing his ideas.[42] Moholy's mainstream, technological art existed incongruously alongside the narrow, austere romanticism of Nicholson's faction. Hepworth even privately complained to the Pipers, who edited *Axis*, for illustrating what she regarded as Moholy's flimsy light play.[43] Crowther observed that Moholy sought his company as a relief from artistic in-fighting. Read's favourite, Moore, disagreed with Moholy's insistence on proclaiming contemporaneousness, but appreciated its importance,[44] and appears to have been the most tolerant of his artist friends. Even Read later admitted reservations about Moholy's artworks. However, he found his teaching 'unrivalled', a view shared by William Holford when Moholy visited Liverpool School of Architecture, and Martin,

fig.39
Simpson's Piccadilly show windows,
(designed by László Moholy-Nagy)
during the opening week, April – May
1936 as illustrated in *International
Textiles*, 25 May 1936

in watching him 'fizz' with stimulating ideas at Hull School of Architecture.[45] Blacker observed how his conversation often involved the philosophy of science, leaving listeners behind, and obliging the avant garde to reassess their modernist credentials. Martin felt that Moholy uniquely occupied the gap between art and industry when this was a controversial issue. Even so, J.D. Bernal did not recognise Moholy's work as an integration of art and science. Unsurprisingly, Moholy revealed to Crowther that his favourite English artist was not among the avant garde, but was the Socialist political cartoonist and cartographer J.F. Horrabin. Further reflecting his interest in humour, Moholy also admired the popular caricaturist and AIA (Artists' International Association) artist David Low, taking an interest in his London Gallery exhibition and designing the catalogue.[46]

Even before his London Gallery exhibition, Moholy was thinking of emigrating to America, tired of England, its 'lack of concern' for his transparent paintings, and 'hard resistance to basic functional design'.[47] His commercial work was considered highly satisfactory, but he enjoyed little success in persuading English industrialists, who regarded him as ahead of his time. For instance, his proposal for Courtauld's stand at the British Industries Fair of 1937 was rejected, and dissenting personnel at Simpson's regarded him as 'uncommercial'.[48] Moholy's datable posters for his second major client, London Underground, arose as late as 1937, possibly reflecting political insularity in the Chief Executive and Chairman of the government Council for Art and Industry, Frank Pick. This trait had worked against Gropius's appointment at the Royal College of Art, and necessitated the architect's diplomatic correction of misconceptions about modernism in Pick's draft introduction to *The New Architecture and The Bauhaus*.[49] In October 1936, Pick had rejected Moholy as a designer for the British pavilion at the Paris International Exhibition of 1937 due to his alleged Continental 'tricks', and 'modernistic tendency' as a 'surrealistic', photographic pasticheur.[50] Furthermore, Moholy had been extremely disappointed that so much of his work for *Things to Come* had gone unused because of its abstraction.[51]

American attention came in 1936 when Beaumont Newhall borrowed photographs including Moholy's highly respected Dufaycolor experiments, and Ernestine Fantl commissioned a film on the new zoo architecture of Lubetkin and Tecton for seminal exhibitions at New York's Museum of Modern Art.[52] However, not until Gropius emigrated to America and recommended him to direct what became the New Bauhaus did Moholy resolve his 'crisis', his sense of feeling 'stuck fast' reported by Herbert Bayer during a London visit in March 1937.[53] To encourage Moholy to America, Gropius held out the prospect of realising his long advocated Academy of Light, an objective reinforced in his final English article, for the avant-garde survey *Circle* (1937). He wrote to Gropius of being tired of England, and heartened by the possibility of realising 'something positive again … after all those enervating trifles', points reiterated to his brother, Jenő, anticipating concentration on 'worthy business' again after the 'hectic' and 'disjointed' recent years.[54]

Demonstrably, a new Bauhaus promised regained personal equilibrium, and much more, as Moholy declared in December 1937. He pitched the 'desperate' situation in Europe, 'the cradle of our culture', where everywhere preparation for war dictated the creative subservience of the individual artist, and the 'real meaning' of 'right ideas' would be distorted. European cultural workers, he observed, looked to America to rescue and 'preserve the fundamentals of our cultural heritage when Europe perishes in its inability to govern itself'.[55]

fig.40
László Moholy-Nagy
*Sketch for a Three-Dimensional
Construction 9 January 1937* 1937
Crayon on paper
21 x 21 cm
Bauhaus-Archiv, Berlin

Emigrating from London on 2 July 1937, Moholy left unfinished the management of a MARS exhibition. Kepes completed E. Maxwell Fry's commission for murals at the Regent Street electricity showrooms. Although wearying, the English period proved Moholy's commercial resourcefulness and his need to codify and practise the new vision from the unified perspective offered by teaching. This period also extended his vocabulary, with the use of background colour-blazes recalling McKnight Kauffer and Ashley.[56] Furthermore, he developed abutted, rectangular arrangements evocative of projected geometry or Bernal's specialism, crystallography, as well as circular dissections, procedures that extended into his American period. Above all, compound, linear curvatures reminiscent of Breuer's *Isokon Long Chair* 1937, and the manipulation of Rhodoid were demonstrable precursors of his dominant American iconography and works in stable Perspex (see fig.40). Like Gropius[57], Moholy left England disappointed at the lack of opportunity and modern, creative enterprise. Moholy felt that the English concern with numbers resulted in superior commercial performance, but an undiscriminating attitude not only to modern art, but art in general.[58] In design, he publicly commended the English 'culture of merchandise' as the equivalent of Continental 'high artistic culture'[59], but privately, he abhorred what he regarded as English naivety, and lack of vitality, visual awareness and imagination. He quoted an example of the national demand for conclusiveness in the annoyance he encountered from a prominent agent at having to go to the trouble of deciding between eight alternative show window designs that Moholy submitted to him.[60] As unifying educationists, Moholy and Gropius supported the new village colleges created by Pritchard's friend, Henry Morris, to strengthen rural communities against the disintegrating lure of cities by combining local school and leisure facilities. Gropius and Fry designed such a college at Impington, while Moholy advised Morris on the interior colour scheme for another.[61] Ultimately, Moholy saw 'the real English contribution to our culture', not in the visual sphere, but patently in another constituent of his modernist 'new view of life', 'the solution to the problems: Leisure, recreation and hobby', citing as examples the village colleges, the notion of the 'weekend', and taking tea.[62]

THE BAUHAUS IDEA IN AMERICA

Hal Foster

The Bauhaus closed in 1933, but it did not die. In the same year Josef Albers, who had taught its *Vorkurs* (or preliminary course) from 1923 to 1933, went to Black Mountain College in North Carolina with his talented wife Anni. Four years later, in 1937, László Moholy-Nagy, who had taught the Vorkurs with Albers from 1923 to 1928, founded the New Bauhaus in Chicago, with the tentative support of the Association of Arts and Industries, a small group of local patrons and businessmen. Other versions of the Bauhaus appeared in the post-war period, each guided by a different agenda and adapted to a particular setting. (One influential recreation, driven by a technological imperative, was the Institute of Design in Ulm, West Germany, founded in 1950 by the Swiss artist Max Bill, who had studied at the Bauhaus in 1927–9.) However, the partial recoveries of the Bauhaus by Albers and Moholy were most consequential for subsequent art.[1]

They were also divergent: Albers brought his rigorous teaching in drawing, design and colour to the unfettered curriculum of a new liberal arts college in the rural South, while Moholy, long associated with socialist artists, went into partnership with capitalist leaders like Walter P. Paepcke, the president of the Container Corporation of America, to create a design institute in the industrial Midwest (its first home was a mansion donated by a department store heir). From Dessau and Berlin, then, to the camp life of Black Mountain College and the old estate of Marshall Fields III: how, apart from the sheer exigencies of this troubled period, are we to understand these dramatic transformations of the Bauhaus idea in America?

The very notion of a 'Bauhaus idea' is a fiction, of course, yet it can be used to isolate a number of principles shared by Moholy and Albers. As is well known, the Bauhaus broke with the Beaux-Arts model of the fine arts, and, especially after the arrival of Moholy in 1923, it extended the arts-and-crafts model of the applied arts as well: its students also explored industrial materials and methods, and it changed its slogan to 'Art and technology – a new unity.' This development was driven first by the social conflicts exposed by World War I and then by the economic demands of post-war reconstruction. In this regard the Bauhaus resembled its contemporaries, Constructivism in Russia and De Stijl in Holland, and leaders of both movements were active in Germany during this formative time. In 1921 Theo van Doesburg arrived in Weimar, where he interacted with many Bauhausians, and in 1922 El Lissitzky came to Berlin, where Moholy met him, and both visitors influenced the reorientation of the Bauhaus.

In fact 'the Bauhaus idea' might be grasped, initially, as a triangulation of Constructivist definitions and De Stijl methods. On the one hand, Moholy and Albers

adapted the characteristic Constructivist emphasis on truth to materials – on what the Constructivists called *faktura*, or 'the organic state of the worked material', and *tectonics*, or 'the expedient use of industrial material'.[2] For instance, Albers focused, in practice and pedagogy alike, on what he termed *matière*, or surface appearance, and *material*, or structural properties. On the other hand, they assumed the distinctive De Stijl attention to the rapport among the mediums. For De Stijl aimed not only to define what is fundamental to each discipline, but also to use elements held in common as a way of transforming the disciplines as an ensemble; thus painting and architecture were reworked through the shared category of the colour plane, which became the central aspect of De Stijl design.[3] Here it was Moholy who took over this dialectical operation of analysis and synthesis, and made it his own.

Typically, Moholy would penetrate the facture of a given material or medium, extract the key properties of its structure, reconceive them as general principles, and then push them as far as they might go. The operation could be literally radical: to cut under and so displace conventional categories of the object, to redefine and so refunction its common uses, and to extend these renewed capacities to other fields. His 1922 text 'Production-Reproduction' is already explicit about this strategy: 'What is this equipment/medium for?' Moholy asks of the gramophone, the photograph and the film. 'What is the essence of its function? Is it possible, and worthwhile, to open it up so that it can serve productive ends as well?'[4] In each instance his answer is the same: under or beyond the accepted purpose of 'reproduction' – the mediated recording of instruments in the gramophone, of appearances in the photograph and of drama in the film – there lies an original capacity for 'production' – the direct inscription of sounds, of light effects, and of 'motion as such' – that must be tapped if each medium is to be understood deeply and used fully.

With the photograph, his privileged instance of the medium, Moholy proceeds almost etymologically: its essence is light (*photo*) written (*graphed*) on a support; it thus combines the transparency of light with the indexicality of its inscription. The question then becomes how to develop these very different attributes, or, rather, how to demonstrate them (the two operations are never far apart for Moholy). A primary way is through the photogram, the cameraless image of transparent forms made when objects on coated paper are exposed to light, an old device that, along with Christian Schad and Man Ray, Moholy recovered for art (see fig.41). Here, rather than a curiosity, the photogram becomes a paragon of photography, a demonstration of its very nature. Yet it is this nature, its principle of transparent light imprinted indexically, that is most important. And for Moholy it must be extended: the specificity of the medium is only the first step of the process; the crucial move is its expansion.[5] This imperative of analysis-abstraction-extension made him the quintessential modernist that he is; it also made him, on occasion, somewhat tendentious, aesthetically as well as conceptually.

For Moholy the transparency of light affects other mediums as well. In his next important text, 'From Pigment to Light' (written 1923–26), Moholy argues a necessary development of painting, too, into 'optical expression' at large, and already film begins to trump photography as the preferred instrument of this transformation.[6] He then maps this 'entire field of optical expression,' provisionally, in his celebrated 1925 book *Malerie, Fotografie, Film* (Painting, Photography, Film), which appeared as volume eight in the Bauhaus series that he co-edited with director Walter Gropius. There Moholy surveys a wide array of photographic views and techniques: 'oblique',

fig.41
László Moholy-Nagy
Photogram (Positive) 1924
Photogram
39 x 29 cm
Collection Angela Thomas Schmid

'displaced', celestial, high-speed, micro, X-ray, photogrammatic, negative, multiple-exposed, montaged, animated and filmic. Contrary to a common criticism of Moholy, *Malerei, Fotografie, Film* does not detach technological inventions from social contexts; the book includes night-time shots of city life, for example, and concludes with a 'typophoto' titled 'Dynamic of the Metropolis', essentially a film storyboard of appropriated photos, typographic symbols and action sketches. For Moholy it is this 'unprecedented' nexus, at once photo-filmic and metropolitan, that constitutes the 'new culture of light'.[7] Here *in nuce* is his famous notion of 'the new vision': as one-point perspective informed the Renaissance, so photography and film inform the modern age, and social relations as well as artistic forms must be rethought accordingly. 'It is not the person ignorant of writing', Moholy once stated (in an aphorism soon adopted by Walter Benjamin), 'but the one ignorant of photography who will be the illiterate of the future'.[8]

Moholy put 'the new vision' to the public test in the epochal 1929 exhibition *Film und Foto* in Stuttgart (he curated the German section of this immense show with Gustav Stotz). He also articulated the notion in his signature book *Von Material zu Architektur* (From Material to Architecture) of the same year (published in English in 1932 as *The New Vision*, with many revisions in subsequent editions), which sums up his Bauhaus pedagogy and practice (again, Moholy left the school in 1928). Here his 'Bauhaus idea' – to delve into a given medium in order to extract and to extend its productive principles – is made all but synonymous with the modernist revolution at large: painting is redefined abstractly as 'material' (in the sense of 'surface treatment'), sculpture as 'volume', and architecture as 'space'; and, as the title suggests, a necessary development is posited from the first category to the last, from 'material' to 'architecture'. Transposed from photography, transparency becomes the 'new medium of spatial relationship' in general, the shared principle that transforms all the disciplines. Indeed, for Moholy transparency is the very *Kunstwollen* (or artistic will) of modernist culture.[9]

In *The New Vision* Moholy first rethinks painting in 'vivid contrast to the classical conception of the picture: the illusion of an open window'.[10] Yet he does not redefine it, as per modernist expectation, strictly as a flat surface; rather, he conceives painting as both plane and picture, as the dialectical sublation of the two paradigms, at once two-dimensional and infinite. Clearly Lissitzky is influential here. Yet if Lissitzky saw his *Prouns* as 'way-stations' between painting and architecture (see fig.42), from abstract plane to utopian plan, Moholy sees his *Transparents* as trajectories 'from pigment to light'. And in fact they appear both materially flat and optically expansive – an effect due in part to his juxtaposition of opaque and translucent areas and in part to his use of experimental substances.[11] Here, then, the differences from Lissitzky are as important as the similarities to him: while Lissitzky projected painting into architecture, Moholy aims 'to produce pictorial space from the elemental materials of optical creation, from direct light', and already in *The New Vision* he imagines painting as no more or less than a projection screen for 'light and shadows effects'.[12]

As the modernist *Kunstwollen*, transparency impinges on sculpture and architecture as well. For Moholy sculpture has passed through three historical stages – 'blocked', 'modeled', and 'perforated' – in a progressive abstraction of the medium. In the modernist epoch Constantin Brancusi has done the most to advance this necessary development; in effect he has delivered sculpture to its present apogee, 'a bold sublimation of the material, a triumph of relations pure and simple', which Moholy

fig.42
El Lissitzky
*Proun 19D c.*1922
Gesso, oil, paper and cardboard on plywood
97.5 x 97.2 cm
The Museum of Modern Art, New York, Katherine S. Dreier Bequest

fig.43
László Moholy-Nagy
A II 1924
Oil on canvas
115.8 x 136.5 cm
Solomon R. Guggenheim Museum, New York

fig.44
'"Architecture" ...The illusion of spatial interpenetration is secured by superimposing two photographic negatives'
Final illustration in László Moholy-Nagy, *The New Vision* (1938 edition)
Original photographs: Jan Kamman

fig.45
Lyonel Feininger
Front cover of the Weimar Bauhaus Manifesto 1919
Woodcut
31.9 x 19.6 cm
Bauhaus-Archiv, Berlin

fig.46
Otti Berger
Tactile Table of Threads 'These assignments were introduced by a class experiment ...' 1928
Illustrated as fig.1 in László Moholy-Nagy, *The New Vision* (1938 edition)

represents with 'equipoised' constructions by Naum Gabo and his own Bauhaus students.[13] Here Moholy expressly defines the *telos* of sculpture as 'the freeing of a material from its weight', a process that is furthered next by the addition of motion, which he represents with 'kinetic' pieces again by Gabo and his own Bauhaus students – though his own *Light Prop for an Electric Stage* (later known as 'light-space modulator') is also clearly exemplary of this ultimate stage of sculpture.[14] Just as painting has exceeded its framed surface, according to Moholy, so sculpture has transcended its material base; yet in each instance the move is not into the actual space of everyday life so much as into the virtual realm of futuristic 'light'.[15] If Moholy dematerialised the *Prouns* of Lissitzky in his own *Transparents*, here he turns Constructivism on its head; or rather, he displaces the materialist proposals of Vladimir Tatlin and Alexander Rodchenko in favour of the idealist definitions of Naum Gabo and Anton Pevsner. For Moholy material does not determine structure *à la* Tatlin; it is sublimated into structure, rendered transparent by light, *à la* Gabo.

If so weighty a medium as sculpture can thus be lightened, so too can architecture. And in fact, at the conclusion of the transformations traced in *The New Vision*, Moholy makes 'architecture' one with transparency, however improbable that equation might seem: the final image is a double-exposure that interpenetrates two buildings, one facade in traditional masonry, one structure in modern glass-and-steel, as if in an X-ray. This sublimation of architecture suggests yet another transvaluation, one that involves not only the materialist understanding of Constructivism but the original orientation of the Bauhaus as well (fig.44). In the 1919 proclamation of the school, Gropius appropriated the Expressionist emblem of 'glass architecture' for his own version of the utopian recovery of communal culture under the aegis of building craft; as is well known, this programme was illustrated by a Lyonel Feininger woodcut, in good 'Gothic' style, of a cathedral ablaze with stars emblematic of the arts and crafts (fig.45). With his image of 'glass architecture' in *The New Vision*, Moholy appropriated this appropriation in turn: the end remains utopian, but the means are futuristic-technological, not medieval-mystical, and 'the whole man' imagined in this vision is remade for the future, not restored from the past.[16]

'It is the most completely dematerialized medium which the new vision commands', Moholy states, and this categorical imperative affects all modernist practices, not only in the visual arts but in music and poetry as well (the first has passed 'from instrumental tones to spheric tones', Moholy claims, the second 'from individual thoughts to sound relationships').[17] Again, as the German title makes explicit, *The New Vision* moves from 'material' to 'architecture': it begins with an illustration from a Bauhaus exercise in the texture of various substances (fig.46) and ends with the skeletal image of 'glass architecture'. On the one hand, this trajectory reverses the Hegelian hierarchy of the arts, whereby World Spirit begins its slow progress toward self-consciousness with a struggle to emerge from the 'symbolic' inertia of massive architecture (the pyramids, for example). On the other, it follows the Hegelian story of sublimation closely, for with Moholy 'architecture' is the most idealist of forms and represents the most rarefied of stages.[18] In any case, his repeated use in *The New Vision* of the term *Sublimierung* or 'sublimation' evokes the historical operation of *Aufhebung* or 'sublation' in Hegel, as well as the civilisational process of *Sublimierung* in Freud.[19]

Yet there is a twist to this story of sublimation through transparency: it is pledged to the autonomy of artistic form, yet at the end of *The New Vision* Moholy shows 'optical expression' to be already loose in the world, with several photographs of the new

fig.47
'Street traffic at night: the lights of the passing motor-cars create a virtual volume'
Photograph by Die Woche
Illustrated as fig.158 in László Moholy-Nagy, *The New Vision*
(1938 edition)

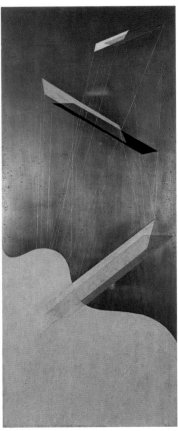

fig.48
Sil 1 1933
Oil and incised lines on aluminium (silberit)
50 x 20 cm
Scottish National Gallery of Modern Art, Edinburgh. Purchased 1977

modernity of the Machine Age, of its speeds and spectacles: 'a diagram of tracks of light made by electric signs, street lights, and passing cars' and images of 'street traffic at night' (fig.47), 'a building in Times Square', 'a gigantic advertising projector' and so on. 'The culture of light' might culminate in the abstract effects of his *Light Prop*, but it is also full-blown in the everyday events of the metropolis (this convergence is already apparent in *Malerei, Fotografie, Film*, especially in 'Dynamic of the Metropolis'). This is a dialectical turn: as the arts become more autonomous, they are also made more instrumental. Moholy does not acknowledge this turn explicitly, but at this point he does take his cue from it, and reorients his practice accordingly.

Moholy left the Bauhaus in 1928, four days after Gropius resigned. He was not sympathetic to the new director, Hannes Meyer, who wished to concentrate on industrial production alone; yet this difference also provided a pretext for Moholy to compete with 'optical expressions' already in play in the world. Relocated in Berlin, he ventured further into commercial design – for theatre and opera as well as for books and exhibitions – even as he also continued to experiment with new materials and mediums (Rhodoid, Plexiglas, aluminium, film). Throughout this period transparency remained essential to both kinds of enterprise. 'I felt like the sorcerer's apprentice', Moholy recalled in his autobiographical 'Abstract of an Artist' (written 1944). 'My stage design, three-dimensional "lantern slides," and motion picture work grew out of the same interest, to "paint with light".'[20]

In 1934 the spread of Nazism prompted Moholy to move to Amsterdam and, a year later, to London, where he also had success as a designer. Then in 1937, on a recommendation from Gropius, came the call from the Association of Arts and Industries to found the New Bauhaus. In a sense Moholy already had his passport. With an account of the Bauhaus *Vorkurs* as well as the modernist transformation of the arts, *The New Vision* offered a pedagogy of visual fundamentals that was also a report on avant-garde practices. This made 'the new vision' possible to import to an urban milieu such as the Association in Chicago, committed as it was to the pragmatic instruction and application of new techniques in art and design alike. Indeed, pared of its residual socialism, 'the new vision' could be adapted to the social, economic and political conditions of corporate America: Moholy suggested a way to make modernism not only teachable but exploitable.[21]

At the New Bauhaus Moholy amended the old *Vorkurs* strategically: training still began with the analysis of materials, but a new stress was placed on science and representation, photography and film, display and publicity (see fig.49). 'Our concern', he wrote in the programme announcement (1937), 'is to develop a new type of designer' – note that he does not say 'artist', much less 'craftsman' – one who can integrate 'specialized training in science and technique' with 'fundamental human needs'.[22] The subject headings of his next important text, 'Education and the Bauhaus' (1938), advance this cause as well: 'The Future Needs the Whole Man', 'Not Against Technical Progress, but With It' and so on. These slogans run back to *The New Vision*, but the change in setting brings a change in import, for here in effect Moholy revises the Bauhaus idea once again: if the mature Bauhaus adapted Constructivist and De Stijl concerns for a post-World War I Germany, the New Bauhaus adapts this adaptation for an interwar America. Utopian unity is now sought neither in the recovered past of a communal culture (as in the original Bauhaus), nor in a transformed future announced by modernist experiment (as in *The New Vision*), but on *the other side* of the divisions of labour and knowledge – an other side where such

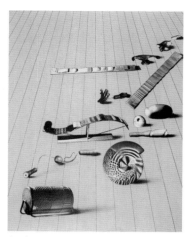

fig.49
László Moholy-Nagy
Tactile Exercises and *Hand Sculptures*
1938 (for *More Business* magazine,
vol.3, no.11, November 1938)
Letterpress print on paper
35.5 x 28 cm
Bauhaus-Archiv, Berlin

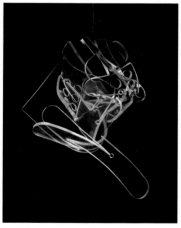

fig.50
László Moholy-Nagy
Leda and the Swan 1946
(pl.101, p.137)

specialisations are to be recouped as a new unity ('unity' remains the ideal). For the Moholy of the New Bauhaus it is only through a 'new vision' retooled technologically and applied practically that 'the whole man' might be remade: 'We are faced today with nothing less than the reconquest of the biological bases of human life. Only when we go back to these can we reach the maximum utilization of technical progress in the fields of physical culture, nutrition, housing and industry – a thoroughgoing rearrangement of our whole scheme of life.'[23]

This project became more urgent with World War II. In *Vision in Motion* (published in 1947 after his premature death at fifty-one from leukemia) Moholy updates *The New Vision* further: here the apparent contradiction at the end of the original text – the artistic autonomy of 'optical expression' versus its spectacular instrumentality in the modern city – is conceived as a necessary 'integration'.[24] In the 1920s a committed avant-gardist such as Moholy might still be optimistic about the progressive dimension of this modernity; in the 1940s this position was more difficult to maintain. Yet Moholy soldiers on nonetheless toward this 'integration'; in fact he goes so far as to propose, in *Vision in Motion*, a 'Parliament of Social Design' that might 'embody all specialized knowledge into an integrated system through cooperative action'.[25] If the old Bauhaus idea was to extrapolate the principles of each art into a *Gesamtkunstwerk* of 'glass architecture' (first presented by Gropius in Expressionist terms, then with Moholy in technological ones), the New Bauhaus idea is to exchange this utopia for 'planning' through design.[26]

Finally, Moholy did not fully acknowledge how his technophilia and his humanism might be at odds, and, further, how his techno-humanist idealism might be turned to ideological ends. In good modernist fashion the art of his final years (especially the sculpture in Plexiglas and chrome) is true to materials and inventive of forms (fig.50), but it can also look like so much 'experimentalism' (as van Doesburg remarked of the young Moholy) or, worse, like so much research-and-development – research into new substances, development of new products (here again artistic autonomy and commercial instrumentality converge). After his arrival in the United States, his critique of capitalism became muted, and more than once Moholy suggested that the logical beneficiary of the modernist evolution in abstract styles was commercial design, and close connections do exist between some of his artworks and some of his advertisements.[27] For good and for bad, this squaring of the circle – of techno-science with human biology, of capitalist divisions in labour and knowledge with a 'universal outlook' – became the American version of his Bauhaus idea.

* * *

In 1933, not long after the Bauhaus closed in Berlin, Black Mountain College opened in North Carolina – a fortunate coincidence for Josef and Anni Albers. Its founders wanted to make the arts central to the curriculum, and so, on the recommendation of Philip Johnson (who was then already curator of architecture at the Museum of Modern Art), they invited the Alberses to join the faculty; the Alberses were thus the first Bauhausians to teach in the United States. Asked what he hoped to accomplish at the school, Albers replied in his scant English, 'To open eyes.'[28] As with Moholy, 'vision' was the modernist password.

The college stressed holistic teaching and democratic participation; 'there were to be no legal controls from the outside: no trustees, deans, or regents'.[29] More radical in structure than the Bauhaus, old or new, this arrangement produced an artistic

community that, though quite marginal in the 1930s (when there were only about 180 students), was very influential from the mid-1940s through the mid-1950s. In part this influence was due to the summer sessions that Albers arranged from 1944 to 1949 with figures often foreign to his own taste and teaching. Apart from such old warriors as Gropius, Feininger and Amédée Ozenfant, these visitors, then and later, included Willem de Kooning, Franz Kline, Robert Motherwell, Theodore Stamos and Jack Tworkov, Harry Callahan and Aaron Siskind, Buckminister Fuller and Bernard Rudofsky, Paul Goodman and Clement Greenberg, John Cage, Merce Cunningham and David Tudor. The roster of students was almost as impressive: not so dominated by men (especially during the war), it numbered Ruth Asawa, John Chamberlain, Elaine de Kooning, Robert de Niro (father of the actor), Ray Johnson, Kenneth Noland, Pat Passloff, Kenneth Snelson, Robert Rauschenberg, Dorothea Rockburne, Cy Twombly, Stan Vanderbeek and Susan Weil. The encounters between faculty, guests and students were often catalytic, as evidenced by the collaborations of Cage, Cunningham, Tudor and Rauschenberg alone.

To this experimental community Albers brought his analytical focus. He offered courses in drawing, which stressed techniques of visualisation; in design, which concentrated on proportion, progression, the golden mean and spatial studies; and in colour, which explored its manifold properties with papers received from manufacturers. Albers taught painting only as an advanced colour course, and then mostly in watercolour; his emphasis on painting in his own practice developed only at this time. In formulations reminiscent of Moholy, he proclaimed that 'abstracting is the essential function of the Human Spirit', and that it requires the 'disciplined education of the eye and the hand'.[30] Yet Albers also differed from his old colleague in his American application of the Bauhaus idea of visual analysis, in part because he operated within a liberal arts college, not a professional design institute.

Albers was led to two basic revisions of this idea. First, he gave it a Goethean inflection foreign to Moholy: 'Every thing has form, every form has meaning', he once wrote, and art concerns 'the knowledge and application of the fundamental laws of form'.[31] Far less technophilic than Moholy, Albers thus complemented the new study of modern vision with an old attention to natural forms and found things, which could be quite abstract in appearance. Second, again unlike Moholy, he reoriented the Bauhaus idea not to the idealist Constructivism of Gabo but to the American pragmatism of John Dewey (who was not unknown at the Bauhaus). For example, Albers called his primary course at Black Mountain not *Vorkurs* but *Werklehre*, or learning through working or by doing, which intimated a pragmatist credo in keeping with a workshop apprentice more than a commercial designer. Although the principle of the course remained much the same – '*Werklehre* is a forming out of materials (e.g. paper, cardboard, metal sheets, wire), which demonstrates the possibilities and limits of materials' – the focus was less on the essence of mediums or the elaboration of concepts than on the manipulation of appearances.[32] Rather than industrial units of Plexiglas and chrome, say, Albers favoured singular things like autumn leaves and egg shells in the classroom (fig.52). Again, he was interested in 'how a substance looks', and how this semblance changes with marking, lighting and setting: hence his obsession with the combination of different forms and the interaction of different colours.

Early on at the Bauhaus, Albers produced assemblages of glass shards mounted with chicken wire and placed by windows; he also made sandblasted glass pieces in pure colours. 'I wanted to work with direct light', he once recalled, 'the light which comes

fig.51
Student at Black Mountain College
Texture Study n.d.
Dabs of white paint on black coated paper
20.4 x 14 cm
The Josef and Anni Albers Foundation

fig.52
Josef Albers
*Leaf Study c.*1940
Dried ferns beneath translucent paper mounted on black board
41.9 x 56 cm
The Josef and Anni Albers Foundation

fig.53
Josef Albers
Windows 1929
Glass
37.5 x 34.3 cm
Westfälisches Landesmuseum für
Kunst und Kulturgeschichte, Münster

fig.54
Josef Albers
Homage to the Square: Saturated 1951
Oil on Masonite
59 x 59.4 cm
Yale University Art Gallery, Bequest
of Katharine Ordway 1980

fig.55
Page from Josef Albers, *Interaction of
Color* (1963)
(pl.122, p.152)

from behind the surface and filters through that surface plane'.[33] In many ways coloured light was to Albers what photographic transparency was to Moholy – a phenomenon to explore in various mediums and formats – and this concern persists from his initial glass reliefs (whose banded compositions are similar to contemporaneous weavings by Anni) to his late abstract paintings, whose exact rectangles of luminescent colours echo the implicit windows of the early works. However, if Moholy transposed the general principle of transparency from medium to medium, Albers concentrated on the specific relationships of coloured light within each format. Attention to 'relationality' is key to both his practice and his pedagogy; it might well qualify as his version of the Bauhaus idea.

Relationality is already pronounced in his glass assemblages, grids and furniture from the early 1920s, all of which foreground the interaction, within a strict geometry, of colour, line and structure.[34] Like Mondrian, Albers often reduced relationality to its elemental form, a stark opposition of figure and ground, sometimes with obvious contrasts of line and colour, an opposition that he then worked to complicate (this is perhaps where the influence of De Stijl is felt most strongly in his practice). This double operation of reduction-complication is also evident from his glass pieces to his abstract paintings, many of which are based on architectural forms (again as with Mondrian), as the titles sometimes suggest: 'factory', 'skyscraper', 'pergola', 'window', 'interior' (see fig.53). For example, the abstract motif of the *Variant* series (1947–55), which present nested rectangles of various colours in doubled or bilateral compositions, derives from two adobe houses that Albers saw on one of many trips to Mexico. These works led to his celebrated series, *Homage to the Square* (1950–76), which consists of many paintings (usually in a four-foot square format) of precise squares of consistent colour that are also nested into one another (seed fig.54). Applied with a palette knife straight from the tube, the paint is flat and smooth on its support (usually the rough side of masonite panel), but it is also luminescent enough to suggest depth, either projective or recessional. If Albers, like Mondrian, sometimes undid the traditional opposition of figure and ground, he also, like Moholy, often overcame the old dichotomy of picture and plane. In this way, too, all three figures complicated any simple binary of representation and abstraction.

For Albers the interaction of form came to depend on 'the interaction of colour', the relationality of the former on the relativity of the latter. 'Painting is colour acting', he wrote in 1948. 'To act is to change character and behavior, mood and tempo.'[35] This line of inquiry culminated in his *Homage to the Square* series, which was intended 'to proclaim color autonomy as a means of plastic organization'.[36] Albers also pursued this investigation in his teaching, first at Black Mountain and then at Yale, as summed up in his famous book, *Interaction of Color* (1963), which came replete with lavish screen-print demonstrations. 'Color is the most relative medium in art', he writes there, and the point is elaborated in many ways. Far from suspicious of 'illusion' and 'deception' (as Greenbergian modernists came to be), Albers saw them as productive capacities: indeed his mantra, in *Interaction* and elsewhere, is the rich range of effects to be culled from the 'discrepancy between physical fact and psychic effect', and his *Homage* in particular demonstrates as much.[37] 'Nothing can be one thing but a hundred things', Albers once claimed; and more strongly: 'all art is swindle'.[38] In this respect he departs from all of his Constructivist associates and most of his Bauhaus colleagues: Albers was interested in ambiguities of perception more than in 'truth to materials'; or rather, he saw the first as the only way to clarify the second. To educate the eye one must fool the eye: 'swindle' had both practical and ethical

value for him.[39] It is this interest that led Albers to all the subtle modulation in his work – within each painting, between paintings, and from series to series – and yet it also led him to all the insistent repetition there. Ironically, if the scientific Moholy could sometimes be indulgent, the experimental Albers could sometimes be formulaic.

Albers was seen as severe as a teacher, and he is still regarded as a reductive painter. But his pedagogy was fecund for different students, and his abstraction allowed for various departures. His influence at both schools continued long after he left (Yale was as important an artistic training ground in the 1960s as Black Mountain was in the 1950s), and it was diverse in its effects. For one thing, Albers was not simply the formalist other to the avant-gardist cluster at Black Mountain – to Olson in poetry, Cage in music, Cunningham in dance and so on – that he is often taken to be. In some ways the stringent German committed to the refining of vision is antipodal to the rambunctious Americans pledged to the opening up of poetry, music and dance, respectively, to the breath of the body, to the vagaries of chance, and to non-symbolic movements. In other ways, however, Albers was aligned with Cage and company in his opposition to other aesthetic models then on the rise – to an art based either on expressive subjectivity (as represented by Black Mountain visitors like de Kooning and Kline) or on extreme objectivity (as in the medium-specific 'modernist painting' advocated by Greenberg). Moreover, both the Albers and the Cage camps were involved, each in its own way, in a pragmatic approach to research and experiment, and Black Mountain students like Rauschenberg and Twombly might be seen as the unlikely offspring of this odd coupling.[40] ('Albers was a beautiful teacher and an impossible person', Rauschenberg once remarked, with a mix of alienation and affinity. 'What he taught had to do with the entire visual world ... I consider Albers the most important teacher I've ever had, and I'm sure he considered me one of his poorest students.')[41] In short, with his version of the Bauhaus idea combined with the Cagean interpretation of the Dadaist impulse, Albers was a primary element in the chemical reaction that made Black Mountain catalytic for much advanced art in post-war America.

If Albers helped to mediate modernist and avant-gardist models of art at Black Mountain, he also served to connect pre-war and post-war forms of abstraction at Yale. Yet this relationship, which was already recognised by the mid-1960s, is sometimes misconstrued. For example, his *Homage to the Square* might resemble the spare geometries of the young Frank Stella (see fig.56), but Albers aimed to engage spatial illusion, whereas Stella worked to negate it with his exposed grounds and shaped supports. 'What you see is what you see', Stella remarked of his early paintings, yet with Albers one is never certain: again, for all his interest in Gestalt forms, his primary concern was 'discrepancy' and 'deception'.[42] If his sometime student Rauschenberg worked in the broad 'gap' between 'art and life', Albers operated in the tight space between the known and the perceived – again, 'the physical fact and the psychic effect'.[43] In short, the deep connection between Albers and, say, the Minimalists lies here – in a shared concern with the complexities of perception.[44] Such attention also influenced not only Op artists like Bridget Riley but light artists such as Robert Irwin and James Turrell, all of whom were provoked by the phenomenological investigations of Minimalism that were cued, in part, by the perceptual exercises of Albers.[45]

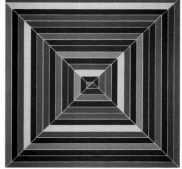

fig.56
Frank Stella
Hyena Stomp 1962
Oil on canvas
195.6 x 195.6 cm
Tate

In the end Moholy and Albers are fraternal twins, like and unlike in equal measure. Both are committed to an idea of art as an objective mode of experiment and research. Both tend to privilege perceptual response over aesthetic appreciation, indeed 'vision' over art. Both are modernists and humanists. Yet here the differences begin. Albers developed an abstract version of the traditional focus in German aesthetics on natural *Gestaltung* (or formation), whereas Moholy concentrated on the new abstraction of 'the second nature' of metropolitan modernity, of industrial production and spectacular consumption. Moreover, informed by Gestalt psychology, Albers sought to reclaim the innate capacities of the human senses, whereas, fascinated by 'biotechnics', Moholy aimed to find 'the whole man' on the other side of techno-scientific transformation. In 1969 Albers prefaced his definitive text, *Search Versus Re-Search*, with a prose poem about the precious singularity of natural stone; forty years earlier Moholy concluded his signature book, *The New Vision*, with images of the revolutionary fungibility of modern light.[46] One can see these different orientations as a static opposition in which the Bauhausian 'unity of art and technology' is split between them, with Albers pledged, finally, more to the liberal arts and Moholy more to industrial design. Or one can understand the difference as an active dialectic, with Albers focused more on material tactility and Moholy more on transparent opticality, a dialectic that, deep in modernist art, the two men both represent and advance.

'The discourse of vision and the tropes that go with it are crucial to adapting art to the university campus; it is both professionalizing and democratizing', Howard Singerman argues in *Art Subjects: Making Artists in the American University*. 'Vision counters the vocational, the local, and the manual; the visual artist shapes the world, designing its order and progress.'[47] Under this dispensation, pioneered by Moholy and Albers, the fine arts of the old Beaux-Arts tradition were reworked as the visual arts of the modernist order, in which guise they were relocated in the university in alignment less with the humanities than with the sciences, with the artist-in-the-studio patterned after the scientist-in-the-laboratory, both engaged in research.[48] This is not a question of simple co-option: there is no direct line from the Bauhaus *Vorkurs* to the design and colour courses that became standard in many post-war universities. Here again a dialectical view is welcome: Moholy and Albers also radicalised design and colour instruction, just as they both revised the Bauhaus idea and allowed it to be transformed by contact with new techniques and other avant-gardes.

Finally, the refining of 'vision' is the great legacy of both figures. Yet here Moholy and Albers faced a difficulty, or rather they left us one to contemplate: how to separate the refining of vision from the disciplining of vision. Art as experiment might activate the subject, but it can also be turned round on the subject as the object of experiment. The 'man' posited by Moholy is a Constructivist work-in-progress, already implanted with a 'mechanical imagination' and always subject to alteration, while the person imagined by Albers is both examiner and examinee, one whose perceptual sensitivity is pressured by the very mass-produced normativity that it resists.[49] Two photographs of the pair are somehow suggestive in this regard. The image of Albers, published in *Harper's* in May 1946, shows him at a blackboard in front of a Black Mountain class involved in 'a comparative analysis of proportionate and non-proportionate rectangles' (fig.57).[50] Although the exercise concerns 'the different results' obtained in the perception of the two similar rectangles, all the students are tilted in the same direction – through their hands, pencils, and heads – and thus lined up not only with the diagonal of the rectangle at left but with the disposition of the master, whose back is turned to them. The image of Moholy shows him, next to Gropius, peering down

fig.57
Albers teaching at Black Mountain College as reproduced in *Harper's Junior Bazaar*, May 1946

fig.58
Moholy and Gropius with students on the circular staircase in the home of Marshall Field, Chicago 1938

from the renovated staircase of the New Bauhaus *c.*1937; arrayed around the spiral, nine students look down as well (fig.58). We see them all from below, and both masters are grinning, as if pleased with the modernism put into practice here (also evident in abstract lights and clock). Moholy points like a demiurge (not unlike God on a more celebrated ceiling), but his finger indicates no other creation than the spiral of the staircase on which his students appear. It is a confident gesture, as though the dialectic of modernism had only just begun to unwind.

'I WANT THE EYES TO OPEN': JOSEF ALBERS IN THE NEW WORLD

Nicholas Fox Weber

fig.59
Barbara Morgan
Josef Albers 1944

Josef and Anni Albers were fond of recalling their journey to the US in 1933. It not only saved them from the horrors of Nazi Germany, but also opened them to forms of warmth and camaraderie that they had never before experienced. Albers, who had been at the Bauhaus longer than any other artist, had benefited enormously from being a student and master at Germany's pioneering school for art and design, but had known it to be rife with personal disputes and internecine complications. In 1932 the newly elected Nazi authorities had frozen payment of faculty salaries and soon afterwards the Gestapo had padlocked the school's doors.

Until recently, Albers's emigration has been reported (because of the way it was initially told by the Alberses themselves) as if it began when the warm-hearted Philip Johnson, not yet a practising architect but working at the new Museum of Modern Art in New York, encountered Anni, quite by chance, on a street in Berlin, and she invited him to the Alberses' new flat for tea. That visit indeed occurred, but what has never been previously revealed is that Albers was already working hard to establish links with leading figures in the American art world. A previous connection between Albers and Alfred Barr, the founding director of the Museum of Modern Art, has now come to light. Research for this exhibition led to the discovery of letters between the two. They had initially been in touch in 1929 after Barr, then at the Farnsworth Museum at Wellesley College, an all-female educational institution in Massachusetts, had visited the Bauhaus. Then, on 29 June 1933, from his apartment in Berlin, Albers sent Barr some photographs of his 'material studies'. In his covering letter, he explained that he also taught 'object drawing' – in addition to 'basic design' – inspiring him to remark: 'I place much importance on the conceptual recognition of the three-dimensional form.'[1] 'You know how attached I am to teaching', he continued, 'and how few opportunities for practical application there are here now … Perhaps new work opportunities or even a collaboration will result from my propositions.'[2]

Even if Albers did not specifically ask to emigrate, he made it clear to Barr that he needed help and counted on the United States to offer a friendly and receptive climate in complete contrast to the hostility that had come to dominate in Germany. On 7 August, restless in his homeland, he wrote to Barr, 'I am sure you know that abstract art is not shown here at the moment. That is why I am trying to make my work known outside.'[3] He sought museums and dealers, and wondered about the possibility of a travelling show of his work in the US. In their correspondence, Barr apologised to Albers for his poor German, and Albers to Barr for his wobbly handwriting (he explained that the August letter was written in the countryside, which is why he could not type it), but they nonetheless made their points clearly.

The next chapter of the story becomes clear in a letter sent to Barr on 31 August by another American, the twenty-five-year-old Edward M. M. Warburg, a rich young supporter of modernism who worked unpaid at the Museum of Modern Art: 'Dear Alfred: I want to tell you about another project that I have been playing with during the last few weeks.' Because of a conversation between two acquaintances of Eddie's mother, one of them his cousin, at the Cosmopolitan Club, a traditional institution for upper-class ladies on New York's east side, Eddie had met 'one Mr Rice', who had recently helped found Black Mountain College, a progressive educational institution in North Carolina. John Andrew Rice 'came in to see me about a man to head their Fine Arts Department, and both Phil and I immediately thought of Albers. We have written him a letter to find out whether he and his wife would come over here, and we received a cable to the affirmative.' The problem was that the immigration authorities with whom 'Phil', Rice and Eddie had met had pointed out that Black Mountain was not accredited. They needed to come up with money for a modest salary for both Josef and Anni Albers, and for their steamship tickets.

'Unfortunately, Albers not being a Jew, my usual contacts are fairly useless as my friends are only interested in helping Jewish scholars', young Warburg lamented to Barr, after which he went on to ask about the diplomacy of approaching Mrs Rockefeller, one of the founders of the Museum:

> I cannot help but feel that getting Albers into this country would be a great feather in the cap of the Museum of Modern Art. His Summer Vacations would be, so to speak, free, and I am sure he would be interested in working at that time with us on anything that we might have in mind. With Albers over here we have the nucleous [sic] for an American Bauhaus![4]

Anni Albers often recounted that, when she and her husband went to the US Consulate and began the complex process of applying for visas, it was as if someone had put their file folder at the top of the pile. Indeed, Black Mountain founder Ted Dreier and others were working hard to get the couple approved. Black Mountain guaranteed Albers an annual salary of $1,000, and while Anni would receive nothing, even though she was expected to give some instruction in weaving, the college also offered room and board. Eddie Warburg paid for the steamship tickets (first-class) himself.

The warmth and spirit with which that journey had been organised, and the positive energy that Josef and Anni felt upon their arrival in America at the end of November of that year, would immediately become manifest in the art they both began to make. Albers's spontaneity, informality and warmth were tapped in a new way. He had discovered what Graham Greene called the America of 'the skyscraper and the express elevator, the ice-cream and the dry Martini, milk at lunch, and chicken sandwiches on the Merchant Limited.'[5] Albers saw those buildings, took those trains, ate the new food, and felt himself infused by all the freshness and energy.

A wire-service news article showed a photograph of him and Anni taken as their ship docked. They are the image of rich and distinguished first-class passengers. He is wearing an impeccably fitted double-breasted topcoat, his necktie pushed forward and his hair perfectly combed; she is in hat and veil and a sealskin jacket with square shoulders and a large collar. The welcome they received in the US filled them both with enthusiasm. For one thing, the press coverage was laudatory. Edward Warburg was quoted as saying, 'Professor Albers may exert an influence in this country that will fundamentally change present methods of approach to art education.

fig.60
Josef Albers
Elephant 1933
Linoleum cut
(Printed at Pan-Presse Felsing, Berlin)
20.3 x 20.3 cm
The Josef and Anni Albers Foundation

On their first full day in New York, Josef and Anni marvelled at the skyscrapers, the crowds at the Metropolitan, the line for a Brancusi exhibition organised by Marcel Duchamp (to whom Albers had been introduced by Katherine Dreier, a great patron of modern art and aunt of Ted Dreier). He found Duchamp highly sympathetic, as he did George Grosz. He was also impressed by the graciousness of Johnson and Warburg. The latter, heir to banking and railroad fortunes, took them into his parents' five-storey mansion on upper Fifth Avenue to show them the collection of Rembrandt etchings; the family spoke German; Europe was not so far away.

Immersed in their new life, they kept their ties to the Old World – asking Wassily Kandinsky if he could get Gertrude Stein to visit Black Mountain, corresponding with Marcel Breuer in Budapest, Xanti Schawinsky in Milan, the Klees in Bern. Hans Arp had written that he was interested in Albers's work, and wanted to show and publish it. In May, Albers was included in an exhibition organized by the Carl Schurz Foundation that showed his art with that of Kandinsky, Lyonel Feininger, Oskar Schlemmer and others. Willi Baumeister wanted to exchange works with him and Kandinsky organised an exhibition of his woodcuts in Milan. In his catalogue essay the older artist praised his former Bauhaus colleague's 'artistic invention, clear and convincing composition, simple but effective means; and finally a perfect technique'.[6]

Yet, on another level, Europe appeared increasingly distant. On 3 December, less than a week after the arrival at Black Mountain, Albers wrote to Kandinsky and his wife Nina, who were still in Berlin, 'One would never believe how much salt water exists between Germany and America.' News began to worsen with fewer people succeeding in their efforts to leave Germany; some seeking to emigrate were being turned back at the borders, and the Alberses had heard that the sculptor Ernst Barlach had suffered a nervous depression. The more bad news they heard, the more they appreciated their new host country: the Americans were 'very very friendly. It's a long time since we have encountered such kindness, so much youth and interest in culture. New York has a marvelous vitality, and one sees the best art there. Black Mountain is splendid, completely in the mountains, all luxuriant.'[7] Albers enjoyed the wild rhododendrons, the mountain grass and the warm sunshine even at that time of the year. He and Anni were, he told the Kandinskys, 'very very happy'.[8]

When Albers had entered the Bauhaus at the age of thirty-two, he compared the experience to throwing everything out of the window and starting all over again. Now, at forty-five, he had a wife, a reputation and a job, but he was still beginning anew. He was fascinated by what he gleaned, instantly, of American culture. At Black Mountain he and Anni quickly befriended Ted Dreier and his wife Bobbie. From patrician East-Coast families, the Dreiers nevertheless had an informality that, in the Alberses' eyes, was a refreshing contrast to their European counterparts.

What struck Albers above all in America, and what infused his art, was the natural abundance. In April of 1934, he wrote to the Kandinskys, 'Certain trees are red-brown (maples), and now there are others with large white flowers, bright green, pink, chestnut-colored. The violets are their usual color, but there are also yellow and white ones. In general, the shapes of the leaves and the flowers are incredible.'[9] His excitement at his new surroundings showed up in his vibrant abstract improvisations of the period and their exploration of pure colour (fig.61).

Adjusting to a new language, though, was not always easy. Albers had to rely on a simultaneous interpreter for his classes at Black Mountain, a Mrs Zastrot. Anni, who

fig.61
Josef Albers
Leaf Study IV c.1940
(pl.89, p.125)

had been taught English by an Irish governess, sat in on his lessons one day and observed that Mrs Zastrot was making her husband far too Teutonic. If he gently suggested painting in a certain way, Mrs Zastrot gave his words autocratic insistence, and Anni had her fired. The devoted wife insisted that her husband had sufficient vocabulary in English, and, moreover, could teach by demonstrating visually. Albers, whom Bobbie Dreier remembers arriving at Black Mountain with the words, 'I want the eyes to open', now simplified his ambition with the words, 'to open eyes' on the many occasions when he declared his ambitions.

Anni assumed the role of her husband's English teacher. They were walking in the countryside near the campus when they saw a sign that said 'Brown's pasture'. Albers asked her what a 'pasture' was. She replied, with assurance, 'That's very clear, Josef. It's the opposite of future.' They may not have had the vocabulary right, but they knew enough to recognize the mistake quickly, and had a sufficient passion for puns to tell the story afterwards.

The Alberses spent their first American summer mostly in North Carolina, but they also travelled to New York and Lake George. On one of those trips north, while staying at Katherine Dreier's house in Redding, Connecticut, they all wrote a joint letter to Kandinsky. The Alberses said that they liked America all the more because they could see so much of Kandinsky's work at the Dreiers' house, since her two sons – aged two and five in 1934 – were already great admirers of the Russian's work.

During the few months spent in Berlin when the Alberses had been preparing to move, they had discovered the art of the ancient Americas in the museum of antiquities. They craved a chance to see it in situ, and by the end of 1934 they were driving to southern Florida with Ted and Bobbie Dreier in their Model 'A' Ford, and travelling by boat to Havana. Albers gave three lectures at the Lyceum in the Cuban capitol, but it was again the bounty of nature that struck him. He enthusiastically talked of palm trees, of places where bananas and pineapples grew. The Alberses sent the Kandinskys Floridian pine needles, with a note in which they extolled the delights of Spanish wine, of rum and of strong coffee.

Cuba was a foretaste of pleasure they would soon begin to experience in Mexico, to which they made fourteen trips. The Alberses believed that in Mexico 'art was everywhere': in the ponchos people wore, in the local pottery, in the adobe architecture. The palette of Mexican textiles and folk art quickly showed up in Albers's painting, as did his exuberant spirits (see fig.62).

Albers quickly extended his contacts with the American art world as it then existed, Warburg, Johnson and Barr acting as the main links. Johnson put on an exhibition of Machine Art at the Museum of Modern Art in 1934, and Albers designed the catalogue cover – a close-up photograph of a ring of ball bearings that suggested both the triumph of modern engineering and the movement of great sculpture. Warburg helped organise an exhibition of Albers's latest prints at the Addison Gallery in Andover, Massachusetts. Those prints, with their use of wood grain and cork, reflected Albers's unprecedented engagement with the surfaces of nature, as well as with the endless possibilities of linear movement. They betrayed nothing of the hardships of his life—the sharp reduction in financial resources, the displacement, their fears about Anni's Jewish family being stranded in Nazi Germany. Art was the antidote to problems, the reality one chose instead of the one over which one had no choice. Printmaking techniques – chiselling, engraving, etc – and the application of oil

fig.62
Josef Albers
To Mitla 1940
(pl.87, p.123)

fig.63
Josef Albers
*Untitled (Thornton Wilder) c.*1956
Reel prints on mounted cardboard
12 x 27.4 cm
The Josef and Anni Albers Foundation

pigment directly to hard Masonite and wooden surfaces gave Albers palpable satisfaction. In his art as in his life, he was constantly exploring the new.

The American writer Thornton Wilder (fig.63) became Albers's first client in his new country, when he visited Black Mountain in 1934. He spoke German, which added to the ease of an evening spent with Albers and Anni and the poet John Evarts in the Dreiers' cottage. Albers was happy to have someone with whom he could discuss Goethe's colour theories and Kandinsky's art, and he was enchanted by Wilder's ability to memorise telephone numbers as melodies. This reflected the powers of observation as well as the inventiveness he cherished. When the writer said he wanted to buy a woodcut but feared the price, the obstacle was overcome when it was given as $10 – and Albers then made a present of a second print to honour the purchase.

Albers never forgot Wilder's commitment. Over two decades later, he addressed a letter of congratulation to the novelist playwright 'to my first promoter in the USA.',[10] to which Wilder replied, 'THAT is too much. I suddenly loved and admired you – yes! But many have done that … I shall never forget your demonstration of certain principles of composition. How wonderful, dear master, that you combine the two God-given gifts – creation and instruction.'[11]

Black Mountain was a haven, but Albers was initially uncertain about remaining there. Philip Johnson served as an intermediary for discussions with Bennington College, a progressive's educational institution for women in Vermont, about Albers taking a teaching position, but it fell through, the main issue being that the émigré was considered 'too German'.[12] If Bennington, small and experimental like Black Mountain, seemed feasible, more mainstream institutions were less enticing. Ted Dreier would later recall:

> As soon as we got them over here from Germany, many other colleges wanted them and made Albers offers … at salaries that were several times as much as what Black Mountain was able to offer … Walter Gropius greeted me on one of his visits to the college soon after President Conant at Harvard had offered him a chance to completely reorganize the School of design at Harvard. He told me that this was a wonderful opportunity to change the whole nature of the teaching of architecture in America, but that one of the key people that he simply had to have to accomplish this was Josef Albers. Albers, he said, was absolutely unique in both the breadth and depth of his knowledge and in his ability to stimulate the creativity of students by the combination of theory and practice … He hated to have to tell me this. But he knew I would understand … the necessity of taking Albers away from us and offering him what he considered to be a key position on the faculty at Harvard … neither of us dreamed that Josef would turn down such a golden opportunity and stay on working at Black Mountain for practically nothing. He stayed for 16 years.[13]

At the same time that the Alberses relished their refuge at Black Mountain, they were keenly aware of the mounting hardships abroad. They were in touch with the wife of Kurt Schwitters, who was miserable because she could not obtain the authorisation to send her husband's work abroad because the German authorities considered it too decadent. And much of the Alberses' energies over the next few years went into their efforts to get people out of Germany. The Rector of Black Mountain College, J.A. Rice, officially invited Wassily and Nina Kandinsky to come to the school so that the Russian-born painter might teach there. Anni explained all the possibilities that

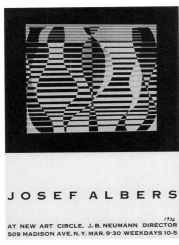

fig.64
Josef Albers
Cover for a booklet accompanying an exhibition at the New Art Circle, New York, 9 March – 30 March 1936 1936
19.3 x 14 cm
The Josef and Anni Albers Foundation

fig.65
J.B Neumann, Anni and Josef Albers
Gelatin silver print
19.5 x 24.5 cm
The Josef and Anni Albers Foundation

American life might offer them – with representation in New York galleries and perhaps a show at the Museum of Modern Art, elegant evening parties and plenty of supporters fluent in German and French. The Kandinskys replied that they were greatly tempted, but would have to put off accepting – although they certainly did not rule out the possibility.

The Alberses were responsible as well for close friends from Berlin, and their children, all of whom needed jobs at Black Mountain to gain permission to make the journey across the Atlantic. Before too long Anni's family was among those they were trying to bring into the United States. Although himself a Catholic, Albers made no distinction between Anni's Jewish relatives and his own. When, in 1935, the Alberses applied for a visa for Anni's younger brother, Hans Fleischmann, he was described to the authorities as 'our brother'. (He arrived in the US in December of 1936, and became an American citizen in 1940.) Jointly Josef and Anni engineered the escape of her sister Lotte and Lotte's two children. The letters beseeching the American Consul in Berlin to permit her parents, siblings and nieces and nephews to escape a Berlin savaged by Nazism had a tone completely opposite to that of their deliberately playful art.

Albers could juggle the complexities of his existence deftly. He was taking abstract painting into unprecedented directions. Having joined the American Abstract Artists' Group, he participated in a protest at the Museum of Modern Art that challenged the prevailing aesthetics of that Museum – its collecting and exhibition policies – and that he felt damaged his relationship with Barr forever after. That March, he had a solo exhibition with the pioneering dealer J.B. Neumann in his gallery The New Art Circle in New York (figs.64 and 65). It occurred simultaneously with a show of abstract art at the Museum of Modern Art from which Albers's work was conspicuously absent, and at least one critic made a comparison, urging viewers to go to the private gallery exhibition first. 'Mr. Albers deals in the rhythms of space-relationships in so appealingly simple and pure a style that you wonder why other painters of abstractions want to be so involved and complicated in their designs.'[14] Albers's work seemed to appeal to a critical public not yet open to other forms of non-representational art. Edward Alden Jewell, then the main art critic for *The New York Times*, offered the guarded praise, 'While Mr. Albers's abstractions never transcend a certain expert simple elegance, they triumphantly dispense with most of the folderol that is so apt to accumulate as an artist delves in this overworked field.' Jewell also went out of his way to praise Albers as a pedagogue, commenting on the 'artist-instructor' as possessed of 'mellow wisdom' and quoting a text written by Albers for the Black Mountain College Bulletin: 'Life is more important than school; the student and the learning more important than the teacher and the teaching. More lasting than having heard and read is to have seen and experienced.'[15] Thus the critic evoked not only Albers's primary educational emphasis – on experimentation and the value of 'search versus research' – but also his particular manner of expressing himself, the simultaneously soft yet strident tone that marked his painting style too.

The geographic isolation of Black Mountain notwithstanding, Albers had entered the mainstream. In a show that was on view for a mere two weeks at the end of 1936, at Delphic Studios, 724 Fifth Avenue, then one of New York's major gallery buildings, six of his major paintings were presented alongside works by, among others, Juan Gris, Kazimir Malevich, Kandinsky and Schwitters. However, when the Jeu de Paume in Paris organised a show of 'International Independent Art' in 1937, he was excluded. This prompted a public letter of protest calling for a fairer reorganisation of the

exhibition. Among the people voicing their objections to the omission of, amongst others, Malevich, Moholy-Nagy, Schwitters and Albers himself were André Breton, Constantin Brancusi, Robert and Sonia Delaunay, Hans (Jean) Arp and Sophie Taeuber Arp.

This did not mean that Albers necessary allied himself with all of his fellow rejects. 'When you relate me to Moholy', he commented thirty years later, 'that's impossible because I hate that man because he was never original'.[16] While there is no justifying the statement, it bears repeating mainly because it reflects Albers's famous crankiness, and the arch opinions that were an important part of his personality.

Albers himself had to cope with a range of criticism, much of it due to a misreading of his work. When he showed at the Katherine Kuh Gallery in Chicago in 1937 – Kuh being a curator and critic of great significance to the acceptance of American modernism – one critic compared the work to 'geometric figures piled ... like slices of cheese' and another adumbrated the 'weakness which is the weakness of his school. The Constructivists felt the influence of mathematical science and technology in modern art and set out to isolate it ... They have not transformed it humanistically as Klee and Picasso and Brancusi have done.'[17]

Albers was often forced into a defensive mode. One of the times this came to a head was when the Museum of Modern art mounted a Bauhaus exhibition in 1938. Albers later recalled:

> I remember when the Bauhaus exhibition at the Museum of Modern Art in New York opened: very late. 11 or 12 when all were gone except a few from the Bauhaus. Gropius, Bayer, Anni, me. Appeared Frank Lloyd Wright. In a Havelock [a cloth covering the back of the neck] and Wagnerian velvet cap (with a challenging older lady) telling us very loud, 'You are all wrong.' And who was it later saying: 'Frank Lloyd Wright? – he is always frank, and not always right.'[18]

The need to fight for the survival of their artistic beliefs was one of the Alberses' battles; simultaneously, their lives remained dominated by the struggle for survival in a more rudimentary sense. Family was a perpetual preoccupation, the Alberses regularly needing to send what they could from their modest teaching salaries to help the formerly rich relatives who were arriving penniless in America. Anni's sister was, in 1938, still in London, desperate to move to the US, and Anni was working to find a job for her doing domestic work in New York, and to organise the necessary affidavits. She was also trying to get her younger brother's life on surer footing in a new country.

Meanwhile, Albers enjoyed growing support for his art. A show at the Artist's Gallery on Eighth Street in New York's Greenwich Village marked a turning point in his critical reception (see fig.66). Again the reviewers felt a need to disparage other forms of abstraction concurrently being made, but they were enthusiastic about Albers. In the mainstream American press, the magazine *TIME* reported, 'A Bauhaus alumnus who has had better luck than Moholy-Nagy since he landed in the US in 1933 is Josef Albers, a granitic little man.' *TIME* applauded the '20 abstract paintings, whose clarity and subtle kick showed up the usual dilettante work in that line.' It quoted Albers saying, 'Everybody knows one and one is two. That's arithmetic. But as soon as we see that with an artistic eye, we can see one and one makes three.'[19] This, of course, was Albers's alchemy: his marvellous ability to deceive through art, to use two expanses of unmodulated colour and give the illusion of shadows, to create impossible

fig.66
Josef Albers
Cover for a booklet accompanying an exhibition at the Artists' Gallery, New York, 6 December – 31 December 1938
1938
15.3 x 21 cm
The Josef and Anni Albers Foundation

spaces with contradictory exits and entrances, to make physically impossible things happen optically.

In 1939, Josef and Anni Albers became naturalised US citizens. They regarded Franklin Delano Roosevelt as a father figure, and their new country felt more and more like home. That same year, Albers's work was the subject of different shows in five major US cities, and in 1940 it was presented in an exhibition at the San Francisco Museum of Art and together with Feininger's work at the Mint Museum in Charlotte, North Carolina.

Soon afterwards, Albers took a sabbatical in New Mexico. Unknown to Anni, he was involved with the landlady of an adobe rooming house. The relationship with Betty Seymour warrants mention because the communication between them shows Albers at his most playful and mischievous, exhibiting the fancifulness as well as the passion that lie beneath his cool veneer in his art of the period. One letter reads:

> Monday morning:
> No news.
> Therefore: Love only
> Lots of love
> Longing love

In letters to Betty, he fooled around by signing his name either as 'C'rasus,' 'C'razuz', 'Jofez', 'Joe Fez', or 'Anni's husband'.[20]

Naturally the war put a damper on exhibitions. After 1940 there was only the odd show (see fig.67) until another with J.B. Neumann at New Art Circle in New York in January 1945. The unsigned catalogue essay, probably written by Neumann himself, hit the nail on the head when it described Albers: 'he draws ... from the spirit and from turning to the absolute. He finds that life is ever-shifting and that a turn of the head, a change in lighting, makes objects appear different one minute from the next.'[21]

Following World War II, Albers began to show the work he had produced during the previous years in some of the best-known American art institutions – among them the Jacques Seligman gallery and the Museum of Non-Objective painting, housed at the Solomon Guggenheim Foundation on upper Fifth Avenue in New York. Two of the leading New York galleries – those owned by Sidney Janis and Charles Egan – showed his work. The simultaneous one-man shows at those two galleries inspired unprecedented press coverage. In *TIME*, Albers made a statement that remains a key to his work of that period when he was just about to leave Black Mountain College, move to Yale, start painting his *Homages to the Square* (see fig.68), and thus begin a new phase of his life. The artist said:

> In the end, I am concerned with emotion in spite of everything. Some of my things are sorrowful, some are jokes ... You see I want my inventions to act, to lose their identity. What I expect from my colors and forms is that they do something they don't want to do themselves. For instance, I want to push a green so it looks red ... All my work is experimental.[22]

Albers's life in the United States, the nurturing if complicated atmosphere of Black Mountain College, gave him an opportunity to experiment. The new world into which he had been forced because of the horrors in his old one provided not just physical survival, but also the chance to flourish.

fig.67
Josef Albers
Invitation to an exhibition at the art Department of North Texas State Teachers College, 1943 1943
Screenprint on card
11.3 x 16 cm
The Josef and Anni Albers Foundation

fig.68
Josef Albers
Homage to the Square 1976
Oil on masonite
60.7 x 60.7 cm
The Josef and Anni Albers Foundation

LÁSZLÓ MOHOLY-NAGY: TRANSNATIONAL

Hattula Moholy-Nagy

One of the most remarkable aspects of László Moholy-Nagy's life and career is the extensive geographic arena in which his activities took place. In the time of general upheaval and migration between the two world wars, Moholy moved more often and covered greater distances than most of his associates. By the end of his relatively short life, he had taken up residence in five countries, leaving Hungary for Austria in 1919 and then moving on to Germany, Holland, England and finally to the United States. Furthermore, he had managed to extend the network of his professional and social contacts around the world from Europe to the United States to as far away as Japan. One wonders what drove him. On what inner resources did he draw when moving from country to country? How did he adjust to different cultures and different languages? How was he able to sustain his creative output in the face of so many significant dislocations? Much documentation and other information has disappeared in the six decades since his premature death at the age of fifty-one in 1946; few who knew him personally are still available to answer these questions. Nevertheless, we can offer some tentative suggestions.

THE SON OF A KING

> So we just thought that Father was a bum. Although at that time this surprised us because Ákos and I knew that we were the sons of a king and were only boarding out with Mother's family. But once Mother told us a story of a king who was formerly a bum, and at that moment we were again completely certain.[1]

> As a child I thought I was a king's son who had been exchanged, who would later come into his rights. Now I know that one remains what one is. I am satisfied with my fate. Even more: I am happy to be who I am.[2]

The first quotation comes from a short story that Moholy published in 1918 when he was twenty-three years old. In it a boy tells of a meeting that he and his younger brother have with their father, estranged from his family, who regard him as a ne'er-do-well. The second quotation puts this story into a special light. It comes from a remarkably candid and informative interview that Moholy gave ten years later to Jane Heap, one of the editors of the avant-garde magazine, *The Little Review*.

Moholy's childhood years were difficult. His father had, in fact, left the family shortly after the birth of his younger brother, Ákos. He, Ákos and his mother lived with various members of her family, while their older brother, Jenő, was boarded out. The family moved several times during his early years, so that he was never able to become attached to one place. His mother lived on financial assistance from her relatives for

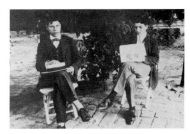

fig.69
Moholy and his brother, Ákos, in
Szeged, 1912

fig.70
Moholy at his Chicago School, 1940s

fig.71
László Moholy-Nagy and Lucia
Schulz, later Lucia Moholy, seated
between Hungarian artist friends
Sándor Gergely and Erzsébet Milkó,
Berlin, 1920

the rest of her life, a socially painful position. The above quotations show that even as a young boy, László felt distanced from his relatives. He imagined himself to be a king's son who for some reason was being raised by people of lower station. However, the sons of kings are princes and he already knew at a young age that eventually he would be someone of importance.

Records show that he did well in secondary school. In the absence of a father, he looked to his teachers and his mother's brother, Gusztáv Nagy, for guidance. He became open to new ideas and was willing to accept mentoring. This openness to new points of view was a trait that he retained throughout his life. While still in school, he started to discover his talents. He began to write poetry. In *The Little Review* interview, he describes the incredible joy he experienced with the first publication of one of his poems, the exhilaration of seeing his work in print.

Perhaps his interest in clothes developed during this period in his life. He grew up in a society where clothing still conveyed reliable information about an individual's social class. From the time he was a teenager, photographs always show him well-groomed and perfectly dressed for the occasion (fig.69). He was well aware of the information his clothes transmitted about himself and his values. At the Bauhaus he wore workman's red coveralls, but often over a shirt and tie (fig.1, p.66). At his School in Chicago he wore a technician's white lab-coat over a businessman's dark suit (fig.70). He carried his lunch to school in a worker's metal lunchbox, which never failed to capture the attention of his Hungarian acquaintances.

THE ENTHUSIAST

> My strongest personality trait: that I am an optimist. What I love the most in myself is that I can be happy; the least: that I have a tendency to become fanatical.[3]

The misery of World War I helped awaken Moholy's social consciousness and gave focus to his diffuse ambitions. He wanted to make a contribution to society. He was excited by the end of the old order and the rise of Socialism. Encouraged by a friend, the art critic Iván Hevesy, he decided to become an artist. From then on, this was primarily how he thought of himself. But this did not mean that he gave up writing. He published extensively all of his adult life, understanding that this was one of the most effective means to disseminate his ideas.

In 1919 he launched himself. He left the country of his birth for Vienna, returning to Hungary only for lecture tours and visits to his family. In Vienna he made contact with the Hungarian avant-garde MA (Today) group, who had been exiled there following the political and social unrest that had enveloped Hungary after the end of the war. But he found Vienna uncongenial and after a short time decided that Berlin, the cultural capital of Eastern and Central Europe, would be a better place to make his mark. Characteristically, he stayed in touch with his MA colleagues in Vienna, and continued to work with them after they returned to Budapest. He had already recognised the importance of maintaining a social and professional network.

Once in Berlin, Moholy made contact with artist friends from Hungary, József Nemes Lampérth, as well as Sándor Gergely and his wife Erzsébet Milkó (see fig.71). It was probably through them that his work was included in an exhibition at the Fritz Gurlitt gallery in 1920, the year of his arrival in the city. This first stay in Berlin set the direction for his future career. Within a year of his arrival, he had espoused

Constructivism and its social philosophy, which regarded artists as active agents who could improve society.

Moholy worked in this new style with great energy and enthusiasm. Aurél Bernáth, a Hungarian figurative painter who stayed with him for a short time in Berlin, reported to a friend that Moholy had at least 100 canvases in his studio, and when he painted, he worked on four or five pictures at the same time.[4] We are given a vivid impression of the artist's wholehearted enjoyment of his chosen profession.

Walter Gropius's invitation to Moholy to teach at the Weimar Bauhaus changed his life. It was entirely compatible with his ambition to improve society and, best of all, showed him a way in which he could do it. He never lost his dedication to the Bauhaus values on educating the whole person, teamwork, experimentation and social responsibility, subscribing to its aim of promoting the unity of art, science and technology to serve humanity. He learned how to think holistically and how to recognise connections between things.

In the development of his art, which ran parallel to the development of his position among the European avant garde, he extended his creativity into new media while continuing to produce works in those with which he was already familiar. This versatility arose naturally from his holistic point of view. To the drawings and paintings on which he worked when he first became an artist, he added collage, sculpture, black and white photography, photograms, photoplastics (photomontage), stage design, motion pictures, advertising design and finally colour photography. It is fascinating to see how he applied the solutions to artistic problems he set for himself to different media. Furthermore, he extended them to the commercial and exhibition designs with which he largely supported himself after he left the Bauhaus.

Moholy had been able to retain a talent that he greatly admired in young children: the ability to look at their environment without preconceptions. He could see creative possibilities in unlikely places. One day, in the old house that served as the School's summer quarters in the country, I was astonished to find him on his hands and knees on the living room floor. He was engaged in making crayon rubbings of the raised patterns of the wood grain of the well-worn floorboards but he was using my crayons (fig.72).

THE TRANSNATIONAL

> I don't believe in art as much as in people. Everyone reveals themselves; much of it is art.[5]

> I am Hungarian and besides Hungarian I only know German. But I would still like to know French, English, Italian and Spanish. Then I would be at home everywhere.[6]

Although founded by a German and located in Germany, the Bauhaus was decidedly cosmopolitan. Its faculty and students came from several European countries as well as North America, Japan and Palestine. Its reputation grew steadily within the wider trend towards internationalism that arose and flourished, at least for a while, in the interwar years. Members of the international avant garde visited the Bauhaus, and Moholy made many friends among them. Being at the Bauhaus gave him the opportunity to build up his social and professional network, which eventually reached considerable breadth and depth. He was well aware of the way in which one person

fig.72
László Moholy-Nagy
Untitled 1940s
Crayon rubbing on paper
Collection unknown

could lead to another, of the serendipitous nature of social contacts. His network was of great importance to him and he cultivated it assiduously. He was an indefatigable correspondent, who fortunately left an extensive paper trail even though the letters written to him were lost. This network helped mitigate the inevitable dislocations of moving from one country to another, because he could move to where he was already known. Besides his correspondence, Moholy maintained his contacts through his extensive travels in Europe, especially after he returned to Berlin in 1928. He joined several international avant-garde groups, including the Maison des Artistes at La Sarraz, Switzerland, the CIAM (Congrés International d'Architecture Moderne) and the Abstraction-Création group in Paris. He exhibited his art whenever he could, although he was concerned that many people failed to understand it. He published frequently. Sometimes this took the form of no more than single photographs or sound-bites; occasionally repetitive, they nevertheless kept his name before the eyes of the people with whom he wanted to keep in contact.

He learned how to draw people into his work, how to convince them of the excellence of his ideas and plans, and how to enlist their active support. He could be both charming and demanding. Some of these helping hands were men, but many of them were women. That he was able to accomplish so much in his lifetime is due in large part to the abilities and efforts of his wives. His first wife, Lucia Schulz (see fig.71), was a writer and editor, and shortly after they met, she became a talented photographer. She helped Moholy with his writing in German, with his photography, and made photographic records of much of his work. His second wife, Sibylle Pietzsch (fig.73), was a gifted writer. Besides typing, correcting and otherwise facilitating Moholy's articles and lectures, she ran the School's summer sessions, entertained frequently, kept house, and raised my sister and me.

During his years at the Bauhaus, Moholy became what one might call a transnational. National borders became less important to him than the people living within their boundaries. He learned how to identify and focus on commonalities and made serious efforts to communicate with everyone he met. Though he was not gifted in languages, he did eventually learn enough French, Dutch and English to be able to talk to people. And perhaps he even managed to feel at home everywhere. At least we can hope so.

He became more interested in the potential of what people could accomplish than in the ways in which they were categorised. (It is hard to maintain the prejudices with which you were raised if you come to know heterogeneous groups of people.) His devotion to Bauhaus education carried him through daunting obstacles during the nine years he lived in Chicago (1937–46): the unexpected closure of the New Bauhaus, which he had been invited to direct, the search for financial support for his own School of Design, the enormous difficulties of obtaining students and materials during the worst and most expensive war in history, the problems in enlisting the support of the Chicago business community upon which the School's survival depended. All this in addition to the need to adapt personally to the culture and social structure of a country considerably different from any of the European lands with which he was familiar.

Unsurprisingly, Hungary remained part of his network. He never lost his affection and interest for all things Hungarian. As soon after the end of the war as it was possible to do so, he resumed contact with his family. He surely would have visited them if time had permitted. In Chicago, during the early 1940s, he actively supported a political group that hoped to establish a democratic government in post-war Hungary, even though his doing so delayed his American citizenship for years.

fig.73
László and Sibyl Moholy-Nagy at the School of Design summer school, Somonauk, Illinois, 1939

Yet I think it unlikely that Moholy would have returned to Hungary permanently, had he lived. His transnational view of the world would have prevented him from doing so. His fellow countryman and relative, Sir Georg Solti, eloquently expresses the dilemma of the transnational in his autobiography. He relates a Romanian legend in which the sons of a hunter are turned into stags. Their father searches for them and pleads for them to come home. But one of them tells him that they will never return, because their antlers are too large to pass through the doorway.[7]

THE HOLIST

> It is astonishing how differentiated knowledge can be in spite of a generally similar educational and social background. By directing interest to commonly accepted tasks and problems, this varied knowledge of the experts could easily be united and synthesized into a coherent purposeful unity focussed on sociobiological ends.[8]

If considered in the historical context of the first half of the twentieth century, Moholy's experience is not particularly unusual. World War I was a decisive influence on the way in which political elites and artistic avant gardes saw the world. The war and the fall of the old regimes created both nationalism and internationalism. One can regard Moholy as one of many ambitious, talented young men from small nations who saw their best opportunities beyond their own country's borders.

It is the great diversity and broad scope of Moholy's life and work that set him apart and make his accomplishments so remarkable. His early conviction that he was destined for great things may have made it easier for him to move from one place to another. He recognised that the vision that guided his career was tied to people rather than places. Over the course of his life he constructed an extensive social and professional network that facilitated his international emigrations. His complete confidence in his abilities, his holistic worldview, his widespread contacts and his enthusiasm and dedication to his ideals gave him the courage to seize opportunities as they presented themselves. He saw himself as a person who could transcend geographical and creative boundaries to make a difference in the world.

fig.74
László Moholy-Nagy
Colour Explosion 1945
Colour pencil on paper collaged onto plastic
20.5 x 25.5 cm
Bauhaus-Archiv, Berlinn

TO THE NEW WORLD

81
Josef Albers
Etude: Red-Violet (Christmas Shopping) 1935
Oil on panel
39 x 35.6 cm
The Josef and Anni Albers Foundation

82
Josef Albers
Almost Four (Color Étude) 1936
Oil on Masonite
34.9 x 38.7 cm
The Josef and Anni Albers Foundation

83
Josef Albers
Untitled (Maya Temple, Chichen Itza, Mexico) n.d.
Gelatin silver print
17 x 11.7 cm
Tate. Presented by The Josef and Anni Albers
Foundation 2006

84
Josef Albers
Untitled (Herd of Pack Burros) n.d.
Gelatin silver print
17.8 x 24.4 cm
The Josef and Anni Albers Foundation

85
Josef Albers
Untitled Abstraction V c.1945
Pencil and gouache on paper
25 x 16.2 cm
Tate. Presented by The Josef and Anni Albers
Foundation in honour of Achim Borchardt-Hume,
2006

120

121

86
Josef Albers
Tierra Verde 1940
Oil on Masonite
57.8 x 71.2 cm
The Josef and Anni Albers Foundation

87
Josef Albers
To Mitla 1940
Oil on Masonite
54.6 x 71.4 cm
The Josef and Anni Albers Foundation

88
Josef Albers
Study for 'Memento' (I) 1943
Oil and pencil on paper
40.7 x 30.5 cm
Collection of Katharine and Nicholas Fox Weber

89
Josef Albers
Leaf Study IV c.1940
Two leaves mounted on layered, coloured paper
47.2 x 57.1 cm
The Josef and Anni Albers Foundation

90
Josef Albers
in open air 1936
Oil on Masonite
50.5 x 45.1 cm
The Josef and Anni Albers Foundation

91
Josef Albers
Penetrating (B) 1943
Oil, casein and tempera on Masonite
54.3 x 63.2 cm
Solomon R. Guggenheim Museum, New York

92
Josef Albers
Equal and Unequal 1939
Oil on Masonite
48.3 x 101.6 cm
The Josef and Anni Albers Foundation

93
Josef Albers
Repetition Against Blue 1943
Oil on Masonite
40 x 78.7 cm
Tate. Presented by The Josef and Anni Albers
Foundation 2006

94
Josef Albers
Structural Constellation, Transformation of a Scheme
No.23 1951
Machine-engraved Vinylite mounted on board
43.2 x 57.1 cm
The Josef and Anni Albers Foundation

95
Josef Albers
*Structural Constellation, Transformation of a Scheme
No.12* 1950
Machine-engraved Vinylite mounted on board
43.2 x 57.1 cm
Tate. Presented by The Josef and Anni Albers
Foundation 2006

96
Josef Albers
Structural Constellation, Twisted but Straight 1948
Machine-engraved Vinylite mounted on board
33.6 x 62.2 cm
The Josef and Anni Albers Foundation

97
László Moholy-Nagy
CH X 1939
Oil on canvas
76 x 96.5 cm
Private Collection, courtesy Annely Juda Fine Art,
London

98
László Moholy-Nagy
SRbO 1 1936
Oil on Bakelite laid on the artist's painted
blackboard
79.2 x 64.3 cm
Galerie Berinson, Berlin/ Ubu Gallery, New York

99
László Moholy-Nagy
CH 4 1938
Oil on canvas
68.5 x 89 cm
Collection of Hattula Moholy-Nagy

100
László Moholy-Nagy
Untitled 1941
Photogram
36.2 x 28 cm
Musée national d'art moderne, Centre Pompidou,
Paris

101
László Moholy-Nagy
Leda and the Swan 1946
Plexiglas
55.9 x 41.3 x 40 cm
IVAM, Instituto Valenciano de Arte Moderno,
Generalitat Valenciana

102
László Moholy-Nagy
CH For Y Space Modulator 1942
Oil on yellow Formica
152 x 60 cm
Collection Hattula Moholy-Nagy

103
László Moholy-Nagy
CH for R1 Space Modulator 1942
Oil on red Formica
152.5 x 60 cm
Collection Hattula Moholy-Nagy

104
László Moholy-Nagy
Composition CH B3 1941
Oil on canvas
131 x 208 cm
Private Collection, Switzerland

105
László Moholy-Nagy
Study with Pins and Ribbons 1937–8
Colour print, assembly (Vivex) process
34.9 x 26.5 cm
Courtesy of George Eastman House. Gift of Walter
Clark

106
Untitled 1937–46
Six 35mm Kodachrome Slides
Courtesy Hattula Moholy-Nagy

107
László Moholy-Nagy
Untitled 1946
Pencil and crayon on paper
28 x 21.5 cm
Collection Hattula Moholy-Nagy

108
László Moholy-Nagy
Untitled 1946
Pencil and crayon on paper
21.5 x 28 cm
Collection Hattula Moholy-Nagy

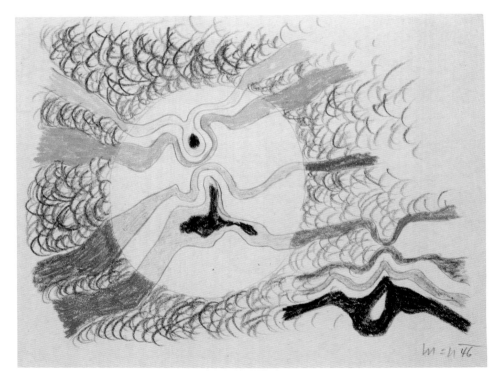

109
László Moholy-Nagy
Untitled 1946
Oil on Plexiglas
22.2 x 45.4 x 7.6 cm
Whitney Museum of American Art, New York, Gift
of Mr and Mrs Marcel Breuer

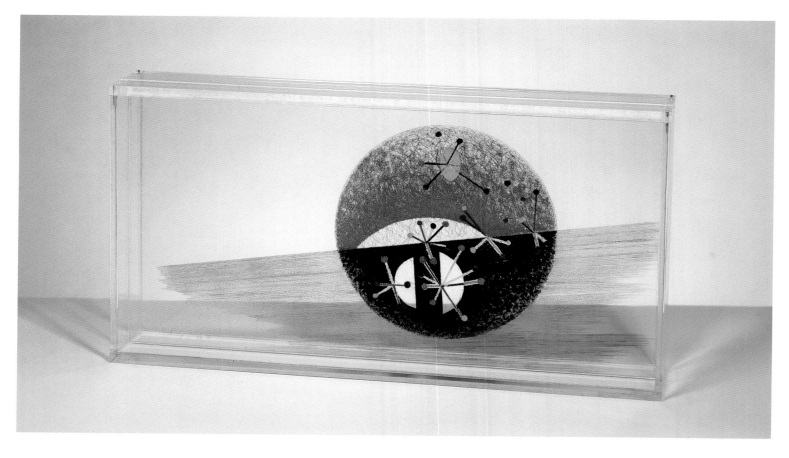

110
László Moholy-Nagy
Nuclear II 1946
Oil on canvas
130.2 x 130.2 cm
Milwaukee Art Museum, Gift of Kenneth Parker

111
László Moholy-Nagy
Nuclear I, CH 1945
Oil on canvas
96.5 x 76.2 cm
The Art Institute of Chicago, Gift of Mr and Mrs Leigh B. Block

112
Josef Albers
Variant 1948–52
Oil on Masonite
62 x 81 cm
Josef Albers Museum, Bottrop

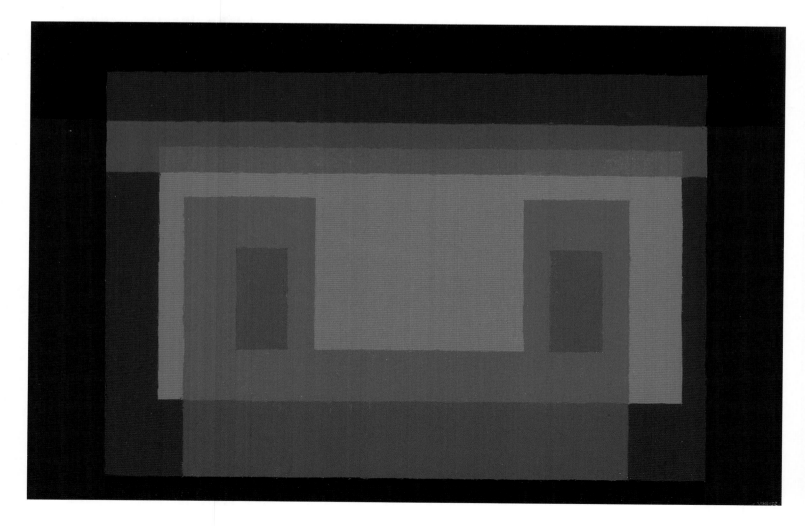

113
Josef Albers
Adobe (Variant): Luminous Day 1947–52
Oil on Masonite
28 x 54.6 cm
The Josef and Anni Albers Foundation

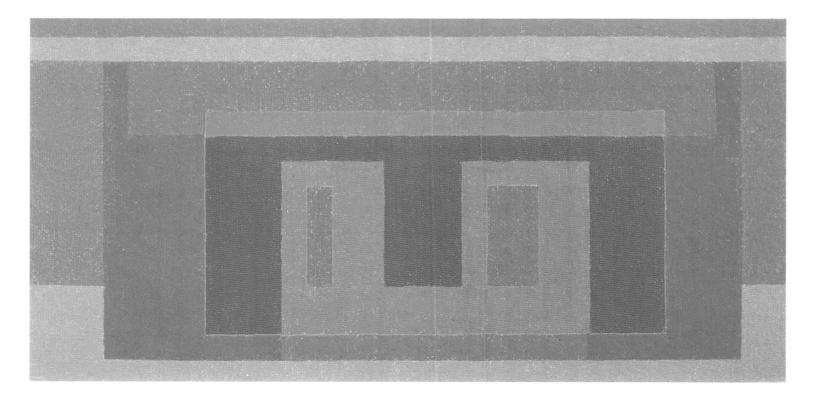

114
Josef Albers
Homage to the Square: Study for Nocturne 1951
Oil on Masonite
53.3 x 53.3 cm
Tate. Presented by The Josef and Anni Albers
Foundation 2006

115
Josef Albers
Homage to the Square 1951–5
Oil on Masonite
61 x 61 cm
Los Angeles County Museum of Art, Gift of Mrs
Anni Albers and the Josef Albers Foundation

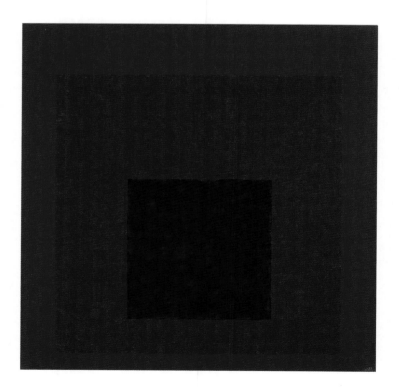

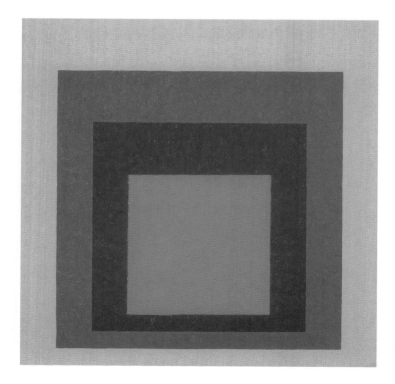

116
Josef Albers
Study for Homage to the Square: Light Rising 1950
Oil on Masonite
81.6 x 81.9 cm
National Gallery of Art, Washington, Robert and
Jane Meyerhoff Collection

117
Josef Albers
Homage to the Square: Dissolving/Vanishing 1951
Oil on Masonite
60.7 x 60.7 cm
Los Angeles County Museum of Art, Gift of Mrs
Anni Albers and the Josef Albers Foundation

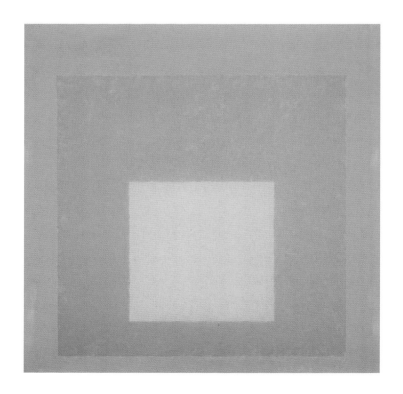

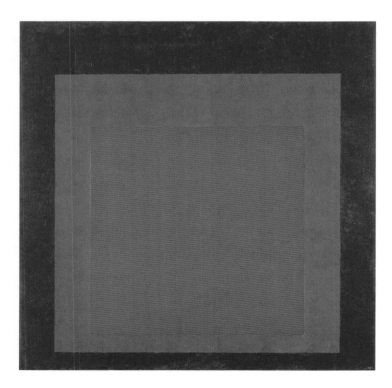

118
Josef Albers
Study for Homage to the Square: Far in Far 1965
Oil on Masonite
61 x 61 cm
The Josef and Anni Albers Foundation

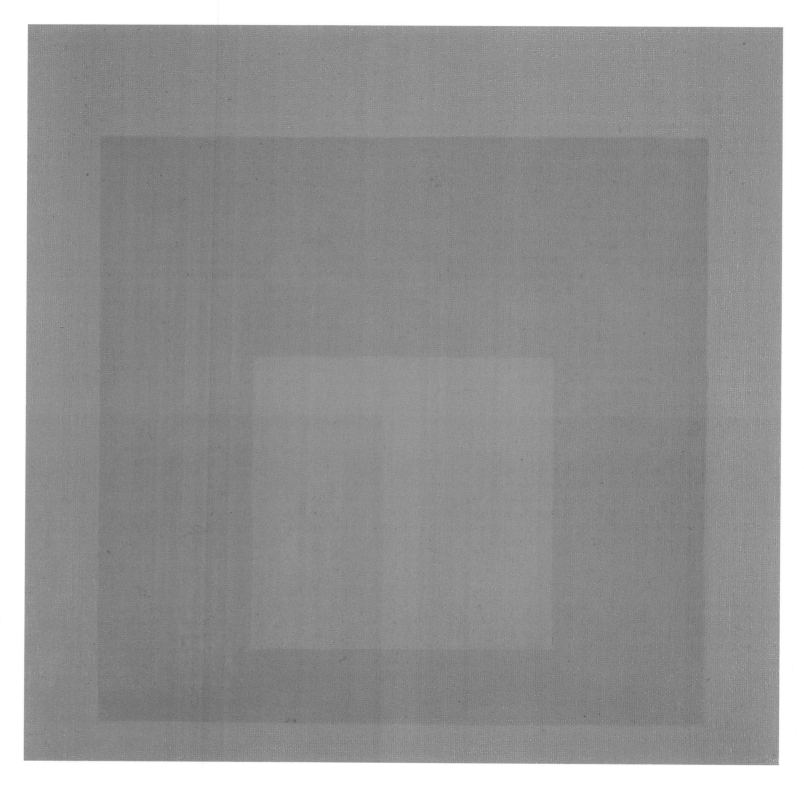

119
Josef Albers
Study for Homage to the Square 1968
Oil on Masonite
61 x 61 cm
The Josef and Anni Albers Foundation

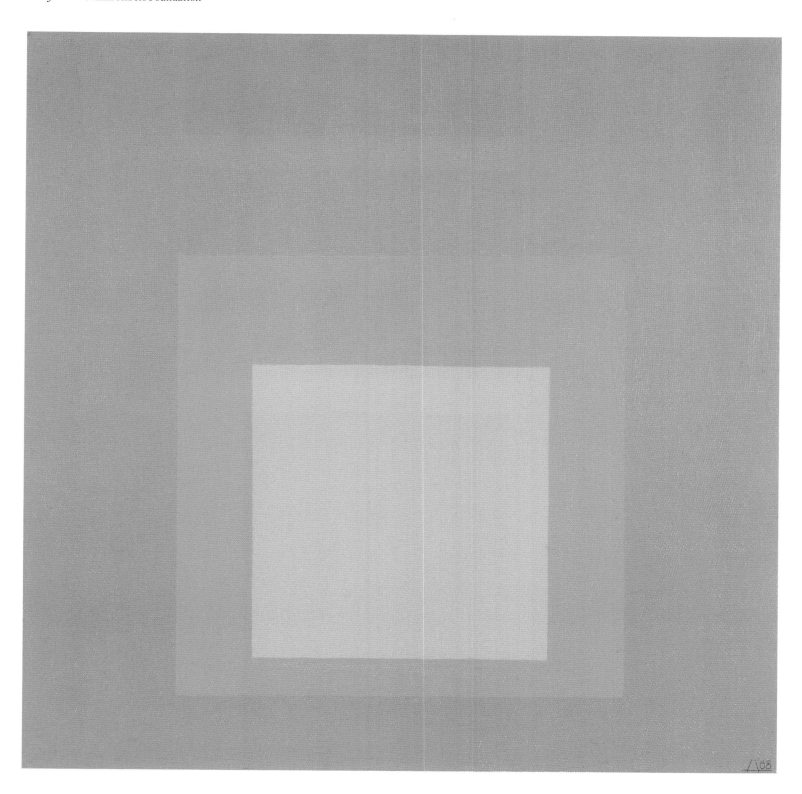

120
Josef Albers
With All Best Wishes for '43 1942
Postcard with hand-painted alterations
8.9 x 13.7 cm
The Josef and Anni Albers Foundation

121
Josef Albers
Merry Christmas + Happy New Year 1941
Postcard with hand-painted alterations
8.9 x 13.7 cm
The Josef and Anni Albers Foundation

122
Josef Albers
Illustration from *Interaction of Color* 1963
33 x 50.8 cm
The Josef and Anni Albers Foundation

ARTISTS' WRITINGS

Selected by Maeve Polkinhorn

JOSEF ALBERS

Calm down
what happens
happens mostly
without you

Poems and Drawings, New Haven 1958, {p.21}

HISTORICAL OR CONTEMPORARY

The youth of today is aware of the false direction: that further stress on singularity in education produces unbearable fragmentation and inhibits production.

We cannot bring the dead back to life. What has been chewed cannot be eaten again, what has been said does not simply belong to us. We must find a form appropriate to ourselves. Taking inspiration from the good old days, delighting in them, learning from them, is good. But to do so exclusively that is to forget oneself. Singing nothing but *Minnelieder* also obliges you to use clay rather than soap or not wash yourself at all. [...]
Liberation from the gloom of individuality and from taught knowledge can easily look like a levelling-out. But the risk is outweighed by an important result: unification. If we all wear the same clothes, it indicates that our houses and our other clothes do not have to be very different. (All ancient cultures had a type of house that formed unified streets and cities.) Most utility objects today are produced mechanically, in factories. We are on the way to improving the attitude to life through the extremely economical manufacture of utility objects that work well. In order to encourage this, school should allow a lot to be learned, which is to say that it should teach little. (Let everyone test out his possibilities in many different directions, so that he may find his proper place in active life.)

The Bauhaus wants to take a path in that direction. It has arisen out of the merger of a school of graphic arts and a school of arts and crafts. Its task was recently formulated in these terms:

The aim of the Bauhaus is to harmonise art education, hitherto isolated from practical life, with the demands of work in contemporary life.

To this end it has introduced into its education programme the unity of theoretical training and workshop work, which is to be cultivated in reference to the technical industrial working method of the present day. From the point of view that many isolated specialist professions or creative services, standing side by side, are finally directed towards building.

Thus the goal of the individual Bauhaus workshops is 'building' as a synthesis. We believe our attempts are not misguided when it comes to educating designers, and that our will to the simplest, clearest form will make human beings more united and life more real, which is to say more essential.

'Historisch oder jetzig?', *Junge Menschen* (Hamburg), no.8, November 1924, p.171. Special Bauhaus issue.

ON MY GLASS WALL PAINTINGS

these glass wall paintings represent a new kind of picture that is significantly determined by the material (glass) and its technical treatment (patterned cutting, double-layered sand-blasting).
here the glass is less like transparent window paintings, as before, and more like opaque panel paintings.
they are not assembled, but are single-pane pictures of opaque milk glass, with coloured (in this case mostly black) double layer (a very thin glass overlay).
a precise, sharp contour and surface edge are technically produced. this requires clear composition, very exact drawing and precise cutting.
the brittleness of the material and the colour, which cannot be modulated, limit the range of shapes, but also provide a special colour intensity, including the deepest black and the purest white, as well as a particular charm in terms of form and material.
appearance, substance and treatment of the material receive intense consideration in areas of civilisation with interests in construction. our own age, with its interest in technology, clearly displays this interest in 'material', like the gothic age in this respect. in the design of the works, combination then becomes as important as composition.
the fact that the double-layered paintings are produced according to a precise method generates the possibility of repeating them precisely. consequently the paintings need not remain unique. here, as in graphic art or plastic moulds, the larger edition will reduce the costs of manufacture, and avert the snobbish interest in the unique single work.

'zu meinen glas-wandbildern' *a bis z: Organ der Gruppe progressiver Künstler* (Cologne), vol.3, no.30, February 1933, p.117.

TEACHING FORM THROUGH PRACTICE

in the experimental results supposed innovations in application or treatment are often recognised in retrospect as already existing procedures. but the result is experienced and owned, because learned and not taught.

learning is better, because more intensive, than teaching: the more that is taught the less can be learned.[1]

1 This method should not be applied to pure areas of knowledge.

we know that education through learning travels further along the paths it takes, including detours and false turnings. but the beginning of everything does not lead straight on. and errors acknowledged encourage progress. deliberate detours and controlled errors sharpen criticism, point the way to more intelligent directions through mistakes, and produce the will to achieve things that are better and more correct.

experiences from handicraft are often more easily passed on from pupil to fellow-pupil than by the older, more remote teacher. for that reason the results are examined in shared discussion and responsibly communicated. this gives rise to the adoption of separate, but neighbouring and simultaneously related experiences.

the more different relationships arise and the more intense they are, the more the elements increase, the more valuable is the result, and the more generous the work. this emphasises one chief element of education: economy. economy in the sense of thrift in relation to expense (material and labour) and the most effective of exploitation.

the activation of negatives (residual, intermediate and minus values) is perhaps the only entirely new, perhaps the most important element in contemporary formal innovation, but this has gone unnoticed by many – it hasn't been much discussed – because the sociological parallels are not noticed. (closer examination of this chapter commands here and elsewhere to perceive the opportunity to examine the sociological reasons for the form aspired to in the present day.) taking the positives and negatives equally into account and assessing them evenly leaves nothing 'over'. we no longer significantly distinguish between bearing and borne, we no longer divide between serving and served, decorating and decorated. each element or structural member must be effective both as helper and helped, supporting and supported. thus pedestal and frame fade away, and with them the monument that bears, on an abundance of substructure, a dearth of substance borne.

individualism is not primarily a school matter. because individualism stresses isolation; while the school's task is to align the individual with contemporary events, with society (state, profession, economy). the nurturing of the individual is the task of the individual, not of collective enterprises such as the school. the school should nurture the individual *passively*, without disturbing personal development. let us ask how many personalities exist! we must number *types* in the majority. sociological economy must reject the personality cult of existing educational practice: productive individuality asserts itself without and against education.

in short, the inductive educational method propagated here seeks to achieve responsibility and discipline – with regard to itself, to material and to labour – and to pass on to the learner the knowledge required for his choice of profession about the areas of labour and material that most closely reflect his requirements. [...] it strives towards training in movement on the broadest possible foundation, which will not leave later professional specialisation isolated. it leads to economic form. this practical form of study is deliberately set against the idea of apprenticeship in an industrial school, in which craftsman-like skill is supposed to be 'taught'. where a bit of carpentry, a bit of book-binding, a bit of dressmaking goes on, and sawing and planing (the most difficult aspect of carpentry) and filing and hammering, and gluing and sticking, remains unproductive because it only satisfies the drive towards occupation, not the need for design.

as pupils and teachers we must learn together, with and from each other, as pupils and teachers (in competition, which elevates), otherwise education is both a thankless task and bad business.

'Werklicher Formunterricht', *Bauhaus: Zeitschrift für Gestaltung* (Dessau), no. 2/3, 1928, pp.3–7.

<center>* * *</center>

When I paint and construct
I try to develop visual articulation

I do not think then – about abstraction
and just as little – about expression

I do not look for isms
and not at momentary fashion

I see
that art essentially is purpose
and seeing (schauen)
that form demands
multiple presentation
manifold performance

I do not see
that forced individualism
or forced exaltation
are the source
of convincing formulation
of lasting meaning

In my work
I am content to compete
with myself
and to search with simple palette
and with simple color
for manifold instrumentation

So I dare further variants

Published in *Josef Albers at The Metropolitan Museum of Art: An Exhibition of his Paintings and Prints*, exh. cat., The Metropolitan Museum of Art, New York, 1971, p.1.

PHOTOS AS PHOTOGRAPHY AND PHOTOS AS ART

I suppose some of you have seen the advertisement of commercial photo dealers saying 'You push the button and we do the rest'. This promotes a taking of pictures with the least care possible. Such a way of looking at photography, I believe, is of the lowest level possible and should not be our way of approaching and understanding photography.

Photography is first a handicraft. It can also be art. It can produce works of art as any

handicraft does, if the product represents a significant expression of the mentality of a period or an individual. Because such demonstrations reveal and evoke emotional participation, or, in other words, give us an aesthetic experience, pre-supposed that we are sensitive enough for it.

[…]

Photography, though very young, and suffering together with industry, from children's diseases, continues to have better prospects than most of the older crafts. The danger of industrialization is taken away from it by the mass production of the press, and a degeneration toward a repair shop is outside of its nature. Though young, photography has already developed a large number of specialized branches and gained the attention of all who can read as well as of those unable to decipher letters.

As an international and inter-linguistic means of communication it has conquered the attention of all.

Photography seems to work so simply and particularly so quickly that some people believe it cannot be of great value. Well, is a doctor when he just with one cut achieves what he wants to achieve, or, are Chinese drawings which are done obviously in a few minutes not good because they are done in such a short time?

Here as there the discovery or selection and the way of using the means count. Also here the ability to select is the result of vision or of long preparatory study.

Furthermore, photographs, being on the one hand an immediate and often instantaneous record of the external world, and, having on the other hand no way to show a personal handwriting at the surface of the picture, seem to be impersonal.

It is true, the photographer does not betray his personality as much by craftsmanship as by the intensity of his vision. The absence of facture and draftsmanship as marks of the individual hand seem to be a loss. But it is a gain as it enables us to grasp the vision of the photographer in the most direct and immediate way.

Photographs reveal the individuality of the photographer if we as spectators are able to read it. Just as the unmusical ear is not competent to judge music, so it is like-wise with pictures, whether they are paintings, drawings or photos. Only a sensitive and trained eye gives us the right to judge, as it gives us a deeper reading and enjoyment.

It belongs, I believe, to education to get beyond the point of mere likes and dislikes.

Unpublished lecture by Josef Albers preserved in The Josef and Anni Albers Foundation. Delivered by Albers at Black Mountain College on February 24, 1943.

LÁSZLÓ MOHOLY-NAGY

LIGHT: A MEDIUM OF PLASTIC EXPRESSION

Since the discovery of photography virtually nothing new has been found as far as the principles and technique of the process are concerned. All innovations are based on the esthetic representative conceptions existing in Daguerre's time (about 1830), although these conceptions, i.e., the copying of nature by means of the photographic camera and the mechanical reproduction of perspective, have been rendered obsolete by the work of modern artists.

Despite the obvious fact that the *sensitivity to light* of a chemically prepared surface (of

glass, metal, paper, etc.) was the most important element in the photographic process, i.e., containing its own laws, the sensitized surface was always subjected to the demands of a *camera obscura* adjusted to the traditional laws of perspective while the full possibilities of this combination were never sufficiently tested.

The proper utilization of the plate itself would have brought to light phenomena imperceptible to the human eye and made visible only by means of photographic apparatus, thus perfecting the eye by means of photography. True, this principle has already been applied in certain scientific experiments, as in the study of motion (walking, leaping, galloping) and zoological and mineral forms, but these have always been isolated efforts whose results could not be compared or related.

It must be noted here that our intellectual experience complements spatially and formally the optical phenomena perceived by the eye and renders them into a comprehensible whole, whereas the photographic apparatus reproduces the purely optical picture (distortion, bad drawing, foreshortening).

One way of exploring this field is to investigate and apply various chemical mixtures which produce light effects imperceptible to the eye (such as electro-magnetic rays, X-rays).

Another way is by the construction of new apparatus, first by the use of the *camera obscura*; second by the elimination of perspective. In the first case using apparatus with lenses and mirror-arrangements which can cover their environment from all sides; in the second case, using an apparatus which is based on new optical laws. This last leads to the possibility of 'light-composition,' whereby light would be controlled as a new plastic medium, just as color in painting and tone in music.

This signifies a perfectly new medium of expression whose novelty offers an undreamed of scope. The possibilities of this medium of composition become greater as we proceed from static representation to the motion pictures of cinematograph.

I have made a few primitive attempts in this direction, whose initial results, however, point to the most positive discoveries (and as soon as these attempts can be tested experimentally in a laboratory especially devised for the purpose, the results are certain to be far more impressive).

Instead of having a plate which is sensitive to light react mechanically to its environment through the reflection or absorption of light, I have attempted to *control* its action by means of lenses and mirrors, by light passed through fluids like water, oil, acids, crystal, metal, glass, tissue, etc. This means that the filtered, reflected or refracted light is directed upon a screen and then photographed. Or again, the light-effect can be thrown directly on the sensitive plate itself, instead of upon a screen. (Photography without apparatus.) Since these light effects almost always show themselves in motion, it is clear that the process reaches its highest development in the film.

From *Broom*, IV, 1923. Reprinted in Richard Kostelanetz (ed.), *Moholy-Nagy: An Anthology*, New York 1970, pp.117–18.

IN ANSWER TO YOUR INTERVIEW

1 What should you most like to do, to know, to be? (In case you are not satisfied.)
2 Why wouldn't you change places with any other human being?
3 What do you look forward to?
4 What do you fear from the future?
5 What has been the happiest moment of your life? The unhappiest? (If you care to tell.)
6 What do you consider your weakest characteristic? Your strongest? What do you like most about yourself? Dislike most?
7 What things do you really like? Dislike? (Nature, people, ideas, objects, etc. Answer in a phrase or a page, as you will.)
8 What is your attitude toward art today?
9 What is your world view? (Are you a reasonable being in a reasonable scheme?)
10 Why do you go on living?

When I was a school-boy, in the Latin hour, we used to pass around secretly a 'confession-book' ... in it each one had to answer truthfully certain questions. The most important questions were usually the following:

> Do you believe that friendship can exist between man and woman?
> Are you in love?
> Where did you meet her?

Each chose for this purpose a pseudonym: Apollo, Hephaistos, 'Lederstrumpf' – 'Dowegofarther' was chosen by one.
In that confession-book we all lied in chorus.
This memory still makes me happy; the world is a ball; the questions of the confession-book again roll around to me. I shall rise to my heights – a chance to lie. One thing however I know today better than in my school-days; if I now wish to lie, it is because I am still unripe.

1 I am a Hungarian and besides Hungarian I know only German. But I should like to know French, English, Italian and Spanish. Then I should be at home everywhere.
2 When I was a child I thought that I was a king's son, who had been exchanged for another, but who later would come into his own. Today I know that one is what one is ... chicken stays chicken ... I am satisfied with my fate. More, I am happy to be as I am. What could I do if I were better than I am? My failings give me impetus in the fight, they sharpen my effort.
3 What do I expect? That some time I will be able to comprehend society, social relations, the relation of individual to the mass better than I do today. Till now I have been guided in this largely by my feelings. But this feeling is much duller today than formerly, when I really had pangs of conscience if I took a good drink or rode in an automobile.
4 Subjective! That out of gratitude, out of mistaken kindness, I can be forced to make concessions. I know the feeling of being good out of weakness: to let things drag on, in order not to give pain to another, although that other has long since known that all was ended.
 Objective! That men will again make war instead of working on themselves.
5 I was still a small boy when a friend pressed into my hand a paper in which my first printed poem appeared – I am in general quite happy; but when one wishes really

to get at something, has it been that childish ambition or an incident of the war? That is a whole novel, but I will make it short: It was in a retreat, after a never-ending march over soaked ground, mud to the knees, face beaten by wind and hail, half blind, every step more falling than advancing, I could go no farther. I was left behind in the dark, on the open field alone, without strength. Suddenly my horse appeared: I wept and kissed him overcome with joy.

I have never, strictly speaking been deeply unhappy. Of course I have been very, very sad, once when I was able to overcome my jealousy through the recognition of it.

6 It is difficult for me to make up my mind not to want to please everyone. My strongest characteristic: that I am optimistic. I like most about myself that I can be happy; the least; that I have a tendency to become a fanatic.

7 To be clean inside and out. I like least, people who cannot stand me.

8 I do not believe so much in art as in mankind. Every man reveals himself; much of it is art.

9 I find the actual world scheme, in respect of the social system, most incomprehensible and gruesome. I have slowly formed the opinion that, seen in perspective, everything develops organically. This does not necessarily mean that one can accept the present system without opposition.

10 I live because it makes me enormously happy to live.

Originally published in *The Little Review*, vol.12, May 1929, p.2. Reprinted in Krisztina Passuth, *Moholy-Nagy*, London 1985, pp.403–4.

DESIGNING IS NOT A PROFESSION BUT AN ATTITUDE

Design has many connotations. It is the organization of materials and processes in the most productive, economic way, in a harmonious balance of all elements necessary for a certain function. It is not a matter of façade, of mere external appearance; rather it is the essence of products and institutions, penetrating and comprehensive. Designing is a complex and intricate task. It is integration of technological, social and economic requirements, biological necessities, and the psychophysical effects of materials, shape, color, volume, and space: thinking in relationships. The designer must see the periphery as well as the core, the immediate and the ultimate, at least in the biological sense. He must anchor his special job in the complex whole. The designer must be trained not only in the use of materials and various skills, but also in appreciation of organic functions and planning. He must know that design is indivisible, that the internal and external characteristics of a dish, a chair, a table, a machine, painting, sculpture are not to be separated. The idea of design and the profession of the designer has to be transformed from the notion of a specialist function into a generally valid attitude of resourcefulness and inventiveness which allows projects to be seen not in isolation but in relationship with the need of the individual and the community. One cannot simply lift out any subject matter from the complexity of life and try to handle it as an independent unit.

There is design in organization of emotional experiences, in family life, in labor relations, in city planning, in working together as civilized human beings. Ultimately all problems of design merge into one great problem: 'design for life'. In a healthy society this design for life will encourage every profession and vocation to play its part since the degree of relatedness in all their work gives to any civilization its quality.

This implies that it is desirable that everyone should solve his special task with the wide scope of a true "designer" with the new urge to integrated relationships. It further implies that there is no hierarchy of the arts, painting photography, music, poetry, sculpture, architecture, nor of any other fields such as industrial design. They are equally valid departures toward the fusion of function and content in 'design.'

László Moholy-Nagy, *Vision in Motion*, Chicago 1947, p.42.

THE FUNCTION OF ART

Art is the most complex, vitalizing and civilizing of human actions. Thus it is of biological necessity. Art sensitizes man to the best that is immanent in him through an intensified expression involving many layers of experience. Out of them art forms a unified manifestation, like dreams which are composed of the most diverse source material subconsciously crystallized. It tries to produce a balance of the social, intellectual and emotional existence; a synthesis of attitudes and opinions, fears and hopes.

Art has two faces, the biological and the social, the one toward the individual and the other toward the group. By expressing fundamental validities and common problems, art can produce a feeling of coherence. This is its social function which leads to a cultural synthesis as well as to a continuation of human civilization.[1]

Today, lacking the patterning and refinement of emotional impulses through the arts, uncontrolled, inarticulate and brutally destructive ways of release have become commonplace. Unused energies, subconscious frustrations, create the psychopathic borderline cases of neurosis. Art as expression of the individual can be a remedy of sublimation of aggressive impulses. Art educates the receptive faculties and it revitalises the creative abilities. In this way art is rehabilitation therapy through which confidence in one's creative abilities can be restored.

László Moholy-Nagy, *Vision in Motion*, Chicago 1947, p.28.

1 'Culture' and 'civilization' are used in this book as synonyms, though in German, for instance, a differentiation is made between the two: 'civilization' is the term of the technological and 'culture' for the humanistic sphere.

CHRONOLOGY

Jacob Dabrowski and Maeve Polkinhorn

	ALBERS	MOHOLY-NAGY
1888	Born 19 March in Bottrop, Westphalia, Germany.	
1895		Born 20 July in Borsod, later Bácsborsód, Southern Hungary
1905		Begins secondary school in Szeged.
1905–8	Attends teachers college in Büren and receives teacher's certificate.	
1908	Sees works by Cézanne and Matisse for first time, in Folkwang Museum, Essen.	
1908–13	Teaches in an elementary school for Westphalian regional educational system.	
1911		Publication of some early poems in Szeged daily newspapers.
1913		Graduates from secondary school. Moves to Budapest, where he enrols as law student at Royal Hungarian University of Sciences.
1913–15	Attends Royal Art School, Berlin, and qualifies as art teacher. Visits Berlin museums and galleries. Executes first figurative oils and makes many drawings, some reminiscent of Albrecht Dürer.	
1915		Called into Austro-Hungarian army, serves on Italian and Russian fronts as artillery officer. Executes drawings (many on postcards) and watercolours documenting war experience.
1916–18	Attends part-time classes at the School of Applied Arts, Essen, where he studies under Johan Thorn Prikker, known for his stained-glass windows. Executes first lithographs, blockprints and figurative drawings, including self-portraits. Begins independent work in stained glass. Influenced by Cubism and Expressionism, his work at this time is characterised by its economy of line	
1917	Completes first commission, a stained-glass window *Rosa mystica ora pro nobis* for St Michael's Church in Bottrop (later destroyed).	Wounded on Russian front, recovers in military hospital in Budapest, where he ontinues to execute drawings related to war trauma. Takes an interest in photography and shows an early interest in light as a life principle, as seen in his poem *Lichtvisionen*.
1918		After being discharged from army, abandons law studies to become an artist. Attends free evening classes in life drawing in Budapest. Exhibits for first time at National Salon, Budapest. Makes contact with avant-garde artists around journal *MA* (Today).

	ALBERS	**MOHOLY-NAGY**
1919 April: the Bauhaus opens in Weimar under Walter Gropius	Begins study in Munich at Bavarian Academy of Art under Franz von Stuck, with whom his future Bauhaus-colleagues Paul Klee and Vassily Kandinsky had studied ten years earlier. Attends Max Doerner's course in painting technique.	March: Exhibits in Budapest. August: Moves back to Szeged. November: Exhibits in Szeged. Towards end of year leaves Hungary for Vienna.
1920	Spring: Starts 'all over again' by enrolling in the Bauhaus. Attends the preliminary course (*Vorkurs*) under Johannes Itten, while pursuing his own work with glass. From this point on, all his art, except photography and functional design, is abstract.	After short stay in Vienna, arrives in Berlin. April: Meets journalist and photographer Lucia Schulz. Autumn: Shows works for first time on the international art scene in group exhibition at Fritz Gurlitt Gallery, Berlin. First encounter with Dada, meeting Kurt Schwitters, Hannah Höch and Raoul Hausmann; also makes contact with the Der Sturm gallery. Development of material collages and abstract paintings, such as the *Glasarchitektur-Bilder* (Glass architecture pictures).
1921	Begins work on the *Scherbenbilder* (Shard pictures), assemblages made from found glass pieces.	January: Marries Lucia Schulz. Engages in the development of Constructivist aesthetics: claiming 'Constructivism is the Socialism of Looking'. Russian avant-garde views on social relevance of art meet Moholy's concerns regarding pursuing art as a private activity. Sees technology as the domineering principle of the century. April: Made Berlin representative of *MA*, holding the post for four years. With Raoul Hausmann, Hans Arp and Ivan Puni signs 'Aufruf zur Elementaren Kunst' (Manifesto of Elemental Art), published in *De Stijl* late in the year. The Manifesto aims to free art from any alliance with a political programme, instead advocating expression of inner values shaped by forces of contemporary life.
1922	Appointed 'journeyman' at the Bauhaus, he is placed in charge of the Bauhaus glass workshop, which he reorganises. Designs and executes windows for the Bauhaus director's office in Weimar and for houses designed by Walter Gropius and Adolf Meyer in Berlin. In the furniture workshop, designs table and bookshelf for reception room of Gropius's office. Meets Anneliese Fleischmann (Anni), a weaving student at Bauhaus.	February: With László Peri exhibits at Galerie Der Sturm. With Lajos Kassak publishes *Buch neuer Künstler*, an anthology of modern art and poetry. Creates so called *'Telephone Paintings'*. Meets Gropius, who visits his exhibition at Galerie Der Sturm. May: Attends Dadaist and Constructivist conference in Weimar, part of First International Congress of Progressive Artists, Düsseldorf. Begins to experiment with photograms: camera-free photography. Begins work on simple sculptures made from wood, glass and reflective metal components. Together with Alfred Kemény writes manifesto 'Dynamisch-konstuktives Kraftsystem' (Constructive System of Forces), published in journal *Der Sturm* in December.
1923 August–September: Bauhaus exhibition in Weimar	February: Invited by Gropius to conduct Preliminary Course in material and design studies together with Mohoy-Nagy. Albers is the first ex-student to be appointed as a teacher. Executes stained-glass window for the Grassi Museum, Leipzig (destroyed 1944). Designs display cabinets to be used in first official Bauhaus exhibition.	February: Second exhibition at Der Sturm together with László Peri. March: Appointed by Gropius with Albers as Itten's successors to run Premilinary Course at Bauhaus. Takes over metal workshop from Paul Klee. Many view Moholy's appointment as paradigmatic of Bauhaus's shift from crafts to industry-inspired aesthetics.
1924 26 December: Due to pressure of nationalists from the Thuringian Parliament, Gropius announces that the Bauhaus in Weimar will be closed with effect from end of March 1925	Completes stained-glass commission for Ullstein Publishing House, Berlin (later destroyed). Publication of his first essay, 'Historisch Oder Jetzig'. It appears in a special Bauhaus issue of the Hamburg periodical *Junge Menschen*.	February: with Hugo Scheiber exhibits at Der Sturm; five *Telephone Paintings* included. Starts work with Gropius on series of fourteen Bauhaus books.

	ALBERS	MOHOLY-NAGY
1925 April: the Bauhaus moves to Dessau	Glass workshop is dissolved, since its emphasis on individual craftsmanship does not correspond with the Bauhaus's new focus on mass-production design. Continues to work with glass and develops sandblasted flashed glass technique. May: Marries Anneliese Fleischmann. They travel to Italy on their honeymoon. Albers is appointed a Bauhaus Master, responsible for teaching first semester of Preliminary Course.	March: Moholy's final exhibition at Der Sturm. Publication of first of the Bauhaus Books (Bauhausbücher). Moholy designs eleven out of fourteen volumes and authors three: volume four (together with Farkas Molnár and Oskar Schlemmer) *Die Bühne im Bauhaus* (The Bauhaus Stage); volume eight *Malerei, Fotografie, Film* (Painting, Photography, Film) and volume fourteen *Von Material zu Architektur* (From Material to Architecture).
1926 4 December: New Bauhaus building designed by Gropius inaugurated	Designs upholstered bentwood chair, glass and metal household objects and a universal typeface. Commissioned to design furniture for Berlin apartment of Drs. Fritz and Anna Moellenhoff.	Shows works in *Deutsche Photographische Ausstellung* (German photographic exhibition) and in the Abstract Section of the Experimental Art show at Kronprinzenpalais, Berlin. Also included in Sociéte Anonyme exhibition at Brooklyn Museum, New York.
1927		January: Becomes Film and Photography Editor for newly launched Dutch journal *i10*. Socialist Hannes Meyer appointed Professor of Architecture at the Bauhaus. Moholy falls out with Meyer, who subordinates artistic creativity to science and technology.
1928 3 February: Gropius resigns. 1 April: Hannes Meyer appointed as New Director of Bauhaus.	Following Moholy-Nagy's resignation Albers takes over responsibility of teaching entire Preliminary Course. He also heads the Bauhaus furniture workshop after the departure of Marcel Breuer. Creates the dismountable *Armlehnstuhl Ti 144* in bentwood, which goes into serial production. Lectures at International Congress for Art Education, Prague. Publication in *Bauhaus* journal of 'Werklicher Formunterricht', seimnal article outlining his view on educational philosophy and methods.	January 17: Resigns from Bauhaus, together with Marcel Breuer and Herbert Bayer. Moves to Berlin, where he sets up a commercial design office. With considerable success creates stage and costume designs until 1933.
1929	Develops glass works further, introducing more complex optical patterns. Shows twenty glass works in exhibition of Bauhaus masters in Zurich and Basel. Takes over wallpaper-design workshop whilst its director, Hinnerk Scheper, is away in Moscow. Summer: Takes photographs documenting travels with Anni to Avignon, Geneva, Biarritz and Paris. August: Visits Barcelona where they see the International Exposition including the German Pavilion designed by Mies van der Rohe.	Separates with Lucia. Makes the film *Marseille Vieux Port*, one of seven surviving short films completed by 1937. Secures three-year design contract for cover design of fashion magazine *Die Neue Linie* (Leipzig/ Berlin). Publication of *Von Material zu Architektur*, his account of Bauhaus education, in Bauhaus Books series. Participates in Stuttgart Werkbund exhibition *Film und Foto*. Exhibits with Novembergruppe in Grosse Berliner Kunstausstellung. Autumn: Lectures on Bauhaus at Institute of Sciences, Bielefeld.
1930 Meyer resigns and moves to USSR; his successor is Mies van der Rohe.	Period of unrest at Bauhaus, following resignation of Meyer; students call for teachers such as Albers and Kandinsky to be replaced by teachers of economics, sociology and psychology. Albers appointed Assistant Director of Bauhaus. Summer: Travels with Anni through Italy and Spain, taking photographs along the way.	Spring: Meets J.G. Crowther, Science correspondent for *The Manchester Guardian* in Berlin. Together with Gropius and Bayer, organises German section of *20e Salon des Artistes Décorateurs Français* at Grand Palais in Paris. Shows for first time his kinetic sculpture, *Light Prop for an Electric Stage*, developed in collaboration with architect Stephan Sebök and sponsored by Berliner AEG. This sculpture is the subject of his best-known film, *Light Play: Black-White-Grey* Publication by Franz Roh of *60 Photos*, a book on Moholy's photographic works. Participates in numerous exhibitions across Europe, in Munich, Budapest, Stockholm and Amsterdam. 1930–6: Spends part of each summer at the Maison des Artistes at La Sarraz, Switzerland, an annual gathering of international artists.

	ALBERS	MOHOLY-NAGY
1931	Designs furnishings for a hotel living-room for Berlin Building Exhibition. Begins his first sustained serial work, the *Treble Clef* gouaches.	Creates the exhibition design with Bayer for *Deutsche Bundesausstellung.* Photography is exhibited for first time in the US at Delphic Studios, New York Winter: Meets Sibylle Pietzsch in Berlin. Makes his first documentary film *Berliner Stilleben.*
1932 Due to political pressure the Bauhaus is moved to Berlin.	First solo exhibition at the Bauhaus.	*Von Material zu Architektur* published in the US as *The New Vision.* Makes contact with Abstract Création group in Paris, founded by Theo van Doesburg in 1931; meets Ben Nicholson. Shows works *Surrealism* and *Modern European Photography*, both at Julien Levey Gallery, New York.
1933 Nazis seize power	July 20: the Bauhaus closes for good, with decision by faculty to dissolve. August: Edward M.M. Warburg in a letter to Barr: 'I cannot help but feel that getting Albers into this country would be a great feather in the cap of the Museum of Modern Art … With Albers over here we have the nucleuos [sic] of an American Bauhaus!' ('Exile', p.273) November: As a first member of the Bauhaus on recommendation of Philip Johnson (curator at the Museum of Modern Art) Anni and Josef emigrate to the US to take up teaching posts at Black Mountain College, North Carolina. The college had been founded only a few months earlier by iconoclast John Andrew Rice. 1933–4. Albers completes first series of abstract prints.	February: Exhibits his photographs with other artists at the George Walter Vincent Smith Art Gallery in Springfield, USA. Summer: Attends the fourth International Congress of Modern Architecture in Greece; makes the official documentary film of the Congress.
1934	Paints in oils for first time in many years. Gives three lectures at Lyceum Club, Havana, Cuba, travelling there with Black Mountain friends and colleagues Ted and Bobbie Dreier.	Moves to Amsterdam, where he runs a commercial design studio. August: Studies colour photographic process at Kodak, London. Begins to work with colour photography in advertising design. Autumn: Dutch Society for Arts and Crafts organises his one-man exhibition at the Stedelijk Museum, Amsterdam.
1935	The Alberses make the first of fourteen visits to Mexico and Latin America. Josef makes his first abstract oil paintings using unmixed paint straight from the tube.	May: Encouraged by Herbert Read, moves to London, where he works as an art adviser at Simpson's mens store, Piccadilly. Gropius also living in London. Meets Henry Moore and Barbara Hepworth and develops close friendship with Ben Nicholson. Works as a commercial artist with György Kepes and is commissioned to produce publicity material for Imperial Airways and London Transport. Films documentary *Lobsters.* Experiments with painting on transparent plastics and with shadows on a white background. He calls these paintings *Space Modulators.*
1936	Publishes *Art as Experience*: calls for artists to abandon scientific study and to experience the outdoors instead. 1936–40: Invited by Gropius, gives lectures and seminars at Graduate School of Design, Harvard University, Cambridge, Massachusetts. Produces series of spare abstract drawings.	Designs special effects for Alexander and Vincent Korda's film *Things to Come*, but these are not used in final version. Exhibits in numerous one-man and group exhibitions in the US, England and France. Travels for the last time to Hungary to visit his brother. Designs dust jackets and takes photographs for three books: *The Street Markets of London* by Mary Benedetta; *Eton Portrait* by Bernard Fergusson and *An Oxford University Chest* by John Betjeman. Made Honorary Member of Art Societies of Oxford and Cambridge and Design Institute, London

	ALBERS	MOHOLY-NAGY
1937	April: Participates in first *American Abstract Artists* exhibition at Squibb Galleries, New York.	Through Gropius, is appointed director of Design School in Chicago sponsored by 'Association of Art and Industries'. Moholy names it The New Bauhaus – American School of Design; the school opens in October. July: His work is included in *Degenerate Art* exhibition at Haus der Kunst, Munich.
1938 *Bauhaus 1919–28* exhibition at The Museum of Modern Art, New York		Initially enthusiastically welcomed, the New Bauhaus school closes in the summer due to financial problems. Has works included in *Bauhaus 1919–1928* at Museum of Modern Art, New York.
1939	Along with Anni becomes a US citizen. June: Travels to Mexico where he teaches at Gobers College, Tlalpan.	February: Using his earnings from commercial design, founds the School of Design in Chicago. His efforts are successful in convincing businessmen in Chicaco to lend financial support to the school or to donate equipment. Makes stationary and mobile sculptures of transparent plastic often combined with chromed metal.
1940	1940–2: Makes small drypoint etchings of meandering linear compositions, and the collages, *Leaf Studies*.	Participates in exhibitions in Chicago, New York and Oakland, California.
1941 December: the US enters World War II	Spends sabbatical year in New Mexico and Mexico. Spring: Teaches Basic Design and Color at Harvard University's Graduate School of Design. Begins work on *Graphic Tectonics* series, begun from a series of drawings made at Harvard and developed into zinc plate lithographs in North Carolina.	Faced with financial crisis due to war, arranges for the school to be designated a certified school for camouflage training and develops a rehabilitation course in art therapy for wounded soldiers. Continues to exhibit in Chicago and New York.
1943	Begins *Biconjugate* and *Kinetic* series.	Begins writing his last book *Vision in Motion*, the most comprehensive account of his teaching philosophy. The book is published posthumously in 1947.
1944		Name of the school changes to *Institute of Design*. Moholy is relieved to hand over control of the school's finances, publicity and administration to a Board of Directors so that he can devote his energies to his art, writings and teaching. Parker Pen Company appoint him as art adviser. Campaigns among Hungarian-Americans for re-election of President Franklin D. Roosevelt. Writes autobiographical essay, *Abstract of an Artist*
1945		Autumn: Diagnosed with leukemia but continues teaching, writing and producing artworks.
1946	Autumn: Spends sabbatical year in Mexico with Anni.	February: Contemporary Arts Society organises retrospective exhibition of his works at the Cincinnati Art Museum. Works prolifically, producing photograms, photographs, oil paintings, drawings, watercolours and sculptures in Perspex (Plexiglas) and metal. Also give seminars and attends conferences. April: Becomes American citizen November 24: Dies of leukemia in hospital in Chicago.
1947	In Mexico begins *Variant*, his largest painting series to date. Anticipates the *Homage to the Square* series, in its similar use of various colour schemes within a repeated simple geometric composition.	Posthumous publication of *Vision in Motion*. Spring: Memorial exhibition organised by Solomon R. Guggenheim Foundation at Museum of Non-Objective Art, New York, tours the US for two years.

1948	Elected member of Advisory Council of the School of the Arts, Yale University, New Haven. For first time after World War II exhibits in Germany, at Galerie Herbert Hermann, Stuttgart, with Hans Arp and Max Bill. October: Agrees to be rector of Black Mountain College.
1949	March: Resigns from Black Mountain College. Lectures at the University of Mexico until August. Moves to New York, where he teaches colour courses at Faculty Workshop as visiting Professor at Cincinnati Art Academy and at Pratt Institute. Begins *Structural Constellations* and over next twenty-five years executes them as drawings, prints and wall-reliefs. Makes first studies in black and white for *Homage to the Square* paintings.
1950	Begins *Homage to the Square* series, initially painting on smooth side of Masonite support. Serves as visiting critic, Yale University School of Art, and visiting professor, Graduate School of Design, Harvard. Appointed Chairman of Department of Design at Yale University. Moves with Anni to New Haven, Connecticut. Invited by Gropius, contributes brick reliefs for the interior of the new Harvard University Graduate Center.
1952	First solo exhibition at Sidney Janis Gallery, New York. Designs brick fireplaces for two Connecticut homes by Yale colleague, architect King Lui Wu.
1953	Lectures in Department of Architecture, Catholic University, Santiago, Chile, and at Institute of Technology, Lima, Peru.
1954	Visiting professor at Academy of Design, Ulm, Germany. Also teaches at University of Honolulu, Hawaii.
1956	Retrospective at Yale University Art Gallery. Named Professor of Art Emeritus, Yale.
1957	Receives Officer's Cross, Order of Merit. Exhibits at Galerie Denise René, Paris. Made Honorary Doctor of Fine Arts at University of Hartford, the first of many honorary degrees he is to receive in US and Germany.
1958	Retires as Chairman of Yale University Art School but retains post as Visiting Professor until 1960. Continues to lecture throughout the next eighteen years at numerous universities, mostly in the US. Publication of his *Poems and Drawings*
1959	Mural *Two Structural Constellation* is engraved in lobby of Corning Glass Building in New York.
1961	Designs glass and bronze mural for Time and Life building lobby, New York, and brick altar wall for St Patrick's Church, Oklahoma City.
1962	Receives Graham Foundation fellowship, and awarded Honorary Doctorate in Fine Arts at Yale University.
1963	Publication by Yale University Press of *Interaction of Color*, seminal account of his colour theory. Monumental mural *Manhattan* installed in Pan Am Building in New York and *Repeat and Reverse* is unveiled over the entrance to Yale's Art and Architecture building.

ALBERS	**MOHOLY-NAGY**	
1965	Publication of *Search Versus Re-Search*, Albers's guest lecture series at Trinity College, Hartford, Connecticut.	
1968	Receives Grand Prix at the third Bienal Americana de Grabado, Santiago, Chile and Grand Prix for painting from the State of Nordrhein-Westfalen, Germany. Elected member of National Institute of Arts and Letters. April: *Albers* exhibition organised by Westfällisches Landesmuseum für Kunst und Kulturgeschichte in Münster tours through Switzerland, Germany and Norway.	
1970	The Alberses move from New Haven to Orange, Connecticut. Josef made honorary citizen of his native town of Bottrop, Westphalia, Germany.	
1971	Becomes first living artist to have a retrospective exhibition at Metropolitan Museum of Art, New York.	
1973	Publication of *Formulation: Articulation*, screenprint portfolio reproducing his oeuvre.	
1976	Designs mural for former student, architect Harry Seidler's Mutual Life Center in Sydney, Australia. 25 March: Dies in New Haven, Connecticut.	

FOOTNOTES

TWO BAUHAUS HISTORIES
Achim Borchardt-Hume

1 See 'Vorkurs Albers', in Wulf Herzogenrath (ed.), *bauhaus utopien. Arbeiten auf Papier*, exh.cat., Kölnischer Kunstverein, Cologne 1988, p.69.

2 Neil Welliver, 'Albers on Albers', *Art News*, January 1966, vol.64, no.9, p.48.

3 See, for instance, Wassily Kandinsky, *Über das Geistige in der Kunst*, Munich 1912.

4 Albers recounts this and other Weimar episodes in Eugen Gomringer, *Josef Albers*, New York 1968, p.27.

5 See also Michael White's contribution to this catalogue.

6 Albers in Welliver 1966, p.50.

7 Raoul Hausmann, Hans Arp, Ivan Puni, László Moholy-Nagy, 'Aufruf zur elementaren Kunst' (Manifesto of Elemental Art), *De Stijl*, no.10, 1921; translated in Krisztina Passuth, *Moholy-Nagy*, London 1985, p.286.

8 Commissions for stained-glass windows, all of which were destroyed in World War II, seem to have taken up most of Albers's time in the mid-1920s and explain the lack of other work such as smaller glass pieces during this period.

9 Josef Albers, *Photos as Photography and Photos as Art*, unpublished lecture for Black Mountain College preserved in The Josef and Anni Albers Foundation, Bethany, Connecticut.

10 It would be falsely reductionist to portrait Moholy as a naive adulator of technological progress. In the early 1920s he came into close contact with Theosophy and Mazdaism, a popular form of Eastern-inspired spiritualism,

and later on, bio-technique and the notion of a harmonious co-existence of man and nature greatly influenced his thinking; see also Paul Anker, 'The Bauhaus of Nature', *Modernism/modernity*, vol.12, no.2, pp.229–51. However, around 1923, the time of his Bauhaus appointment, Moholy was primarily known as an advocate of machine aesthetics.

11 Excerpts from an article by Moholy in *MA*, May 1922; translated in Sibyl Moholy-Nagy, *Moholy-Nagy. Experiment in Totality*, New York 1950, p.19.

12 In his posthumously published account of the episode Moholy actually claimed that the order had been placed by telephone; see László Moholy-Nagy, *The New Vision*, New York 1947, pp.79–80. His wife, Lucia, however, corrected this account, recalling that upon delivery of the paintings Moholy had enthusiastically exclaimed that he may as well have ordered the paintings by phone; Lucia Moholy, *Marginal Notes: Documentary Absurdities*, London and Krefeld 1972, p.79.

13 In *Vision in Motion*, Moholy dates the *Light Prop* 1922–30. However, no preliminary sketches prior to 1930 exist, a fact that casts some doubt on this early date; see László Moholy-Nagy, *Vision in Motion*, Chicago 1947, p.238. These dates may refer to first concepts for a moving mechanism, which he described as a theoretical proposition only, in 'Dynamisch-Konstruktives Kraftsystem', *Der Sturm*, vol.14, no.12, 1922, p.186. I would like to thank Nan Rosenthal, Senior Consultant, Metropolitan Museum of Art, New York, for pointing this out to me.

14 Wilhelm Lotz, *On the Design of the Metal Workshop of the Dessau Bauhaus*,

Deutsche Goldschmiede Zeitung, Leipzig, 14 January 1928; translated in Hans M. Wingler, *The Bauhaus. Weimar Dessau Berlin Chicago*, Cambridge, Mass. 1978, p.135.

15 László Moholy-Nagy, 'Zeitgemässe Typographie – Ziele, Praxis, Kritik', Gutenberg Festschrift, 1925; trans. Passuth 1985, p.293.

16 Albers was originally appointed as 'Young Master' (even though he was Moholy's senior by seven years), Moholy as 'Master of Form', with considerable difference in hierarchical and financial status. Moholy, for instance, was accommodated in one of the Master Houses designed by Gropius once the school had transferred to Dessau. Albers moved into Moholy's house when the latter resigned from the Bauhaus in 1928.

17 See, for instance, Rainer K. Wick, *Teaching at the Bauhaus*, Ostfildern-Ruit 2000 and Frederick A. Horowitz and Brenda Danilowitz, *To Open Eyes. Josef Albers at the Bauhaus, Black Mountain College and Yale*, London and New York 2006 (forthcoming).

18 Moholy-Nagy, *The New Vision*, 1947, p.14.

19 Josef Albers, 'werklicher formunterricht', *bauhaus*, vol.2, no.3, 1928.

20 Albers encouraged his students to explore the qualities of a particular material such as paper by using it in unconventional ways, for instance stitching or bending it in such a way that it became sturdy. Moholy, on the other hand, placed a greater emphasis on notions of construction; see also see also K. Wick 2000. However, Albers's paper exercises became an important part of Moholy's School of Design Foundation Course requirements.

21 In an only recently discovered letter preserved in The Josef and Anni Albers Foundation, Albers wrote to the publishers of the Bauhaus books: 'Following a decision of the Masters Council the Bauhaus refuses to recognize "moholy-nagy von material zu architektur" as a Bauhaus book. The reason for this decision are the tenor and quality of this book.' The letter goes on to contest Moholy's right to speak on behalf of all Bauhaus teachers, especially two-and-a-half years after having left the school. It also shows Albers's agitation at the suggestion that he had merely continued Moholy's work and that of his predecessor, Johannes Itten. His annoyance is understandable in the light of eyewitness accounts, which leave no doubt that Albers very much developed his own method of teaching.

22 'Art As Experience', reprint from *Progressive Education*, October 1935, n.p.

23 Letter from Walter Gropius to Kurt Schwitters, 14 July 1947, Kurt Schwitters Archive, Staatsbibliothek, Hannover.

24 See for example Nan Rosenthal, 'Let Us Now Praise Famous Men', in Gary Garrels (ed.), *The Work of Andy Warhol*, Seattle 1989, pp.34–51.

25 Tut Schlemmer (ed.), *The Letters and Diaries of Oskar Schlemmer*, Middletown CT, 1972, pp.183–4.

26 See also László Moholy-Nagy, 'Fotografie is Lichtgestaltung', *bauhaus*, vol.2, no.1, 1928; trans. Passuth 1985, pp.302–5.

27 László Moholy-Nagy, 'Produktion – Reproduktion', *De Stijl*, no.7, 1922, pp.97–100; trans. Passuth 1985, pp.289–90.

28 See also, Rosalind Krauss, 'Jump Over the Bauhaus', *October*, no.15, Winter 1980, pp.102–10.

29 Josef Albers, *Photos as Photography* (see note 9)

30 Katharine Kuh, *The Artist's Voice: Talks with Seventeen Artists*, New York 1960, pp.11–22.

31 László Moholy-Nagy in Sibyl Moholy-Nagy 1950, p.12.

32 Theo van Doesburg, El Lissitzky and Hans Richter, 'Erklärungen der internatioalen Fraktion der Konstruktivisten des ersten internationalen Kongresses der fortschrittlichen Künstler', *De Stijl*, vol.5, no.4, 1922.

33 Josef Albers, 'Historisch oder Jetzig', *Junge Menschen*, no.8, November 1924, p.171.

34 Sibyl Moholy-Nagy 1950, p.19.

35 Josef Albers, 'zu meinen glas-wandbildern', *a bis z*, vol.3, no.30, February 1933, pp.117–20.

36 Walter Benjamin, 'News about Flowers', *Die literarische Welt*, November 1928; translated in Walter Benjamin, *Selected Writings, vol.2, 1927–34*, Cambridge, Mass. 1999, pp.155–7.

37 Ernö Kállai, Alfred Kemény, László Moholy-Nagy, László Péri, 'Nyilatkozat', *Egység*, no. 4, 1923, p.51; translated in Passuth 1985, pp.288–9.

38 Postcard to Moholy-Nagy of 21 March 1925, Fonds Kandinsky 10584-4, Centre Pompidou, Paris. The sender's name is indecipherable.

39 Sibyl Moholy-Nagy 1950, pp. 46–7.

40 In 1937, the Association of Arts and Industries, a group of Chicago businessmen, invited Walter Gropius to become director of a new design school. Since Gropius had just accepted a position with Harvard University, he recommended Moholy. As Director, Moholy named the school, the New Bauhaus: American School of Design. In 1938 the Association closed the New Bauhaus. A year later, with the support of Walter Paepcke, a former member of the Association of Arts and Industries, Moholy opened his own school, which he called The School of Design in Chicago. In 1944, this school was reorganised and renamed The

Institute of Design in Chicago. In 1949 it became a department of the Illinois Institute of Technolgy (IIT), where it still flourishes.

41 László Moholy-Nagy in Sibyl Moholy-Nagy 1950, p.216.

42 Albers had been recommended to Dreier by the architect Philip Johnson who, in 1929, together with Alfred H. Barr, the founding Director of New York's Museum of Modern Art, had visited the Bauhaus.

43 The title of an article in *The New York Times*, 29 November 1933. Other articles remarking on the Albers's arrival include 'Art Professor, Fleeing Nazis, here to Teach. Liberalism Curbed in Germany, Josef Albers takes Mountain Post', *The Brooklyn Daily Eagle*, 26 November 1933; 'Germans on Faculty at Black Mountain School', *The Asheville Citizen*, 5 December 1933; and 'German Professor to go to Black Mt. College. Professor Josef Albers to Reorganize Art Department at School.', *The New York Herald Tribune*, 10 December 1933.

44 Achim Borchardt-Hume in conversation with Hattula Moholy-Nagy on 21 March 2005.

45 László Moholy-Nagy in Sibyl Moholy-Nagy 1950, p.224.

46 Miklós Peternák, 'Art, Research, Experiment. Scientific Methods and Systematic Concepts', in Lynn Zelevansky (ed.), *Beyond Geometry: Experiments in Form, 1940s–70s*, exh. cat., Los Angeles County Museum of Art, Los Angeles 2004, p.94.

47 Gerald Nordland, *Josef Albers: The American Years*, exh.cat., The Washington Gallery of Modern Art, 1965, p.28.

MECHANO-FACTURE: DADA/CONSTRUCTIVISM AND THE BAUHAUS
Michael White

1 See, for example, Magdalena Droste, *Bauhaus*, Berlin and Cologne 1998, p.54; Frank Whitford, *Bauhaus*, London 1984, pp.116–21 and Gillian Naylor, *The Bauhaus Reassessed*, London 1985, pp.93–7.

2 Two significant books that question the periodisation of the Bauhaus into distinctly Expressionist and functionalist moments are Marcel Franciscono, *Walter Gropius and the Creation of the Bauhaus in Weimar*,

Urbana 1971, and Jeannine Fiedler and Peter Feierabend (eds.), *Bauhaus*, Cologne 1999.

3 Werner Haftmann, *Painting in the Twentieth Century*, I, London 1965, p.237.

4 Krisztina Passuth, *Moholy-Nagy*, London 1985, p.41.

5 For a good account of Van Doesburg's course see Kai-Uwe Hemken and Rainer Stommer, 'Der "De Stijl" Kurs von Theo van Doesburg in Weimar (1922)' in Bernd Finkeldey, Kai-Uwe Hemken, Maria Müller and Rainer Stommer (eds.), *Konstruktivistische Internationale, 1922–1927, Utopien für eine Europäische Kultur*, Düsseldorf 1992, pp.169–77.

6 Theo van Doesburg, letter to Evert Rinsema, 20 August 1922, Fondation Custodia, Paris.

7 Werner Graeff, 'Bermerkungen eines Bauhäuslers' in *Werner Graeff. Gemälde 1921–1963*, exh.cat., Städtische Kunstgalerie, Bochum, 1963, quoted in Frank Whitford (ed.), *The Bauhaus Masters and Students by Themselves*, London 1992, p.131.

8 Colour theory was one of the most discussed topics at the Bauhaus and quite naturally, because of the location in Weimar, Goethe's *Zur Farbenlehre* (Theory of Colours) of 1810 was a touchstone.

9 Raoul Hausmann, Hans Arp, Ivan Puni, László Moholy-Nagy, 'Aufruf zur elementaren Kunst' *De Stijl*, vol.4, no.10, 1921, p.156.

10 In László Moholy-Nagy, *The New Vision and Abstract of an Artist*, Documents of Modern Art, New York, 1947, p.79 can be found his claim that he ordered the paintings over the telephone. However, his first wife, Lucia Moholy, remembered the event differently: Moholy merely proposed that he could have ordered them over the telephone, rather than actually did so. See Lucia Moholy, *Marginalien zu Moholy-Nagy/Moholy-Nagy, Marginal Notes*, Krefeld 1972, pp.74–6.

11 In 1927 Moholy embarked on an extensive debate with the critic Ernst (Ernö) Kállai concerning the status of photography as art, based on its sense of *faktura*. See Ernst Kállai, 'Malerei und Photographie', *i10*, vol.1, no.4, 1927, pp.148–57; László Moholy-Nagy, 'Diskussion über Ernst Kallai's

Artikel "Malerei und Photographie"', *i10*, vol.1, no. 6, 1927, pp.233–4; Ernst Kállai, 'Antwort', *i10*, vol.1, no.6, 1927, pp.237–40.

12 See Veit Loers, 'Moholy-Nagy's "Raum der Gegenwart" und die Utopie vom Dynamische-Konstructiven Lichtraum' in *László Moholy-Nagy*, exh. cat., Museum Fridericarum, Kassel 1991, pp.37–51.

13 Moholy dated the *Light Prop* 1922–30, although it was clearly not constructed until 1930, to signify its connections to earlier ideas. His lead has been followed by later commentators such as Passuth 1985, p.53.

14 See Neil Welliver, 'Albers on Albers', *Art News*, vol.64, January 1966, p.50.

15 See Eugen Gomringer (ed.), *Josef Albers: His Work as Contribution to Visual Articulation in the Twentieth Century*, New York 1968, pp.27–8.

16 The revival of stained-glass practice in Germany at the beginning of the twentieth century is an important topic yet to be thoroughly researched. Thorn Prikker's works were discussed extremely widely and seen as of great significance. See Gottfried Heinersdorff, *Die Glasmalerei, ihre Technik u. ihre Geschichte*, Berlin 1914, for a book that situates Thorn Prikker's stained glass as both modern and part of a great historical tradition, and August Hoff, *Die religiöse Kunst Johan Thorn Prikkers*, Dusseldorf 1924. There are also interesting connections yet to be fully explored between Thorn Prikker and De Stijl. See Johanna Luise Wex, *Johan Thorn Prikker: Abstraktion und Konkretion in Freier und Angewandter Kunst*, Bochum 1984, pp.64–105.

17 Albers's ultimate formulation of his work with colour, *The Interaction of Color*, New Haven 1963, clearly states at the outset that its starting point is neither a physiological nor psychological account of colour, based on neither optics nor physics.

18 Josef Albers, 'Lehrplan, Glaswerkstatt' [c.1922–3], Bauhaus-Archiv, Berlin, inv. no. 8406.

19 Arthur Korn, *Glas im Bau und als Gebrauchs-Gegenstand*, Berlin 1929, trans. Arthur Korn, *Glass in Modern Architecture of the Bauhaus Period*, New York 1968. Unfortunately the translated version omits texts by Ernst

Deutsch and Oscar Gehrig on opaque and stained glass that help contextualise Albers's illustrations.

20 Josef Albers, 'Zu meinen glas-wandbilden', *a bis z*, vol.3, February 1933, p.117.

21 See chapters on Moholy and Albers in Rainer K. Wick, *Teaching at the Bauhaus*, Ostfildern-Ruit 2000, pp.131–87.

22 Fiedler and Feierabend 1999, p.19.

MOHOLY-NAGY: THE TRANSITIONAL YEARS
Terence A. Senter

1 'L. Moholy-Nagy: Experimentalist', *Art and Industry*, vol.22, March 1937, pp.111–3.

2 Lajos Kassák and László Moholy-Nagy, *Buch neuer Künstler*, Vienna 1922; László Moholy-Nagy, 'Richtlinien für eine synthetische Zeitschrift', *Pásmo: La Zone*, no.7/8, 1924, p.5. This article was largely written in 1922, as Moholy made clear.

3 Max Gebhard, 'Errinerungen des Bauhäuslers Max Gebhard an Moholy-Nagy', in Irene-Charlotte Lusk, *Montagen ins Blaue: László Moholy-Nagy Fotomontagen und –Collagen 1922–1943*, Werkbund-Archiv, V, Giessen 1980, pp.181–2; Prof. György Kepes, letter to Terence Senter, 9 May 1977.

4 László Moholy-Nagy, 'Lichtrequisit einer elektrischen Bühne', *Die Form*, no.11–12, 1930, p.297; Douglas M. Davies, 'Art and Technology – Conversations: György Kepes: Searcher in the New Landscape', *Art in America*, vol.56, 1968, p.38.

5 J.G. Crowther, interview with Terence Senter, 27 May 1971. The design, in at least six versions, was for J.G. Crowther, *An Outline of The Universe*, London, 1931.

6 John Halas, 'No Frontiers', *Studio*, vol.176, September 1968, p.108; John Halas, letter to Terence Senter, 22 January 1974.

7 Hans Juda, interview with Terence Senter, 11 May 1972; Paul Hartland, interview with Terence Senter, 20 September 1973.

8 László Moholy-Nagy, letter to Walter Gropius, 16 December 1935, Bauhaus-Archiv, Berlin, GN 9/66–77.

9 Laura Herzberger, daughter of Katz and studio designer under Moholy at *International Textiles*, in a letter from Elizabeth Wray to Terence Senter, 8 May 1972; and Paul Hartland, interview with Terence Senter, 20 September 1973.

10 László Moholy-Nagy, 'How Photography Revolutionises Vision', *Listener*, 8 November 1933, pp.688–90.

11 John Summerson, letter to Terence Senter, 24 April 1971. Shand had appointed Summerson as Aalto's secretary for the exhibition; J.G. Crowther, interview with Terence Senter, 28 November 1971; L. Moholy-Nagy, letter to J.G. Crowther, 17 October 1933, University of Sussex Library, Archive: Manuscripts Section; J.G. Crowther, *Fifty Years with Science*, London 1970, pp.124–5. Crowther's painting, *Sil 1* 1933, is now owned by the Scottish National Gallery of Modern Art, Edinburgh.

12 Nicholson told Charles Harrison that he met Moholy in Paris in summer 1933 (Charles Harrison, interview with Terence Senter, 15 November 1972). Since Nicholson spent the summer in London (Jeremy Lewison, *Ben Nicholson*, exh. cat., Tate Gallery, London, p.241), the more likely date was April. By that time, Hélion, a founder-member of Abstraction-Création, knew all three.

13 László Moholy-Nagy, letter to Walter Gropius, 16 December 1935, Bauhaus-Archiv, Berlin, GN 9/66–77; Barbara Hepworth, letter to Ben Nicholson, post-marked 26 November 1933 in Matthew Gale and Chris Stephens, *Barbara Hepworth: Works in The Tate Gallery Collection and The Barbara Hepworth Museum St Ives*, London 1999, pp.35, 282, n.4; László Moholy-Nagy, letter to Herbert Read, 24 January 1934, in Richard Kostelanetz (ed.) *Moholy-Nagy*, London 1971, pp.18–19; Henry Moore, interview with Terence Senter, 26 March 1973; Walter Gropius, letter to Leonard Elmhirst, 15 November 1933, Dartington Hall, Records Office; László Moholy-Nagy, letter to Sibyl Pietzsch, 13 November 1933, László Moholy-Nagy Papers, Archives of American Art, Smithsonian Institution, Washington, 951:0096-0099; Thorold Dickinson, letter to Terence Senter, 11 March 1979; László Moholy-Nagy, letter to Sibyl Pietzsch, 22 November 1933,

László Moholy-Nagy Papers, Archives of American Art, Smithsonian Institution, Washington, 951: 0094-0095.

14 László Moholy-Nagy, letter to Máriusz Rabinovsky, 27 June 1934 in Krisztina Passuth, *Moholy-Nagy*, London 1985, pp.405–6; László Moholy-Nagy, letter to J.G. and Franziska Crowther, 26 April 1934, University of Sussex Library Archive, Manuscripts Section.

15 László Moholy-Nagy, letters to Sibyl Pietzsch, 16 August and 9 October 1934, László Moholy-Nagy Papers, Archives of American Art, Smithsonian Institution, Washington, 951:0130-0131, 0147-0150.

16 Paul Hartland, interview with Terence Senter, 20 September 1973; Hugo van der Valk, interview with Terence Senter, 20 September 1973.

17 Nieuwe Kunstschool, Amsterdam, 28 February – 1 April 1935. Moholy showed the cover of 11 November 1934, among paintings, photography, graphics and advertising art by Mondrian, Kandinsky, Schwitters and others.

18 Sibyl Pietzsch, letters to László Moholy-Nagy, 21 August and 14 October 1934, László Moholy-Nagy Papers, Archives of American Art, Smithsonian Institution, Washington.

19 Sibyl Pietzsch, letters to László Moholy-Nagy, 14 October and 17 October 1934, László Moholy-Nagy Papers, Archives of American Art, Smithsonian Institution, Washington.

20 Ad Petersen and Pieter Brattinga, *Sandberg: Een Documentaire – A Documentary*, Amsterdam, 1975, pp.15–20; Willem Sandberg, via Geert van Beijeren, interview with Terence Senter, 9 August 1971.

21 Paul Hartland, via Hugo van der Valk, interview with Terence Senter, 20 September 1973.

22 Jack Pritchard, interview with Terence Senter, 11 February 1971.

23 Elsbeth Juda, interview with Terence Senter, 25 May 1979. The cover was for *International Textiles*, 4 April 1935.

24 Richard Carline, *Draw They Must: A History of The Teaching and Examining of Art*, London 1968, p.268n; Richard Carline, interview with Terence Senter, 21 April 1971;

Walter Gropius, letter to László Moholy-Nagy, 6 April 1935, Bauhaus-Archiv, Berlin, GN 7/112-3; Walter Gropius, letter to Martin Wagner, 26 December 1934 in David Elliott, *Gropius in England*, London 1974, [p. 3]; Walter Gropius, letter to Dr W.K. Drake of Dartington Hall, 6 January 1935, Bauhaus-Archiv, Berlin, GN 6/211; Jeremy Lewison, *Ben Nicholson*, London 1993, pp.47–8; Farouk Hafiz Elgohary, 'Wells Coates, and his Position in The Beginning of The Modern Movement in England', unpublished PhD thesis, London University 1966, pp.109–11.

25 Professor Sir Leslie Martin, interviews with Terence Senter, 7 June 1971 and 11 October 1980; S. John Woods, letter to Terence Senter, 29 April 1972.

26 Professor Sir Leslie Martin, interview with Terence Senter, 11 October 1980.

27 H.M. Sutton (then principal assistant to the head of the School of Art, Chiswick Polytechnic), interview with Terence Senter, 14 May 1979; Christopher Frayling, *The Royal College of Art: One Hundred and Fifty Years of Art and Design*, London, 1987, pp.117–9.

28 Jack Pritchard, 'Walter and Ise Gropius in England', 1970, Pritchard Papers, University of East Anglia, Norwich, NU/PP/14, p.15.

29 Walter Gropius, letter to Frank Pick, 6 April 1935, Bauhaus-Archiv, Berlin, GN 7/177.

30 Professor Dr Erich Schott, letter to Terence Senter, 26 June 1975; Harry Blacker, interviews with Terence Senter, 23 November 1979 and 27 April 1983; Hans Juda, interview with Terence Senter, 11 May 1972.

31 Hans Juda, interview with Terence Senter, 11 May 1972.

32 Vincent Korda, interview with Terence Senter, 2 July 1971.

33 J.M. Richards, interview with Terence Senter, 16 December 1971. The article was 'Leisure at the Seaside', *Architectural Review*, July 1936, pp.1, 7–28, 42; Harry Paroissien, letter to Terence Senter, 27 April 1971. The books were Mary Benedetta, *Street Markets of London*, London 1936; Bernard Fergusson, *Eton Portrait*, London 1937; and John Betjeman, *An Oxford University Chest*, London 1938.

Street Markets of London received an award at the Paris International Exhibition in 1937. Cf. Terence Senter, 'Moholy-Nagy's English Photography', *Burlington Magazine,* vol.123, November 1981, pp.659–70.

34 Marcus Brumwell, interview with Terence Senter, 1 June 1972. *The Empire's Airway*: Science Museum, London, 6 December 1935 – 2 February 1936, co-designed with Raymond McGrath; Charing Cross Underground Station, London, 18 June – 7 July 1936; exhibition train tour of 37 towns, 12 July – 3 December 1937.

35 Ashley Havinden, letter to Terence Senter, 6 January 1971; Harry Blacker, interview with Terence Senter, 12 May 1971.

36 Bernard Fergusson, *Portrait of Eton*, London, 1949, p.10; Harry Blacker, interview with Terence Senter, 14 April 1972; J.M. Richards, interview with Terence Senter, 16 December 1971.

37 John Tandy, interview with Terence Senter, 15 January 1980. Simultaneously, he showed 22 works, 9 of them from 1935–6, including 3 Rhodoid paintings of 1936, in the significant group exhibition, *konstruktivisten*, at the Kunsthalle, Basel, 16 January – 14 February 1937.

38 František Kalivoda (ed.), 'L. Moholy-Nagy', *Telehor,* nos.1–2, 1936, pp.30–2.

39 Harry Blacker, interviews with Terence Senter, 11 February 1981 and 29 July 1987. Blacker witnessed the making of the intercrossed version. Another arrangement, *Study with Pins and Ribbon* (George Eastman House, Still Photograph Archive, Rochester, GEH NEG:31357 78:1421:007) was processed by Vivex.

40 Myfanwy Piper, interview with Terence Senter, 19 May 1971.

41 László Moholy-Nagy, letter to Walter Gropius, 12 December 1935, Bauhaus-Archiv, Berlin, GN 9/66–77. For claims of plagiarism by, for instance, El Lissitzky, Raoul Hausmann and Josef Albers, see Sophie Lissitzky-Küppers, *El Lissitzky: Life, Letters, Texts*, London 1968, pp.66–7; Eva Züchner, *Raoul Hausmann in Berlin 1900–1933*, Stuttgart 1998, pp.262–3; Xanti Schawinski, letter to Sibyl Moholy-Nagy, 25 August 1948, Sibyl Moholy-

Nagy Papers, Archives of American Art, Smithsonian Institution, Washington, 944: 0307.

42 Professor Sir Leslie Martin, interview with Terence Senter, 11 October 1980.

43 Myfanwy Piper, interview with Terence Senter, 19 May 1971.

44 Henry Moore, interview with Terence Senter, 26 March 1973.

45 Herbert Read, letter to Jack Pritchard, 29 November 1946, Pritchard Papers, University of East Anglia, Norwich, NU/PP/8/Read; Lord William Holford, letter to Terence Senter, 1 January 1973; Professor Sir Leslie Martin, interview with Terence Senter, 7 June 1971.

46 On Moholy's conversation and view of Low: Harry Blacker, interviews with Terence Senter, 12 May 1971 and 14 April 1972; on Horrabin: J.G. Crowther, *Fifty Years with Science*, London 1970, pp.20–1; on Moholy's uniqueness: Professor Sir Leslie Martin, interview with Terence Senter, 7 June 1971; Bernal's view implied in J.D. Bernal, 'Art and The Scientist', J.L. Martin, Ben Nicholson, N. Gabo (eds.) *Circle: International Survey of Constructive Art*, London, July 1937.

47 John Halas, 'No Frontiers', *Studio*, vol.176, Sept. 1968, p.109.

48 Drummond L. Armstrong and C.H. Ward Jackson (Courtauld's advertising managers of the period), letters to Terence Senter, 27 February 1973 and 28 January 1973, respectively; Courtauld's Ltd Advertising Committee Minutes, book 1, 16 October 1936, p.128; Frederick Brame, Deputy Chairman, Simpson (Piccadilly) Ltd via Martin Moss, Managing Director, Simpson (Piccadilly) Ltd, letter to Terence Senter, 1 Feb. 1973.

49 P. Morton Shand, letter to Walter Gropius, 10 May 1935, Bauhaus-Archiv, Berlin, GN 7/411; Walter Gropius, letter to Frank Pick, 11 May 1935, Bauhaus-Archiv, Berlin, GN 7/162; Christopher Frayling, *The Royal College of Art: One Hundred and Fifty Years of Art and Design*, London 1987, pp.117–19. Gropius would have been ineligible as director in terms of the Aliens Restriction (Amendment) Act, 1919.

50 Frank Pick, letter to Oliver Hill, 14 October 1936, Oliver Hill Papers,

British Architectural Library, London, HiO/63/5, in Alan Powers, 'The Search for a New Reality', *Modern Britain 1929–1939*, Design Museum, London 1999, p.31.

51 Hans Juda, interview with Terence Senter, 11 May 1972; Charles Crichton, letter to Terence Senter, 26 April 1987.

52 Beaumont Newhall, letter to Terence Senter, 31 October 1972; Ernestine Carter, née Fantl, letters to Terence Senter, 14 September 1972 and 30 September 1972. Cf. Beaumont Newhall, *Photography 1839–1937*, exh. cat., Museum of Modern Art, New York 1937, p.115 nos.514–26, and p.119 nos.659–60 (no.661 was a four-colour photo-engraving of Dufay colour transparency no.660); Henry-Russell Hitchcock, *Modern Architecture in England*, exh. cat., Museum of Modern Art, New York, 1937.

53 Ise Gropius, letter to Terence Senter, 8 April 1971.

54 László Moholy-Nagy, letter to Walter Gropius, 13 June 1937, Bauhaus-Archiv, Berlin, in Alain Findeli, *Le Bauhaus de Chicago: L'Oeuvre Pédagogique de László Moholy-Nagy*, Quebec 1995, p.42; László Moholy-Nagy, letter to Jenö Nagy, 27 August 1937, in Krisztina Passuth, *Moholy-Nagy*, London 1985, p.406.

55 László Moholy-Nagy, 'The Designer and his Aims', *Interior Design and Decoration*, vol.9, no.6, December 1937, p.57.

56 Ashley Havinden, letter to terence Senter, 6 January 1971: Ashley felt that Moholy had been influenced by his use of the rough colour patch.

57 Cf. Walter Gropius's address at his farewell dinner in 'The Gropius Dinner', Architects' Journal, 18 March 1937, p.458.

58 László Moholy-Nagy, private English notebook [1935-7], [p.77], Collection Hattula Moholy-Nagy.

59 László Moholy-Nagy, in 'Famous Artist as Display Adviser: L. Moholy-Nagy Takes Appointment with Simpson's', Display, May 1936, p.92.

60 László Moholy-Nagy, private English notebook [1935-7], [pp.31–2, 73], Hattula Moholy-Nagy; Elsbeth Juda, interview with Terence Senter, 25 May 1979.

61 Possibly Linton Village College (Cambridgeshire). (Jack Pritchard. interviews with Terence Senter, 11 February 1971 and 25 October 1972.)

62 László Moholy-Nagy, private English notebook [1935–7], [p.71], trans. from German by Terence Senter except for 'Leisure, recreation and hobby' which Moholy wrote in English. The phrase 'new view of life' derives from László Moholy-Nagy, 'Richtlinien fur eine synthetische Zeitschrift', *Pasmo: La Zone*, no.7/8, 1924, p.5.

THE BAUHAUS IDEA IN AMERICA
Hal Foster

1 Of course, the story of Bauhausians in America is part of the wider narrative of European artists in exile and emigration in the 1930s and 1940s. For this history see especially Stephanie Barron, ed., *Exiles + Emigrés: The Flight of European Artists from Hitler* exh. cat., Los Angeles County Museum of Art, Los Angeles, 1997.

2 Alexander Rodchenko and Varvara Stepanova, 'Programme of the First Working Group of Constructivists' (1922), trans. Christina Lodder, in Charles Harrison and Paul Wood (eds.), *Art in Theory 1900–2000* London 2003, p.342. There are several definitions of these terms in Constructivist texts; tellingly, the third term in the Constructivist lexicon, 'construction', or 'the organisational function of Constructivism' within a Communist order, is left to one side by the Bauhausians.

3 See Yve-Alain Bois, 'The De Stijl Idea', in *Painting as Model*, Cambridge Mass. 1990. See also Eva Forgács, *The Bauhaus Idea and Bauhaus Politics*, trans. John Batki, Budapest, 1995.

4 László Moholy-Nagy, 'Production-Reproduction', in Christopher Phillips, (ed.), *Photography in the Modern Era: European Documents and Critical Writings, 1913–1940*, The Metropolitan Museum of Art, New York, 1989, p.80.

5 In his autobiographical 'Abstract of the Artist' Moholy discusses his early constructions in glass and metal produced in Berlin: 'I hit upon the idea of transparency as epiphany. This problem has occupied me for a long time … My work since those days has

been only a paraphrase of the original problem, light.' See László Moholy-Nagy, *The New Vision and Abstract of an Artist*, New York 1947 (4th revised edition), pp.216–17. His fascination with light, on the other hand, pre-dates even his Berlin days; it becomes productive only with his turn to photography. Though primary in his production of the 1920s, the photogram is diminished in his work of the 1930s; as Noam Elcott (whose dissertation on the photogram is forthcoming) points out to me, it hardly appears at all in the 'Abstract', at which time Moholy wanted to stress the practical applications of his abstract work.

6 László Moholy-Nagy, 'From Pigment to Light', in *Moholy-Nagy: An Anthology*, ed. Richard Kostelanetz, New York, 1970, p.31.

7 László Moholy-Nagy, 'Unprecedented Photography' (1927), in Phillips, *Photography in the Modern Era*, p.85.

8 László Moholy-Nagy, 'Photography is Creation with Light' (1928), as quoted by Walter Benjamin in 'News about Flowers' (1928), *Walter Benjamin: Selected Writings, vol.2: 1927–1934*, ed., Michael W. Jennings et alia, Cambridge, Mass. 1999, p.156.

9 Moholy-Nagy, *The New Vision*, p.84. *Kunstwollen* is the key concept of the great Viennese art historian Alois Riegl, some of whose ideas (I suggest below) might have influenced Moholy indirectly.

10 Ibid., p.86.

11 Moholy describes some of these substances as follows: 'Experiments with painting on highly polished black panels (trolite), on coloured transparent and translucent plates (galalith, matt and translucent cellon), produce strange optical effects: it looks as though the colour were *floating* almost without material effect in front of the plane to which it is in fact applied.' See Moholy-Nagy, *Painting, Photography, Film*, trans. Janet Seligman, Cambridge, Mass. 1969, p.25; emphasis in original. This is not to say that Lissitzky was not also interested in 'infinite' space; see, for example, his great 1925 text 'A. and Pangeometry', in El Lissitzky, *Russia: An Architecture for World Revolution*, trans. Eric Dluhosch, Cambridge, Mass. 1970.

12 Moholy-Nagy, *The New Vision* 1947, pp.85, 86–7. In his 'Abstract' Moholy writes: 'I became interested in painting-with-light, not on the surface of canvas, but directly in space. Painting transparencies was the start' (p.219). Yet Moholy also made his *Telephone* paintings at the time of his *Transparents*; conceived so that they might be ordered from a factory over the phone, they are arguably as radical, in their embrace of industrial production, as any Constructivist proposal of the time. 'I put numbers and letters with the necessary data on the back of the canvas, as if they were cars, airplanes, or other industrial products', Moholy writes in 'Abstract'. 'I could not find any argument against the wide distribution of works of art. The collector's naive desire for the unique can hardly be justified. It hampers the cultural potential of mass consumption' (p.223).

13 Ibid., p.124. Of course Brancusi dematerialised his sculptures further through his own photographs of them; perhaps they influenced Moholy in this sense as well.

14 Ibid., p.132.

15 'An attempt to lift the heavy decorative base (the pedestal)', Moholy writes in *The New Vision*. 'It is an act similar to the elimination of the picture frame' (p.119).

16 This transvaluation is a general project of the Bauhaus c.1922–3 and after. On 'glass architecture' in Moholy see Krisztina Passuth, *Moholy-Nagy*, pp.23–5. I am also indebted to Eleanor M. Hight, *Picturing Modernism: Moholy-Nagy and Photography in Weimar Germany* Cambridge, Mass. 1995, as well as to Noam Elcott for his critical reading of the present text.

17 László Moholy-Nagy, 'A New Instrument of Vision', in Kostelanetz 1970, p.50; Moholy-Nagy *The New Vision* 1947, p.136.

18 Moreover, to pass 'from material to architecture' is also, for Moholy, to pass from the tactile to the visual, and to this extent his narrative also rewrites, in modernist terms, the one posed for art history at large by Alois Riegl a generation before him – as a movement from the haptic to the optical, i.e., from objective representations that distance the world to subjective picturings that

bring it close. See Alois Riegl, *Late Roman Art Industry* (1901), trans. Rolf Winkes, Giorgio Bretschnedier, Rome, 1985. In this Rieglian vein Moholy writes in *The New Vision*: 'To the primitive man, representation of an object probably meant the same thing as being able to seize it, to own it personally … A later stage sublimates this process' (pp.154–5). Here again this model influenced Benjamin as well.

19 'Sublimation' is a tricky concept in Freud, and his most famous exposition of its civilisational role, in *Civilization and its Discontents* (1930), appeared a year after the original publication of *The New Vision*.

20 Moholy-Nagy, *The New Vision* 1947, pp.224, 230.

21 And yet, due to mismanagement of stocks, the Association had to close the school within a year. However, in 1939 with scant recourses Moholy was able to reopen it, now renamed the School of Design, with much the same faculty, including the Russian sculptor Alexander Archipenko, the Hungarian theorist Gyorgy Kepes and the American philosopher Charles Morris. (The Bauhaus veterans Herbert Bayer and Alexander Schawinsky and the French abstractionist Jean Hélion were listed on the New Bauhaus roster, but they did not teach in the first years.) The school continued to meet challenges of funding and recruiting; in 1944, however, it was renamed the Institute of Design, and enrolments improved. It remains a division of the Illinois Institute of Technology to this day.

22 László Moholy-Nagy, 'First Program Announcement', in *Moholy-Nagy: An Anthology*, p.172.

23 László Moholy-Nagy, 'Education and the Bauhaus', in Kostelanetz 1970, p.166. This 'going back' to 'biological bases' is also a going forward with 'technical progress'. Like his contemporaries Benjamin and Siegfried Kracauer, Moholy plays a 'go-for-broke' game here. However, unlike them, he bets not on socialism to deliver 'this other side', but on capitalism – and that truly is 'utopian' (in the sense of misbegotten).

24 See Moholy-Nagy, *Vision in Motion*, Chicago 1947. His entire discussion of the arts falls under this rubric.

25 Ibid., p.360.

26 'It is the artist's duty today to penetrate yet-unseen ranges of the biological functions, to search the new dimensions of the industrial society and to translate the new findings into emotional orientation', Moholy writes in *Vision in Motion*. 'Vision in motion also signifies planning, the projective dynamics of our visionary faculties' (p.12).

27 Greatly influenced by Moholy, Gyorgy Kepes is explicit in this regard in his *Language of Vision*, Paul Theobold, Chicago, 1944. My argument here shortchanges the artistic practice (especially in photography) nurtured by Moholy in Chicago; on this work see David Travis and Elizabeth Siegel, *Taken by Design: Photographs from the Institute of Design, 1937–1971*, Chicago 2002.

28 Albers as quoted by Mary Emma Harris, *The Arts at Black Mountain College*, Cambridge Mass. 1987, p.17.

29 Ibid., p.6. On the College in general see, apart from Harris, Martin B. Duberman, *Black Mountain: An Exploration in Community*, New York, 1972.

30 Harris 1987, pp.13, 17.

31 Albers as quoted by Mary Emma Harris, 'Josef Albers: Art Education at Black Mountain College', in Diane Waldman, ed., *Josef Albers: A Retrospective*, Guggenheim Museum, New York, 1988, p.52. The relationship of Albers, Moholy, and associates (e.g., Kepes) to Gestalt psychology and its adaptation by art historians and theorists (such as Ernst Gombrich and Rudolf Arnheim) is an important topos, but one too complicated to develop here.

32 Albers as quoted in Harris 1987, *The Arts at Black Mountain College*, p.17.

33 Albers in conversation with Margit Rowell, as cited in Rowell, 'On Albers's Color', *Artforum* (January 1972).

34 Relationality is also key to his lesser-known work, such as his clusters of photographs, usually portraits, set within an uneven grid. It is also found (as it were) in some of his documentary photographs (e.g., *Mexican Stonework*, c.1936).

35 Josef Albers, 'The Color in My Painting' 1948, in *Josef Albers*, ed. Milan 1988, p.104.

36 Albers, 'On My "Homage to the Square"', in ibid., p.105.

37 Albers, *Interaction of Color* New Haven 1963, p.2.

38 Albers as quoted by Mary Emma Harris, 'Josef Albers: Art Education at Black Mountain College' in Waldman 1988, pp.53, 56.

39 For example, at a design conference in the 1950s Albers proclaimed: 'So I am looking forward/To a new philosophy/Addressed to all designers/ – in industry – in craft – in art/and showing anew/that esthetics are ethics/that ethics are source and measure/of esthetics.' See Nicolas Fox Weber, *Josef + Anni Albers: Designs for Living*, London and New York 2004, p.28.

40 This shared commitment to experiment at Black Mountain is the subject of a forthcoming dissertation by Eva Diaz. Also see her 'Experiment, Expression, and the Paradox of Black Mountain College', in Caroline and Michael Harrison, eds., *Starting at Zero: Black Mountain College* exh cat., Arnolfini Gallery, Bristol, 2005.

41 Robert Rauschenberg as quoted by Mary Emma Harris, 'Josef Albers: Art Education at Black Mountain College' in Waldman 1988, p.55.

42 See Bruce Glaser, 'Questions to Stella and Judd' (1966), in Gregory Battcock, ed., *Minimal Art: A Critical Anthology* New York 1968, p.158. In this well-known conversation Stella and Donald Judd strive to distinguish their work from 'relational' and 'rationalistic' abstraction of the 'European tradition', with which Albers might be implicated – though Judd responded well to Albers in his criticism.

43 Robert Rauschenberg as cited by John Cage in 'On Robert Rauschenberg, Artist, and His Work' (1961), in *Silence*, Middletown Conn., 1969, p.105.

44 This connection extends to the legatees of Minimalism such as Richard Serra, who, as a student at Yale, helped Albers proof the pages of *Interaction of Color*.

45 Margit Rowell has written of the 'lambent incandescence' of a typical Albers painting: 'We are as in the presence of real light, not the kind of illusionism through which light is artificially projected from an outside source' ('On Albers's Color', in Getulio Avilani {ed.}, *Josef Albers*, Milan 1998, p.244). So it is with the light installations of Robert Irwin and James Turrell, with this obvious difference: Albers worked at the scale of easel painting, careful to retain an intimate relationship with the viewer, not with environmental space that is often manipulated in such a way as to overwhelm the viewer, as in Irwin and Turrell.

46 'More or less/Easy to know/that diamonds are precious/and good to learn/that rubies are deeper/But more to see/that pebbles are miraculous.' See Josef Albers, *Search Versus Re-Search*, Hartford 1969.

47 Howard Singerman, *Art Subjects: Making Artists in the American University*, Berkeley 1999, p.69. Singerman continues: 'Assignments that allow students to discover for themselves the order of vision, the forces and relations of two-dimensional design and three-dimensional space, and the properties of materials – at least of paint, perhaps of paper and clay – mark the presence and the difference of Bauhaus education in the United States, its difference from the sameness and repetition of the academy and its resemblance to the goals of the modern research university.' And further: 'Over and over again in the teaching of art at the Bauhaus and in its teaching in America, the re-creation of design as vision is represented by the field or, more familiarly, by the picture plane as the gridded, ordered, law-bound rectangle with which, and on which, art fundamentals begin. The rectangle marks the teaching of modernism as the visual arts, displacing and containing the human figure that stood at the center of the academic fine arts' (pp.119, 79).

48 This analogy was made explicit by Kepes, who later founded the Center for Advanced Visual Studies at MIT, in his *Language of Vision*: 'the task of the contemporary artist is to release and bring into social action the dynamic forces of visual imagery' (p.201).

49 Moholy repeats this phrase (as he does many others) in his writings; see, e.g., 'Unprecedented Photography', p.84. As for Albers, consider this telling comment in *Interaction of Color*: 'Even when a certain color is specified which all listeners have seen innumerable times – such as the red of the Coca-Cola signs which is the same red all over the country – they will still think of many different reds' (p.3).

50 The Albers photograph is reprinted in *Search Versus Research*, p.82, which suggests that he was not embarrassed by its implications.

'I WANT THE EYES TO OPEN': JOSEF ALBERS IN THE NEW WORLD
Nicholas Fox Weber

In the notes below, all references to Albers Foundation refer to the Josef and Anni Albers Foundation, Bethany, Connecticut.

1 Josef Albers to Alfred Barr, 19 June 1933, Yale University Manuscripts and Archives, New Haven.

2 Ibid.

3 Josef Albers to Alfred Barr, 7 August 1933, Yale University Manuscripts and Archives, New Haven.

4 Edward Warburg to Alfred Barr, 31 August 1933, Albers Foundation.

5 Graham Greene, *The Quiet American*, London 2002, p.12.

6 Wassily Kandinsky, 'Il Milione', from the bulletin of Galleria del Milione, Milan for the exhibition *Silografie Recenti di Josef Albers e di Luigi Veronesi*, 23 December 1934 – 10 January 1935, Milan.

7 Josef Albers to Wassily and Nina Kandinsky, 3 December 1933, Centre Pompidou, Paris.

8 Ibid.

9 Josef Albers to Wassily and Nina Kandinsky, April 1933, Centre Pompidou, Paris.

10 Postcard from Josef Albers to Thornton Wilder, 17 April 1967, Albers Foundation.

11 Thornton Wilder to Josef Albers from Edgartown, Mass., 23 April 1967, Albers Foundation.

12 Philip Johnson to Josef Albers, 17 April 1934, Albers Foundation.

13 Ted Dreier to Nicholas Fox Weber, 24 November 1995, Albers Foundation

14 Charles Z. Offin, 'A Rich Variety of Painters, East and West: Group showing of Ten Pacific painters; also Palazzo, Albers and Russell Cheney', *Brooklyn Daily Eagle*, 15 March 1936.

15 Edward Alden Jewell, 'The Realm of Art', *New York Times*, Sunday 15 March 1936.

16 Tape of interview with Irving Leonard Finkelstein, 1966; done as research for a Ph.D. thesis.

17 Quoted in J. and M. Thwaites, 'Albers and de Monda at the Katherine Kuh gallery', *Magazine of Art*, November 1937.

18 Handwritten note by Josef Albers, undated, Albers Foundation.

19 Anon, 'Mountain Man', *TIME*, 19 December 1938.

20 Josef Albers to Elizabeth Seymour, undated, Nicholas Fox Weber Collection.

21 J.B. Neumann in *Josef Albers*, exh.cat., New Art Circle, January 2–17 1945.

22 Josef Albers 'Nothing definite,' *TIME*, 31 January 1949.

LÁSZLÓ MOHOLY-NAGY: TRANSNATIONAL
Hattula Moholy-Nagy

I would like to thank Achim Borchardt-Hume, Lloyd C. Engelbrecht, Oliver A.I. Botar, and Roger G. Schneggenburger for their suggestions and contributions to this article.

1 'Találkozás', *Jelenkor*, no.5, April 1918, p.138. My translation.

2 From a letter to Jane Heap, one of the editors of *Little Review*, 20 May 1928 (My translation.). The statement was published in English in the final issue of *Little Review*, May 1929, pp.54–6.

3 Ibid.

4 Aurél Bernáth, *Utak Pannóniából*, Szépírodalmi Könyvkiadó Budapest 1960, p.362.

5 *Little Review*, May 1929, pp.54–6.

6 Ibid.

7 Sir Georg Solti, *Memoirs*, New York 1997, pp.3–4.

8 László Moholy-Nagy, *Vision in Motion*, Chicago 1947, p.360.

SELECTED BIBLIOGRAPHY

Compiled by Jacob Dabrowski

ALBERS

WRITINGS BY THE ARTIST

'Historisch oder jetzig?' *Junge Menschen* (Hamburg), no.8 (special Bauhaus issue), November 1924, p.171.

'Zur Ökonomie der Schriftform', *Offset-Buch und Werbekunst* (Leipzig), no.7, 1926, pp.395–7.

'Jubiläumsvortärge des Bauhauses: Vortrag Josef Albers, "Werklehre des Bauhauses", *Volksblatt Dessau*, 29 January 1930.

'zu meinen glas-wandbildern', *a bis z: Organ der Gruppe progressiver Künstler* (Cologne), no.3, February 1933, p.117.

'Concerning Art Instruction', *Black Mountain College Bulletin*, no.2, June 1934, pp.2–7.

'Black Mountain College', *Junior Bazaar*, May 1946, pp.130–3.

'On Art and Expression, On Articulation, On Enunciation and Seeing Art', *Yale Literary Magazine*, no.129, May 1960, pp.49–54.

Interaction of Color, New Haven and London 1963.

Despite straight lines, statements and poems by Josef Albers; an analysis of his graphic constructions by Francis Bucher, New Haven 1961; revised ed., Cambridge, Mass. and London 1977.

'Op Art and/or Perceptual Effects', *Yale Scientific Magazine,* vol. 40, no.2, November 1965, pp.8–15.

BOOKS AND CATALOGUES

Katharine Kuh, 'Josef Albers', in *The Artist's Voice: Talks with Seventeen Artists*, New York 1960, pp.11–22.
Josef Albers: Homage to the Square, exh. cat., Museum of Modern Art, New York 1964.

Josef Albers: Exhibition of Paintings – The America Years, exh. cat., Gallery of Modern Art, Washington 1965.

Eugen Gomringer (ed.), *Josef Albers:His Work as Contribution to Visual Articulation in the Twentieth Century,* articles by Clara Diament de Suj, Will Grohmann, Norbert Lyton, Michel Seuphor, New York 1968, German edition: Starnberg 1968.

Werner Spies, *Josef Albers*, Harry N. Abrams, New York, 1970.

Henry Geldzahler, *Josef Albers at the Metropolitan Museum of Art,* Metropolitan Museum of Art, New York 1971.

Josef Albers at the Metropolitan Museum of Art: an exhibition of his paintings and prints, 19 Nov. 1971 – 11 Jan. 1972, exh. cat., Metropolitan Museum of Art, New York 1971.

Paintings by Josef Albers: Yale University Art Gallery, The Gallery, New Haven 1978.

Irving Leonard Finkelstein, *The Life and Art of Josef Albers,* Ph.D. Diss., New York University, Ann Arbor, Mich. 1968, University Microfilms International, 1979.

Wulf Herzogenrath, *Josef Albers und der 'Vorkurs' am Bauhaus 1919–1933,* Cologne 1979/1980.

Nicholas Fox Weber, *The Drawings of Josef Albers*, New Haven and London 1984.

Neal David Benezra, *The Murals and Sculptures of Josef Albers*, New York and London 1985.

Donald Judd, *Complete Writings 1975–1986,* Eindhoven 1987.
John Szarkowski, *The Photographs of*

Josef Albers: A Selection from the Josef Albers Foundation, New York 1987.

Josef Albers: A Retrospective, exh. cat., Solomon R. Guggenheim Museum, New York 1988.

Josef Albers: Eine Retrospektive, exh. cat., Staatliche Kunsthalle Baden-Baden und Bauhaus-Archiv Berlin, Cologne 1988.

Kelley Szarkowski, *Joseph Albers: Works on Paper*; exh. cat., Art Services Internatonal, Alexandria, Va. 1991.

Josef Albers, exh. cat., The Chinati Foundation, Joseloff Gallery, University of Hartford and Hartford School of Art, West Hartford, Conn., Köln 1991.

Josef Albers: Photographien 1928–1955, exh. cat., Kölnischer Kunstverein, Munich, Paris and London 1992.

Josef Albers: A National Touring Exhibition from the South Bank Center, exh. cat., South Bank Centre, London 1994.

Josef Albers: Glass, Color, and Light, exh. cat., Solomon R. Guggenheim Museum, New York 1994.

Josef und Anni Albers: Europa und Amerika, Künstlerpaare – Künstlerfreunde, exh. cat., Kunstmuseum Bern, Cologne 1998.

Josef Albers: Werke auf Papier, essays by Volker Adolphs, Kornelia van Berswordt-Wallrabe, Margaret Kentgens-Craig, Stefan Gronert and, Lutz Schobe, Kunstmuseum Bonn, Wienand, Cologne 1998.

Kandinsky-Albers: Une correspondance des années trente, Les Cahiers du Musée National d'art Moderne, Paris 1998.

Nicholas Fox Weber (ed.), *Josef Albers: Homage to the Square Paintings and Photographs (1928–1938)*, exh. cat., Waddington Galleries, London 2001.

Josef Albers in Black and White, exh. cat., Boston University Art Gallery, Boston and Seattle 2000.

Brenda Danilowitz, *The Prints of Josef Albers: A Catalogue Raisonné 1915–1976* (foreword by Nicholas Fox Weber), New York 2001.

Josef Albers, exh. cat., Centre Pompidou, Paris 2002.

Nicholas Fox Weber, and Martin Filler, *Josef and Anni Albers: Designs for Living*; exh. cat., Cooper-Hewitt, National Design Museum, New York 2004.

Josef Albers: Omaggio al Quadrato: una retrospettiva, text by Peter Weiermair in collaboration with Giusi Vecchi, exh. cat., Silvana, Cinisello Balsamo, Milan 2005.

Josef Albers: The Development of an Image, exh. cat., essay by Nicholas Fox Weber, Alan Cristea Gallery, London 2005.

ARTICLES

Elaine De Kooning, 'Albers Paints a Picture', *Art News* no.49, November 1950, pp.40–3, 57–8.

Max Bill, 'Josef Albers', *Werk*, no.45, April 1958, pp.135–38.

Dore Ashton, 'Albers and the Indispensable Precision,' *Studio*, June 1963, p.253.

Donald Judd, 'Interaction of Color', *Arts Magazine*, November 1963, pp.67, 73–5.

Neil Welliver, 'Albers on Albers', *Art News* no.64, January 1966, pp.48–51, 68–9.

Paul Overy, '"Calm Down What Happens Happens Mainly without You" – Josef Albers', *Art and Artists* (London), October 1967, pp.32–5.

Sam Overy, 'Josef Albers: Prophet and Presiding Genius of American Op-Art', *Vogue*, October 15, 1970, pp.70–3, 126–7.

Margit Overy, 'On Albers' Color' *Artforum*, 10, January 1972, pp.26–37.

Donald Judd, 'Josef Albers', *Art Press* (France) special issue, 1992, pp.18–24.

Nicholas Fox Weber, 'Josef Albers's Drawings: The Linear Obsessions of a Color Theorist', *Drawing* (US), vol.16, no.5, Jan.–Feb. 1995, pp.97–101.

Michael Craig-Martin, 'The Teachings of Josef Albers: A Reminiscence' *The Burlington Magazine,* vol.137, no.1105, April 1995, pp.248–52.

Kara Vander Weg, 'Josef Albers: Circumventing the Eye', *Glass* (New York)*,* no.88, Autumn 2002, pp.22–9.

MOHOLY-NAGY

WRITINGS BY THE ARTIST

(With Lajos Kassák) *Buch neuer Künstler* (Book of new artists), Bauhausbücher vol.1, Vienna 1922.

'Produktion-Reproduktion' (Production–Reproduction), *De Stijl*, vol.5, 1922, pp.98–100.

(With Alfréd Kemény) 'Dynamisch-Konstruktives Kräftesystem: Manifesto der kinetischen Plastik' (The constructive dynamic system of forces: manifesto of kinetic sculpture), *Der Sturm*, no.13, 1922, pp.9–12 and no.14, 1922, p.7.

(With Farkas Molnár and Oskar Schlemmer) *Die Bühne im Bauhaus* (The Bauhaus Stage), Bauhausbücher vol.4, Munich 1925.

Malerei Fotografie Film (Painting, Photography, Film), Bauhausbücher vol.8, Munich 1927.

'Die beispiellose Fotografie' (Unparalleled photography), *i10 Internationale Revue 1*(Amsterdam), no.3, 1927.

Von Material zu Architektur, Bauhausbücher vol.14, Munich 1929, *The New Vision: from Material to Architecture*, trans., New York 1932.

'Lichtrequisit einer elektrischen Bühne' (Light prop for an electric stage), *Form: Zeitschrift für gestaltende Arbeit* (Berlin), vol.5, June 1930, pp.297–9.

'The New Bauhaus', *Architectural Forum* (New York), vol.67, 1936, supp.22, 82.

Mary Benedatta, *The Street Markets of London* (Photography by Moholy-Nagy)*,* London 1936.

Bernard Edward Fergusson, *Eton Portrait,* (Photography by László Moholy-Nagy), London 1937.

John Betjeman, *An Oxford University Chest,* (Photography by László Moholy-Nagy), London 1938.

'New Bauhaus: American School of Design, Chicago', *Design Magazine*, vol.40, 1939, pp.19–21.

'On Art and Photography', *Technology Review* (Cambridge, Mass.), vol.47, no.8, 1945, pp.491–4, 518.

The New Vision {and Abstract of an Artist}, New York 1947.

Vision in Motion, Chicago 1947

Richard Kostelanetz, (ed.), *Moholy-Nagy: An Anthology*, New York 1970.

BOOKS AND CATALOGUES

Franz Roh, *L. Moholy-Nagy: 60 Fotos,* Berlin 1930.

László Moholy-Nagy, exh. cat., London Gallery 1937.

László Moholy-Nagy, exh. cat., Art Institute of Chicago 1947.

Sibyl Moholy-Nagy, *Moholy-Nagy: Experiment in Totality,* with an introduction by Walter Gropius, New York 1950.

Lucia Moholy, *Marginalien zu Moholy-Nagy: Dokumentarische Ungereimtheiten ... Moholy-Nagy, Marginal Notes: Documentary Absurdities ...,* Krefeld 1972.

Andreas Haus, *Moholy-Nagy: Fotos und Fotogramme,* Munich 1978; *Photographs and Photograms,* trans., London 1980.

László Moholy Nagy: (Paintings, Photographs, Designs, etc), exh. cat., Krisztina Passuth (introd.), Arts Council of Great Britain, London 1980.

Steven A. Mansbach, *Vision of totality: László Moholy-Nagy, Theo van Doesburg and El Lissitzky,* Ann Arbor, Mich. 1980.

Moholy-Nagy: Photography and film in Weimar Germany, exh. cat., Wellesley College Museum, Wellesley, Mass. 1985.

Krisztina Passuth ed., *Moholy-Nagy,* Budapest 1982; trans., London 1985.

László Moholy-Nagy, exh. cat., Musée Cantini, Musées de Marseille/Réunion des Musées Nationaux, Marseille 1991.

Eleanor M. Hight, *Picturing Modernism: Moholy-Nagy and Photography in Weimar Germany,* Cambridge, Mass. and London 1995.

Louis Kaplan, *László Moholy-Nagy: Biographical Writings*, Durham and London 1995.

László Moholy-Nagy: compositions lumineuses, 1922–1943: photogrammes des collections du Musée national d'art moderne-Centre de création industrielle, Centre Georges Pompidou, Paris et du Museé Folkwang, Essen, exh. cat., Centre Pompidou, Paris 1995.

Jan Sahli, *Filmische Sinneserweiterung: Filme, Experimente und Theorien von László Moholy-Nagy* (Cinematic broadening of the senses: films, experiments and theories of László Moholy-Nagy), Zurich 1996.

Victor Margolin, *The Struggle for Utopia: Rodchenko, Lissitzky, Moholy-Nagy: 1917–1946,* Chicago and London 1997.

Thomas Kellein and Angela Lampe (eds.), *Abstrakte Fotografie,* exh. cat., Kunsthalle Bielefeld 2000.

In Focus: Photographs from the J. Paul Getty Museum – Andre Kertesz, László Moholy-Nagy, Man Ray, J. Paul Getty Museum, Los Angeles 2001.

Jeannine Fiedler, *László Moholy-Nagy,* London 2001.

Herbert Molderings, *László Moholy-Nagy und die Neuerfindung des Fotogramms* (László Moholy-Nagy and the rediscovery of the photogram), in Renate Heyne (ed.), *Kunst und Fotografie: Floris Neusüss und die Kasseler Schule für Experimentelle Fotografie, 1972–2002,* Jonas Marburg 2003.

Brancusi, Gabo, Moholy-Nagy, Immaterial, exh. cat., Kettle's Yard, Cambridge 2004.

László Moholy-Nagy, A Life in Motion: Paintings, Sculpture, Drawings and Photography, exh. cat., Annely Juda Fina Art, London 2004.

Expanding Vision: Laszlo Moholy-Nagy's experiments of the 1920s, exh.cat., International Center of Photography 2005.

ARTICLES

John Leslie Martin, 'László Moholy-Nagy and the Chicago Institute of Design', *Architectural Review*, vol.101, 1947, pp.225–6.

Sigfried Giedion, 'Notes on the Life and Work of László Moholy-Nagy, Painter-Universalist', *Architects' Yearbook*, vol.3, 1949, pp.32–6.

Sibyl Moholy-Nagy, 'Moholy-Nagy: Photographer', *American Photography*, January 1950, pp.40–4.

David Irwin, 'Motion and the Sorcerer's Apprentice', *Apollo*, vol.84, July 1966, pp.54–61.

György Kepes, 'László Moholy-Nagy: The Bauhaus Tradition', *Print*, vol.23, Jan.–Feb. 1969, pp.35–9.

Lucia Moholy, 'Bauhaus im Rückblick' (Looking back at the Bauhaus), *Du*, no.3, 1977, pp.50–65, 74.

Rosalind Krauss, 'Jump over the Bauhaus', *October,* no.15, Winter 1980, pp.102–10.

Terence Senter, 'Moholy-Nagy's English photography', *Burlington Magazine* (UK), no.944, vol.123, Nov. 1981, p.659–71.

Alain J Findeli, 'De la photographie à la peinture: la leçon de László Moholy-Nagy (1895–1946)' [From photography to painting: the lesson of László Moholy-Nagy (1895–1946)], *Hungarian Studies Review* (Canada), vol.15, no.1, 1988, pp.53–62.

Louis Kaplan, 'Laszlo Moholy-Nagy and the Plague of Plagiarism', *Yearbook of Interdisciplinary Studies in the Fine Arts*, vol.1, 1989, pp.15–35.

Steven A. Mansbach, 'Confrontation and accommodation in the Hungarian avant-garde', *Art Journal,* vol. 49, Spring 1990, pp.9–20.

Alain Findeli, 'Design Education and Industry: The Laborious Beginnings of the Institute of Design in Chicago in 1944', *Journal of Design History,* vol.4, no.2, 1991, pp.97–113.

Oliver A. I. Botar, 'Four Poems of 1918 by László Moholy-Nagy', *Hungarian Studies Review*, vol.21, no.1, 1993, pp.103–112.

Rolf Sachsse, 'The Dysfunctional Leica: instrument of the German

avant-garde', *History of Photography,* vol.17, Autumn 1993, pp.301–4.

Rainer K. Wick, 'Technik Utopisches bei Moholy-Nagy' (Technical utopia according to Moholy-Nagy), *Thesis,* no.3–4, 1997, pp.350–7.

Peter Stasny, 'Zwischen Sein und Nichts: Schatten und Lichtkunst des Bauhauses bei Ludwig Hirschfeld-Mack und László Moholy-Nagy' (Between existence and oblivion: shadow and light art of the Bauhaus by Ludwig Hirschfeld-Mack and László Moholy Nagy), *Ausschnitt,* no.6, 2001, pp.15–28.

Christian Derouet, 'László Moholy-Nagy: contacts avec l'avant-garde parisienne (1924–1945)', *Cahiers du Musee National d'Art Moderne,* no.79, Spring 2002, pp.100–23.

Oliver A.I. Botar., 'Biocentrism and the Bauhaus', *The Structurist,* nos.43/4, 2003/4, pp.54–61.

Peder Anker, 'The Bauhaus of Nature', *Modernism – Modernity,* vol.12, no.2, April 2005, pp.229–51.

BAUHAUS

Walter Gropius, *Bauhaus,* Bauhaus, Dessau 1926–1931.

H. Bayer, Walter Gropius and Ise Gropius (eds.), *Bauhaus, 1919–1928,* Charles T. Branford, Boston 1959; first published on the occasion of an exhibition organised by The Museum of Modern Art, New York 1938.

Reyner Banham, *Theory and Design in the First Machine Age,* London 1960.

Eckhard Neumann (ed.), *Bauhaus und Bauhäusler: Bekenntnisse und Erinnerungen,* Stuttgart 1970.

Concepts of the Bauhaus: the Busch-Reisinger Museum Collection, exh. cat., John David Farmer and Geraldine Weiss (introd.), The Bush-Reisinger Museum, Harvard University, Cambridge, Mass. 1971.

Kleine Bauhaus-Fibel: Geschichte und Wirken des Bauhauses, 1919 – 1933/ mit Beispielen aus der Sammlung des Bauhaus-Archivs, von Hans M. Wingler, Bauhaus-Archiv, Berlin 1974.

Hans M. Wingler, *The Bauhaus: Weimar, Dessau, Berlin, Chicago,* London and Cambridge, Mass. 1978.

Bauhaus Archiv-Museum: Sammlungs-Katalog (Auswahl): Architektur, Design,

Malerei, Graphik, Kunstpädagogik, exh. cat., Peter Hahn and Christian Wolsdorff (eds.), Berlin 1981.

Rainer K. Wick, *Bauhaus Pädagogik,* Cologne 1982.

Fleischmann, Gerd (ed.), *Bauhaus: Drucksachen, Typografie, Reklame,* Düsseldorf 1984.

Frank Whitford, *Bauhaus,* London 1984.

Bauhaus Berlin: Auflösung Dessau 1932, Schließung 1933: Bauhäusler und das Dritte Reich (e. Dokumentation zsgest. v. Bauhaus-Archiv Berlin), Weingarten 1985.

Gillian Naylor, *The Bauhaus Reassessed: Sources and Design Theory,* London 1985.

Wulf Herzogenrath and Stefan Kraus (eds.), *Bauhaus Utopien: Arbeiten auf Papier,* exh. cat., Kölnischer Kunstverein Köln, Cologne 1988.

Frank Whitford (ed.), *The Bauhaus: Masters and Students by Themselves* London 1992.

Jeannine Fiedler and Peter Feierabenc (eds.), *Bauhaus,* Cologne 1999.

Rainer K. Wick, *Teaching at the Bauhaus,* Ostfildern 2000.

FROM THE BAUHAUS TO THE NEW WORLD

Emanuel Mervir Benson, 'The Chicago Bauhaus and Moholy-Nagy', *Magazine of Art,* no.31, 1938, pp.82–3.

Hans M. Wingler, *Bauhaus in America: Repercussion and Further Development,* Bauhaus-Archiv, Berlin 1972.

Charles Traub (ed.), 'The New Vision: Forty Years of Photography at the Institute of Design', *Aperture* (New York), no.87, 1985, pp.4–76.

Mary Emma Harris, *The Arts at Black Mountain College,* Cambridge, Mass. and London 1987.

Sasha Newman and Leslie Baier (eds.), *Yale Collects Yale,* New Haven 1993.

The New Bauhaus, School of Design in Chicago: Photographs 1937–1944: László Moholy-Nagy, György Kepes, Arthur Siegel, Nathan Lerner, James Hamilton Brown, exh. cat., Banning & Associates, New York 1993.

Tom Watson, 'Making Open the Eyes [brief history of Black Mountain College, North Carolina]', *Art & Antiques,* vol.19, May 1996, pp.94–7.

Stephanie Barron and Sabine Eckmann (eds.), *Exiles + Emigrés: The Flight of European Artists from Hitler,* exh. cat.,Los Angeles County Museum of Art 1997.

Then and Now: Art Since 1945 at Yale, exh. cat., Yale University Art Gallery 1998

Margaret Kentgens-Craig, *The Bauhaus and America: First Contacts 1919–1936,* trans. Lynette Widder, Cambridge, Mass. 1999.

Howard Singerman, *Art Subjects: Making Artists in the American University,* Berkeley and Los Angeles 1999.

Vicki Gadberry, 'Black Mountain College: A Glimpse into its Impact on 20th Century Art and Education', *Shuttle Spindle and Dyepot,* vol.30, no.1, Winter 1999, pp.22–4.

C. Darwent, 'From Bauhaus to Black Mountain', *Modern Painters,* vol.15, no.4, Winter 2002, pp.48–9.

Taken by Design: Photographs from the Institute of Design, 1937–1971, exh. cat., David Travis and Elizabeth Siegel (eds.), Art Institute of Chicago in association with University of Chicago Press, Chicago 2002.

Vincent Katz (ed.), *Black Mountain College: Experiment in Art,* Cambridge, Mass. and London 2003.

Starting at Zero: Black Mountain College 1933–1957, exh. cat., Caroline Collier and Michael Harrison (introd.), Arnolfini and Kettle's Yard , Cambridge 2005.

LIST OF EXHIBITED WORKS

ALBERS

Grid Mounted 1921
Glass pieces interlaced with copper
wire, in a sheet of fence latticework
32.4 x 28.9 cm
The Josef and Anni Albers Foundation

Fensterbild 1921
Glass, wire, painted metal, nails,
mesh, imitation pearls and ink on
wood
54.1 x 54.1 cm
Hirshhorn Museum and Sculpture
Garden, Smithsonian Institution,
Washington, DC, Gift of Joseph H.
Hirshhorn Foundation, 1972
(pl.2, p.10; catalogue only)

Rhenish Legend 1921
Assemblage, glass and copper
49.5 x 44.5 cm
The Metropolitan Museum of Art,
Gift of the artist, 1972
(pl.1, p.10)

Untitled 1921
Glass, wire and metal in a metal frame
37.5 x 29.8 cm
The Josef and Anni Albers Foundation

*Three Designs for a Flag for the Bauhaus
Exhibition* 1923
Opaque white, watercolour and pencil
on paper
23.1 x 15.1 cm
Bauhaus-Archiv, Berlin
(pl.32, p.30)

Park c.1924
Glass, wire, metal and paint in a
wooden frame
49.5 x 38 cm
The Josef and Anni Albers Foundation
(pl.3, p.11)

Coat of Arms for the City of Bottrop 1924
Gouache on paper
24.5 x 17.5 cm
Josef Albers Museum, Bottrop
(pl.31, p.30)

Fruit Bowl 1924
Silver-plated metal, glass and wood
9.2 x 42.5 x 42.5 cm
The Museum of Modern Art, New
York. Gift of Walter Gropius, 1958
(fig.6, p.69)

Tectonic Group 1925
Sandblasted flashed glass with black
paint
29 x 45 cm
Collection Angela Thomas Schmid
(pl.21, p.24)

Bundled 1925
Sandblasted flashed glass with black
paint
32.4 x 31.4 cm
The Josef and Anni Albers Foundation
(fig.32, p.83)

Tea Glass 1926
Heat resistant glass, porcelain, nickled
steel, Ebonite
5.7 x 11.5 x 11.5 cm
Bauhaus-Archiv, Berlin
(fig.7, p.69)

Upward c.1926
Sandblasted flashed glass with black
paint
44.6 x 31.4 cm
The Josef and Anni Albers Foundation
(pl.20, p.23)

Goldrosa c.1926
Sandblasted flashed glass with black
paint
44.6 x 31.4 cm
The Josef and Anni Albers Foundation
(pl.19, p.22)

Study for Lettering 1926
Pencil, black ink and collage on
tracing paper
21 x 30 cm
The Josef and Anni Albers Foundation
(pl.24, p.26)

Dominating White 1927
Sandblasted opaque flashed glass and
black paint
22.1 x 30 cm
The Josef and Anni Albers Foundation

Set of Four Stacking Tables c.1927
Ash veneer, black lacquer and painted
glass
39.2 x 41.9 x 40 cm
47.3 x 48 x 40 cm
55.4 x 53.3 x 40 cm
62.6 x 60.1 x 40.3 cm
The Josef and Anni Albers Foundation
(pl.23, p.25)

Glove Stretchers 1928
Sandblasted opaque flashed glass
39.4 x 52.7 cm
Musée national d'art moderne, Centre
Pompidou, Paris. Donation of The
Josef and Anni Albers Foundation,
2001
(pl.58, p.46)

*Armchair for Hans Ludwig and
Marguerite Oeser, Berlin* 1928
Mahogany, beech, maple, sprung and
padded upholstery, grey woollen
covering and nickel-plated screws
75 x 61.6 x 67 cm
Bauhaus-Archiv, Berlin
(pl.22, p.25)

El Lissitzky at the Bauhaus 1928–30
Gelatin silver print
41.8 x 29.7 cm
The Metropolitan Museum of Art,
Ford Motor Company Collection, Gift
of Ford Motor Company and
John C. Waddell, 1987
(pl.28, p.28)

Skyscrapers on Transparent Yellow c.1929
Sandblasted flashed glass with black
paint
35.2 x 34.9 cm
The Josef and Anni Albers Foundation
(pl.16, p.20)

Skyscrapers A c.1929
Sandblasted opaque flashed glass
34.9 x 34.9 cm
Private Collection
(pl.15, p.20)

Skyscrapers B c.1929
Sandblasted flashed glass
36.2 x 36.2 cm
Hirshhorn Museum and Sculpture
Garden, Smithsonian Institution,
Washington, DC, Gift of the Josepf
H. Hirshhorn Foundation, 1974
(pl.17, p.20)

Windows 1929
Glass
37.5 x 34.3 cm
Westfälisches Landesmuseum für
Kunst und Kulturgeschichte, Münster
(fig.53, p.99)

Interior a 1929
Sandblasted opaque flashed glass
25.6 x 21.4 cm
The Josef and Anni Albers Foundation

Interior A 1929
Sandblasted flashed glass
60.5 x 60.5 cm
Josef Albers Museum, Bottrop

Interior b 1929
Sandblasted opaque flashed glass
25.4 x 21.5 cm
The Josef and Anni Albers Foundation

Interior B 1929
Sandblasted flashed glass
60.5 x 60.5 cm
Josef Albers Museum, Bottrop

Study for Pergola 1929
Gouache and pencil on paper
44.5 x 58 cm
Bauhaus Dessau Foundation,
Germany
(pl.56, p.44)

Study for 'Pergola' 1929
Pencil and ink on graph paper
31.1 x 50.8 cm
The Josef and Anni Albers Foundation
(pl.55, p.44)

Pergola 1929
Sandblasted opaque flashed glass with
black paint
27 x 45.6 cm
The Josef and Anni Albers Foundation
(pl.57, p.45)

Beaker 1929
Sandblasted opaque flashed glass
29 x 37 cm
Private Collection
(pl.53, p.42)

*Oskar Schlemmer IV '29, Masters'
Council 1928, (Hans) Wittner, (Ernst)
Kallai, Marianne Brandt, Exhibition of
the Preliminary Course*
11 photographs and contact strips
mounted onto cardboard
29.7 x 41.7 cm
The Josef and Anni Albers Foundation

Klee in his Atelier in Dessau 1929
6 photographs mounted on cardboard
29.7 x 41.7 cm
The Josef and Anni Albers Foundation

*Wassily Kandinsky, Spring 1929, Master
on the Terrace at the Home of H(annes)
M(eier), May '30*
2 photographs mounted on cardboard
29.7 x 41.7 cm
The Josef and Anni Albers Foundation

Untitled c.1929
Gelatin silver print
11.8 x 17.5 cm
The Josef and Anni Albers Foundation

Untitled c.1929
Gelatin silver print
10.6 x 17.1 cm
The Josef and Anni Albers Foundation

Paris, Eiffel Tower, VIII 1929
2 photographs mounted on cardboard
29.7 x 41.7 cm
The Josef and Anni Albers Foundation
(fig.19, p.73)

Cathedral 1930
Sandblasted opaque flashed glass
35.4 x 49.1 cm
The Josef and Anni Albers Foundation

*Study for Glass Construction 'Six and
Three'* c.1931
Pencil, red pencil and red ink on paper
61.6 x 40.9 cm
The Josef and Anni Albers Foundation
(pl.26, p.26)

*Study for Glass Construction 'Six and
Three'*, c.1931
Pencil, India ink, and gouache on
wove graph paper
52.1 x 26 cm
The Josef and Anni Albers Foundation
(pl.25, p.26)

Six and Three 1931
Sandblasted opaque flashed glass
56 x 35.5 cm
The Josef and Anni Albers Foundation
(pl.27, p.27)

In Water 1931
Sandblasted flashed glass
47 x 51.5 cm
Josef Albers Museum, Bottrop

Flying 1931
Sandblasted opaque flashed glass
30.2 x 35 cm
Staatsgalerie Stuttgart
(pl.59, p.47)

Steps 1931
Sandblasted opaque flashed glass
41.5 x 54.5 cm
Private Collection
(pl.61, p.49)

Cables 1931
Sandblasted opaque flashed glass
40 x 50 cm
Tate. Presented by The Josef and Anni
Albers Foundation 2006
(pl.54, p.43)

Very Thin Ice n.d.
Gelatin silver print
22.9 x 15 cm
The Josef and Anni Albers Foundation
(pl.64, p.51)

Untitled n.d.
Gelatin silver print
23.2 x 15.9 cm
The Josef and Anni Albers Foundation
(pl.63, p.51)

Sport on Bathing Beach, Biarritz n.d.
Photograph mounted on cardboard
23 x 17.1 cm
The Josef and Anni Albers Foundation
(pl.62, p.50)

Light Reflections on Waves, Ascona n.d.
Gelatin silver print on paper
23.8 x 15.8 cm
Tate. Presented by The Josef and Anni
Albers Foundation 2006

Untitled (Bullfight San Sebastian) n.d.
6 photographs mounted on cardboard
29.7 x 41.7 cm
The Josef and Anni Albers Foundation
(pl.60, p.48)

Untitled (Inside View of a Tent) n.d.
Gelatin silver print
12.2 x 8.9 cm
The Josef and Anni Albers Foundation

Berlin Sidewalk n.d.
Gelatin silver print
19.8 x 13.9 cm
The Josef and Anni Albers Foundation

Black Circle 1933
Woodcut
(Printed at Ullstein Press, Berlin)
25.9 x 35.6 cm
The Josef and Anni Albers Foundation

White Circle 1933
Woodcut
(Printed at Ullstein Press, Berlin)
27.9 x 35.6 cm
The Josef and Anni Albers Foundation

Circle 1933
Woodcut
(Printed at Pan-Presse Felsing, Berlin)
26 x 27.9 cm
Tate. Presented by The Josef and Anni
Albers Foundation 2006

Easterly 1933
Cork relief
(Printed at Ullstein Press, Berlin)
21.6 x 31.1 cm
The Josef and Anni Albers Foundation
(pl.70, p.56)

Elephant 1933
Linoleum cut
(Printed at Pan-Presse Felsing, Berlin)
20.3 x 20.3 cm
The Josef and Anni Albers Foundation
(fig.60, p.105)

Homeward 1933
Woodcut
(Printed at Ullstein Press, Berlin)
21.6 x 26 cm
Tate. Presented by The Josef and Anni
Albers Foundation 2006

Sea 1933
Woodcut
(Printed at Ullstein Press, Berlin)
19.7 x 32.4 cm
The Josef and Anni Albers Foundation
(pl.69, p.56)

Viewing 1933
Linoleum cut
(Printed at Pan-Presse Felsing, Berlin)
21.6 x 25.7 cm
The Josef and Anni Albers Foundation

Study for 'Aquarium' c.1934
Brush and ink on wove paper
20.8 x 29.5 cm
The Josef and Anni Albers Foundation
(pl.71, p.57)

Aquarium 1934
Woodcut
(Printed at Black Mountain College,
North Carolina)
18.4 x 26 cm
The Josef and Anni Albers Foundation

Cosmic 1934
Woodcut
(Printed at Black Mountain College,
North Carolina)
22.2 x 32.7 cm
The Josef and Anni Albers Foundation

i (white background) 1934
Linoleum cut
(Printed at Black Mountain College,
North Carolina)
20.3 x 27.9 cm
The Josef and Anni Albers Foundation

i (black background) 1934
Linoleum cut
(Printed at Black Mountain College,
North Carolina)
20.3 x 27.9 cm
The Josef and Anni Albers Foundation

Placards/ Posters 1934
Linoleum cut
(Printed at Black Mountain College,
North Carolina)
29.2 x 22.2 cm
The Josef and Anni Albers Foundation

Segments 1934
Linoleum cut
(Printed at Black Mountain College,
North Carolina)
24.1 x 28.3 cm
The Josef and Anni Albers Foundation

Show Case 1934
Linoleum cut
(Printed at Black Mountain College,
North Carolina)
27.3 x 23.8 cm
The Josef and Anni Albers Foundation

*A Merry Christmas and a Happy New
Year* c.1934
Offset on paper printed in red ink
15.4 x 22.9 cm
The Josef and Anni Albers Foundation
(pl.121, p.152)

Evening (An Improvisation) 1935
Oil on Masonite
28 x 31.5 cm
The Josef and Anni Albers Foundation

Etude: Red-Violet (Christmas Shopping)
1935
Oil on panel
39 x 35.6 cm
The Josef and Anni Albers Foundation
(pl.81, p.118)

Untitled (Grand Pyramid at Tenayuca, Mexico Masonry 'Serpent' Sculptures Surrounding the Base) 1935
Gelatin silver print
11.6 x 8.6 cm
The Josef and Anni Albers Foundation

Untitled (Herd of Pack Burros) n.d.
Gelatin silver print
17.8 x 24.4 cm
The Josef and Anni Albers Foundation
(pl.84, p.120)

Untitled (Maya Temple, Chichen Itza, Mexico) n.d.
Gelatin silver print
17 x 11.7 cm
Tate. Presented by The Josef and Anni Albers Foundation 2006
(pl.83, p.120)

Untitled (Anahuacalli, Mexico) n.d.
Gelatin silver print
24.4 x 16 cm
The Josef and Anni Albers Foundation

Emblem for Black Mountain College 1935
Offset print on paper
23 x 31.5 cm
The Josef and Anni Albers Foundation

Almost Four (Color Étude) 1936
Oil on Masonite
34.9 x 38.7 cm
The Josef and Anni Albers Foundation
(pl.82, p.119)

in open air 1936
Oil on Masonite
50.5 x 45.1 cm
The Josef and Anni Albers Foundation
(pl.90, p.126)

Untitled Abstract c.1938
Gouache on blotting paper
28.6 x 34.6 cm
The Josef and Anni Albers Foundation

A Good '39 1938
Postcard with hand-painted alterations
13.7 x 8.9 cm
The Josef and Anni Albers Foundation

Related I (Red) 1938–43
Oil on Masonite
62.3 x 47 cm
The Josef and Anni Albers Foundation

Equal and Unequal 1939
Oil on Masonite
48.3 x 101.6 cm
The Josef and Anni Albers Foundation
(pl.92, p.128)

Delta 1939
Lithograph
35.6 x 34.3 cm
Tate. Presented by The Josef and Anni Albers Foundation 2006

Beta 1939
Lithograph
27.3 x 38.7 cm
Tate. Presented by The Josef and Anni Albers Foundation 2006

Layered 1940
Oil on Masonite
59.7 x 71.2 cm
The Josef and Anni Albers Foundation

To Mitla 1940
Oil on Masonite
54.6 x 71.4 cm
The Josef and Anni Albers Foundation
(pl.87, p.123)

Tierra Verde 1940
Oil on Masonite
57.8 x 71.2 cm
The Josef and Anni Albers Foundation
(pl.86, p.122)

Untitled Abstraction c.1940
Oil on Victor Talking Machine 'Victrola' cover
36.8 x 31.7 cm
The Josef and Anni Albers Foundation

Study for Mantic c.1940
Oil on paper
32.1 x 34.9 cm
The Josef and Anni Albers Foundation

Two Untitled Abstractions c.1940
Oil on blotting paper
38 x 48.1 cm
The Josef and Anni Albers Foundation

Leaf Study c.1940
Dried ferns beneath translucent paper mounted on black board
56 x 41.9 cm
The Josef and Anni Albers Foundation
(fig.52, p.98)

Leaf Study II c.1940
Collage of leaves on paper
36.8 x 46.7 cm
The Josef and Anni Albers Foundation

Leaf Study IV c.1940
Two leaves mounted on layered, coloured paper
47.2 x 57.1 cm
The Josef and Anni Albers Foundation
(pl.89, p.125)

Life Begins at '40/ Therefore best wishes from both Albers 1940
Postcard and transfer lettering
8.9 x 14 cm
The Josef and Anni Albers Foundation

Merry Christmas + Happy New Year 1941
Postcard with hand-painted alterations
8.9 x 13.7 cm
The Josef and Anni Albers Foundation

Merry Christmas + Happy New Year 1941
Postcard with hand-painted alterations
8.9 x 13.7 cm
The Josef and Anni Albers Foundation
(pl.121, p.152)

Shrine 1942
Zinc plate lithograph
33 x 31.4 cm
The Josef and Anni Albers Foundation

To Monte Alban 1942
Zinc plate lithograph
33.7 x 26.7 cm
The Josef and Anni Albers Foundation

Sanctuary 1942
Zinc plate lithograph
22 x 40 cm
The Josef and Anni Albers Foundation

With All Best Wishes for '43 1942
Postcard with hand-painted alterations
8.9 x 13.7 cm
The Josef and Anni Albers Foundation
(pl.120, p.152)

Study for 'Memento' (II) 1943
Oil and pencil on paper
31.7 x 44.4 cm
Collection of Katharine and Nicholas Fox Weber

Study for 'Memento' (I) 1943
Oil and pencil on paper
40.7 x 30.5 cm
Collection of Katharine and Nicholas Fox Weber
(pl.88, p.124)

Untitled n.d.
Oil and pencil on blotting paper
27.3 x 39.3 cm
Collection of Katharine and Nicholas Fox Weber

Repetition Against Blue 1943
Oil on Masonite
40 x 78.7 cm
Tate. Presented by The Josef and Anni Albers Foundation 2006
(pl.93, p.129)

Penetrating (B) 1943
Oil, casein and tempera on Masonite
54.3 x 63.2 cm
Solomon R. Guggenheim Museum, New York
(pl.91, p.127)

Untitled Abstraction V c.1945
Pencil and gouache on paper
25 x 16.2 cm
Tate. Presented by The Josef and Anni Albers Foundation 2006 in honour of Achim Borchardt-Hume
(pl.85, p.121)

Light Construction 1945
Ink and oil on Masonite
43.2 x 71.7 cm
The Josef and Anni Albers Foundation

Variant, 'Orange, Pink Against Crimson, Dark Gray' 1947
Oil on Masonite
30.5 x 45.7 cm
The Josef and Anni Albers Foundation

Variant, 'Pink Orange Surrounded by 4 Grays' 1947–52
Oil on Masonite
39.4 x 69.2 cm
The Josef and Anni Albers Foundation

Adobe (Variant): Luminous Day 1947–52
Oil on Masonite
28 x 54.6 cm
The Josef and Anni Albers Foundation
(pl.113, p.147)

Structural Constellation, Twisted but Straight 1948
Machine-engraved Vinylite mounted on board
33.6 x 62.2 cm
The Josef and Anni Albers Foundation
(pl.96, p.133)

Variant, '4 Central Warm Colors Surrounded by 2 Blues' 1948
Oil on Masonite
63.5 x 88.9 cm
The Josef and Anni Albers Foundation
(fig.22, p.76)

Variant 1948–52
Oil on Masonite
62 x 81 cm
Josef Albers Museum, Bottrop
(pl.112, p.146)

Variant: Familiar Front 1948–52
Oil on Masonite
34.9 x 53.3 cm
The Josef and Anni Albers Foundation

Homage to the Square 1950
Oil on Masonite
40.6 x 40.6 cm
The Josef and Anni Albers Foundation

Homage to the Square: Tempered Ardor 1950
Oil on Masonite
64.5 x 64.5 cm
Josef Albers Museum, Bottrop

Study for Homage to the Square: Light Rising 1950
Oil on Masonite
81.6 x 81.9 cm
National Gallery of Art, Washington, Robert and Jane Meyerhoff Collection
(pl.116, p.149)

Structural Constellation, Transformation of a Scheme No.10 1950
Machine-engraved Vinylite mounted on board
43.2 x 57.1 cm
The Josef and Anni Albers Foundation

Structural Constellation, Transformation of a Scheme No.12 1950
Machine-engraved Vinylite mounted on board
43.2 x 57.1 cm
Tate. Presented by The Josef and Anni Albers Foundation 2006
(pl.95, p.132)

Structural Constellation, Transformation of a Scheme No.13, 'Multi-mobile' 1950
Machine-engraved Vinylite mounted on board
43.2 x 57.1 cm
Tate. Presented by The Josef and Anni Albers Foundation 2006

Structural Constellation, Transformation of a Scheme No.17 1950
Machine-engraved Vinylite mounted on board
43.2 x 57.1 cm
The Josef and Anni Albers Foundation

Structural Constellation, Transformation of a Scheme No.23 1951
Machine-engraved Vinylite mounted on board
43.2 x 57.1 cm
The Josef and Anni Albers Foundation
(pl.94, p.130)

Homage to the Square: Study for Nocturne 1951
Oil on Masonite
53.3 x 53.3 cm
Tate. Presented by The Josef and Anni Albers Foundation 2006
(pl.114, p.148)

Homage to the Square: Black Setting 1951
Oil on Masonite
80.7 x 80.7 cm
The Josef and Anni Albers Foundation

Homage to the Square 1951
Oil on Masonite
85.1 x 85.1 cm
Los Angeles County Museum of Art, Museum Associates Purchase Award

Homage to the Square: Dissolving/Vanishing 1951
Oil on Masonite
60.7 x 60.7 cm
Los Angeles County Museum of Art, Gift of Mrs Anni Albers and the Josef Albers Foundation
(pl.117, p.149)

Homage to the Square: In the Open 1952
Oil on Masonite
53.3 x 53.3 cm
The Josef and Anni Albers Foundation

Homage to the Square 1951–5
Oil on Masonite
61 x 61 cm
Los Angeles County Museum of Art, Gift of Mrs Anni Albers and the Josef Albers Foundation
(pl.115, p.148)

Structural Constellation, F-32 1954
Machine-engraved Vinylite mounted on board
43.2 x 57.1 cm
The Josef and Anni Albers Foundation

Structural Constellation n.d.
Machine-engraved Vinylite mounted on board
43.2 x 57.1 cm
The Josef and Anni Albers Foundation

Structural Constellation n.d.
Machine-engraved Vinylite mounted on board
43.2 x 57.1 cm
The Josef and Anni Albers Foundation

Study for Homage to the Square: Dimly Reflected 1963
Oil on Masonite
61 x 61 cm
The Josef and Anni Albers Foundation

Study for Homage to the Square: Lone Whites 1963
Oil on Masonite
61 x 61 cm
The Josef and Anni Albers Foundation

Interaction of Color 1963
Book
33 x 50.8 cm
The Josef and Anni Albers Foundation
(pl.122, p.152)

Study for Homage to the Square: Far in Far 1965
Oil on Masonite
61 x 61 cm
The Josef and Anni Albers Foundation
(pl.118, p.150)

Study for Homage to the Square 1968
Oil on Masonite
61 x 61 cm
The Josef and Anni Albers Foundation
(pl.119, p.151)

Study for Homage to the Square 1968
Oil on Masonite
61 x 61 cm
The Josef and Anni Albers Foundation

Color Swatches n.d.
8 pieces of cardboard with oil and pencil
41.9 x 64.1 cm
The Josef and Anni Albers Foundation

Six Miniature Abstracts n.d.
Oil on blotting paper
24.3 x 27 cm
The Josef and Anni Albers Foundation

MOHOLY-NAGY

The Big Wheel 1920–1
Oil on canvas
96.2 x 76.3 cm
Collection Van Abbemuseum, Eindhoven
(pl.8, p.14)

Black Quarter Circle with Red Stripes 1921
Oil on canvas
99.6 x 80.1 cm
Private Collection
(pl.7, p.13)

K VII 1922
Oil on canvas
115.3 x 135.9 cm
Tate. Purchased 1961
(pl.11, p.17)

Telephone Picture EM1 1922
Porcelain enamel on steel
94 x 60 cm
Viktor and Marianne Langen Collection
(pl.18, p.21)

Untitled 1922
Photogram
14 x 9 cm
Musée national d'art moderne, Centre Pompidou, Paris
(pl.5, p.12)

Untitled 1922
Photogram
18.7 x 13.6 cm
Musée national d'art moderne, Centre Pompidou, Paris
(pl.6, p.12)

Untitled 1922
Photogram
17.6 x 12.8 cm
Musée national d'art moderne, Centre Pompidou, Paris

Untitled 1922
Photogram
17.6 x 12.8 cm
Museum Folkwang, Essen

Untitled 1922
Photogram
8.8 x 13.8 cm
Museum Folkwang, Essen

Photogram with Spiral Shape 1922
Photogram
13.7 x 8.7 cm
Dana and James Tananbaum Collection
(pl.4, p.12)

Untitled (Three Untitled Photograms)
1922
Gelatin silver prints
Each 19 x 12 cm
Private Collection, courtesy
Pace/MacGill, New York
(pl.38, p.34)

Construction Z I 1922–3
Oil on canvas
75 x 96.5 cm
Bauhaus-Archiv, Berlin
(fig.4, p.68)

K XVII 1923
Oil on canvas
95 x 75 cm
Kunsthalle Bielefeld
(pl.9, p.15)

Composition Q IV 1923
Oil on canvas
76 x 96 cm
Angela Thomas Schmid
(pl.10, p.16)

Untitled Photogram c.1923
Gelatin silver print
17.6 x 12.2 cm
The J. Paul Getty Museum, Los
Angeles

Letterhead 'Staatliches Bauhaus Weimar'
1923
Letterpress on machine-made paper,
punched
29.5 x 24.5 cm
Bauhaus-Archiv, Berlin

*Letterhead and Envelope for Bauhaus
Publishing* 1923
Letter: 28.4 x 22.3 cm
Envelope: 13 x 16.5cm
Bauhaus-Archiv, Berlin

A II 1924
Oil on canvas
115.8 x 136.5 cm
Solomon R. Guggenheim Museum,
New York
(fig.43, p.94)

Photogram (Positive) 1924
Photogram
39 x 29 cm
Angela Thomas Schmid
(fig.41, p.93)

Untitled 1924
Photogram
12.9 x 11.1 cm
Musée national d'art moderne, Centre
Pompidou, Paris

*Sketch for Score of 'Mechanical
Eccentricity'* 1924–5
Partiturskizze Mechanische Exzentrik
Collage, ink and watercolour on card
140 x 17.8 cm
Collection of the Theatre Studies
Department, University of Cologne
(pl.65, p.52)

Jealousy 1924–7
Gelatin silver print of a photomontage
(Photoplastic)
17.4 x 12.5 cm
Collection Hattula Moholy-Nagy
(pl.48, p.38)

Laci and Lucia 1925
Photogram
15.8 x 12 cm
Collection Hattula Moholy-Nagy

Two Nudes,Positive 1925
Gelatin silver print
27.2 x 36.8 cm
Courtesy of George Eastman House

Two Nudes, Negative 1925
Gelatin silver print
27.2 x 37.4 cm
Courtesy of George Eastman House

Gutter 1925
Rinnstein
Gelatin silver print
28.9 x 20.8 cm
Courtesy of George Eastman House

Between Heaven and Earth 1923–7
Collage with photogram and pencil
65 x 50 cm
Galerie Berinson, Berlin/ Ubu Gallery,
New York
(pl.49, p.38)

Photogram No.II 1925
Silver gelatin print (enlargement after
1922 photogram)
95.5 x 68.5 cm
Galerie Berinson, Berlin/ Ubu Gallery,
New York
(pl.37, p.33)

Untitled 1925
Silver gelatin print on paper
17.9 x 23.8 cm
IVAM, Instituto Valenciano de Arte
Moderno, Generalitat Valenciana

The Broken Marriage 1925
Gelatin silver print of a photomontage
16.5 x 12.1 cm
The J. Paul Getty Museum, Los
Angeles

The Olly and Dolly Sisters c.1925
Gelatin silver print of a photomontage
(photoplastic)
37.5 x 27.5 cm
The J. Paul Getty Museum, Los
Angeles

Leda and the Swan 1925
Gelatin silver print of a photomontage
(photoplastic)
16 x 12 cm
Collection Hattula Moholy-Nagy
(fig.16, p.72)

Composition 1925–7
Ink on paper under red partially-
painted perspex
38.5 x 49 cm
Private Collection
(pl.13, p.18)

Our Big Men 1925–7
Gelatin silver print of a photomontage
(photoplastic)
10 x 15 cm
Collection Hattula Moholy-Nagy

Militarism 1925–7
Gelatin silver print of a photomontage
(photoplastic)
17.9 x 12.8 cm
Collection Hattula Moholy-Nagy

Untitled 1925–8
Photogram
18.3 x 24.1 cm
Museum Folkwang, Essen
(fig.17, p.73)

Untitled 1925–8
Photogram mounted on cardboard
39.9 x 29.9 cm
Museum Folkwang, Essen

Untitled 1925–8
Photogram
23.7 x 17.7 cm
Museum Folkwang, Essen

Untitled 1925–8
Photogram
39.9 x 30 cm
Museum Folkwang, Essen
(fig.11, p.70)

G8 1926
Oil on galalith and cardboard
42.7 x 52 cm
Private Collection
(pl.12, p.18)

*Poster Design for the Exhibition of
Hygiene, Welfare and Physical Exercise*
1926
Gouache on paper
31.3 x 24.2 cm
Collection Hattula Moholy-Nagy

*Poster Design for the Exhibition of
Hygiene, Welfare and Physical Exercise*
1926
Gouache on paper
31 x 24.1 cm
Collection Hattula Moholy-Nagy

Dolls 1926
Gelatin silver print
48.6 x 38.4 cm
Courtesy of George Eastman House

Ascona (Schlemmer Girls on Balcony)
1926
Gelatin silver print
39.8 x 29.9 cm
Galerie Berinson, Berlin/ Ubu Gallery,
New York
(pl.30, p.29)

Bauhaus Balconies 1926
Gelatin silver print
49.5 x 39.3 cm
Courtesy of George Eastman House
(fig.15, p.72)

Ascona 1926
Gelatin silver print
36.7 x 27.7 cm
The Museum of Modern Art, New
York. Anonymous gift
(pl.43, p.37)

Negative Cat c.1926
Gelatin silver print
28.4 x 23 cm
The Art Institute of Chicago, Julien
Levy Collection, Special Photography
Acquisition Fund
(pl.40, p.35)

Sailing 1926
Gelatin silver print
37.4 x 27.2 cm
Courtesy of George Eastman House

Pneumatik 1926
Drawing and collage on paper
52.5 x 41.1 cm
Louisiana Museum of Modern Art,
Humlebaek, Denmark. Donation: The
Josef and Celia Ascher Collection,
New York
(pl.50, p.40)

City Lights 1926
Collage with ink and watercolour on
paper
61 x 48 cm
Bauhaus-Archiv, Berlin
New York only

Joseph and Potiphar's Family c.1926
Gelatin silver print of a photomontage
11.7 x 17.5 cm
The J. Paul Getty Museum, Los
Angeles
(pl.45, p.38)

Birthmark (Salome) c.1926
Muttermal (Salome)
Photo collage mounted on cardboard
63 x 48 cm
Bauhaus-Archiv, Berlin
(pl.52, p.41)

Dessau c.1926–8
Gelatin silver print
24.9 x 18.6 cm
Museum Folkwang, Essen
(pl.42, p.36)

Rothenburg 1926–8
Gelatin silver print
23 x 17.3 cm
The J. Paul Getty Museum, Los
Angeles

Rothenburg 1926–8
Gelatin silver print
39.5 x 29.5 cm
James Hyman, London
(pl.44, p.37)

A 19 1927
Oil on canvas
80 x 96 cm
Collection Hattula Moholy-Nagy
(pl.14, p.19)

A 20 1927
Oil on canvas
80 x 95.5 cm
Private Collection, courtesy Annely
Juda Fine Art, London
(pl.36, p.32)

Oskar Schlemmer in Ascona 1927
Gelatin silver print
16.8 x 12.4 cm
Galerie Berinson, Berlin/ Ubu Gallery,
New York
(pl.29, p.29)

Negative c.1927
Gelatin silver print
29.7 x 21.4 cm
Private Collection, courtesy
Pace/MacGill, New York
(pl.39, p.35)

Untitled 1927
Gelatin silver print
28.4 x 37.8 cm
Museum Folkwang, Essen

The Eccentrics 1927
Die Eigenbrötler
Photomontage
64.4 x 49.7 cm
Museum Folkwang, Essen
(pl.51, p.40)

The Eccentrics II 1927
Die Eigenbrötler II
Gelatin silver print of a photomontage
(photoplastic)
22.1 x 15.8 cm
The J. Paul Getty Museum, Los
Angeles

Sport Makes Appetite 1927
Gelatin silver print on paper, vintage
print
20.3 x 27.9 cm
IVAM, Instituto Valenciano de Arte
Moderno, Generalitat Valenciana
(pl.47, p.38)

View from 'Funkturm' c.1928
Gelatin silver print
39.8 x 29.9 cm
Galerie Berinson, Berlin/ Ubu Gallery,
New York

Negative Portrait n.d.
Gelatin silver print
29.9 x 23.9 cm
The Art Institute of Chicago. Julien
Levy Collection, Gift of Jean and
Julien Levy

How Do I Keep Young and Beautiful?
1920s
Gelatin silver print of a photomontage
(photoplastic)
17.4 x 12.5 cm
Collection Hattula Moholy-Nagy
(pl.46, p.38)

Prospectus for 'Bauhausbücher' 1929
Letterpress
51.5 x 36.5 cm
Bauhaus-Archiv, Berlin

The Diving Board 1931 or earlier
Gelatin silver print
28.3 x 20.7 cm
The Museum of Modern Art, New
York. Anonymous gift
(pl.41, p.36)

Light Prop for an Electric Stage 1928–30
Mobile construction in various metals,
plastic and wood
151 x 70 x 70 cm
Exhibition replica

Light Prop for an Electric Stage 1928–30
Collage on paper
41.8 x 61 cm
Collection of the Theatre Studies
Department, University of Cologne
(fig.9, p.70)

Stefan Sebök
*Construction Drawing for László Moholy-
Nagy's Light Prop for an Electric Stage*
1930
Pencil on tracing paper
42 x 61.5 cm
Bauhaus-Archiv, Berlin
(pl.66, p.53)

*Expositon des artistes décorateurs. Selection
Allemande (Werkbund) Paris, Grand
Palais, 14th May – 13th July* 1930
Booklet
21 x 15 cm
Lent by Ruth Silver and Michael
Blacker in memory of their father,
Harry Blacker

Light Play: Black-White-Grey 1930
5 min 30 sec
16 mm black and white film, silent
Courtesy Hattula Moholy-Nagy
(pl.68, pp.54–5)

Tp 2 1930
Oil and incised line on blue Trolitan
61.5 x 144.3 cm
Solomon R. Guggenheim Museum,
New York. Gift, Solomon R.
Guggenheim
(pl.75, p.60)

Composition TP5 1930
Oil and engraving on Galalith
28.1 x 20.1 cm
Angela Thomas Schmid
(pl.74, p.60)

Untitled 1930s
Gelatin silver print
21.3 x 16.3 cm
Collection Hattula Moholy-Nagy

Untitled 1930s
Gelatin silver print
21.3 x 16.3 cm
Collection Hattula Moholy-Nagy

Untitled 1930s
Gelatin silver print
21.1 x 16.4 cm
Collection Hattula Moholy-Nagy

Untitled 1930S
Gelatin silver print
20.5 x 15.4 cm
Collection Hattula Moholy-Nagy

Untitled 1930s
Gelatin silver print
21.3 x 16.5 cm
Collection Hattula Moholy-Nagy
(pl.78, p.62)

Untitled 1930s
Gelatin silver print
21.3 x 16.5 cm
Collection Hattula Moholy-Nagy

Untitled (39, Savile Street) 1930s
Gelatin silver print
12 x 9 cm
Collection Hattula Moholy-Nagy

*Untitled (Dusk on the Playing Fields of
Eton)*1930s
Gelatin silver print
22 x 27 cm
Collection Hattula Moholy-Nagy
(pl.77, p.62)

*Space Modulator Experiment,
Aluminium 5* 1931–5
Aluminium and Rhodoid
86 x 71 cm
Private Collection, Germany
(pl.73, p.59)

Sil 1 1933
Oil and incised lines on silberit
50 x 20 cm
Scottish National Gallery of Modern
Art, Edinburgh. Purchased 1977
(fig.48, p.96)

Construction AL6 1933–4
Oil on aluminium
60 x 50 cm
IVAM, Instituto Valenciano de Arte
Moderno, Generalitat Valenciana
(pl.79, p.63)

G 11 1934
Oil and tempera on Galalith
32 x 46 cm
Private Collection, Germany
(pl.76, p.61)

The Empire's Airway 1935–7
Letterpress
14 x 21 cm
Collection Hattula Moholy-Nagy

Space Modulator L3 1936
Oil on perforated zinc and
composition board, with glass-headed
pins
43.8 x 48.6 cm
The Museum of Modern Art, New
York, Purchase, 1947

SRhO 1 1936
Oil on bakelite laid on the artist's
painted blackboard
79.2 x 64.3 cm
Galerie Berinson, Berlin/ Ubu Gallery,
New York
(pl.98, p.134)

Facts Imperial Airways 1936
Colour lithograph
14.6 x 65.4 cm
British Airways Archive and Museum
Collection, Hounslow

*Imperial Airways Map of Empire and
European Air Routes* April 1936
Colour Lithograph
99.4 x 63.5 cm
British Airways Archive and Museum
Collection, Hounslow
(pl.72, p.58)

Light Painting 1937
Acetate, metal and paint on board
50 x 51 cm
IVAM, Instituto Valenciano de Arte
Moderno, Generalitat Valenciana
fig.38, p.89)

Empire's Airmail Programme 1937
Booklet
26.7 x 19.4 cm
British Airways Archive and Museum
Collection, Hounslow
(fig.37, p.89)

Empire's Airmail Programme 1937
Booklet
26.7 x 19.4 cm
British Airways Archive and Museum
Collection, Hounslow
(fig.37, p.89)

Soon in the Train by Escalator 1937
Colour lithograph
101.3 x 63.1 cm
Victoria and Albert Museum, London

*Poster for London Transport: Quickly
away, thanks to Pneumatic doors* 1937
Colour Lithograph
101.3 x 63.3 cm
Victoria and Albert Museum, London
(pl.80, p.64)

Bill of Fare. Gropius Dinner March 9th
1937
Offset print
18 x 23 cm
Lent by Ruth Silver and Michael
Blacker in memory of their father,
Harry Blacker

The New Bauhaus 1937
Letterpress
35.5 x 25.5 cm
Collection Hattula Moholy-Nagy

Study with Pins and Ribbons 1937–8
Colour print, assembly (Vivex) process
34.9 x 26.5 cm
Courtesy of George Eastman House.
Gift of Walter Clark
(pl.105, p.140)

Untitled 1937–46
Exhibition copies of original 35mm
Kodachrome Slides
Courtesy of Hattula Moholy-Nagy
(pl.106, p.141)

Tactile Exercises and Hand Sculptures
(from the Magazine *More Business*,
vol.3, no.11) 1938
Letterpress print on paper
35.5 x 28 cm
Bauhaus-Archiv, Berlin
(fig.49, p.97)

Christmas Card 1938
Offset print
17 x 23 cm
Lent by Ruth Silver and Michael
Blacker in memory of their father,
Harry Blacker

CH 4 1938
Oil on canvas
68.5 x 89 cm
Collection of Hattula Moholy-Nagy
(pl.99, p.135)

CH X 1939
Oil on canvas
76 x 96.5 cm
Private Collection, courtesy Annely
Juda Fine Art, London
(pl.97, p.133)

Untitled 1939
Photogram
28.1 x 35.6 cm
Museum Folkwang, Essen

Untitled 1939
Photogram
20 x 25 cm
Museum Folkwang, Essen

Untitled 1940
Coloured crayon on paper
21 x 28 cm
Collection Hattula Moholy-Nagy

Untitled 1940s
Coloured crayon on paper (wood
rubbing)
21.5 x 28 cm
Collection Hattula Moholy-Nagy

Composition CH B3 1941
Oil on canvas
131 x 208 cm
Private Collection, Switzerland
(pl.104, p.139)

Ch 4 1941
Oil on incised Plexiglas, mounted
with chromium clamps on white-
painted plywood
91.2 x 91.2 cm
Solomon R. Guggenheim Museum,
New York

Untitled (Light Modulator) 1941
Photogram
50.4 x 40.5 cm
Musée national d'art moderne, Centre
Pompidou, Paris

Untitled 1941
Photogram
36.2 x 28 cm
Musée national d'art moderne, Centre
Pompidou, Paris
(pl.100, p.136)

CH For Y Space Modulator 1942
Oil on yellow formica
152 x 60 cm
Collection of Hattula Moholy-Nagy
(pl.102, p.138)

CH for R1 Space Modulator 1942
Oil on red formica
152.5 x 60 cm
Collection of Hattula Moholy-Nagy
(pl.103, p.138)

Untitled 1943
Pencil and coloured pencil on paper
21.5 x 28 cm
Collection Hattula Moholy-Nagy

Untitled 1944
Pencil and crayon on paper
21.5 x 28 cm
Collection Hattula Moholy-Nagy

Nuclear I, CH 1945
Oil on canvas
96.5 x 76.2 cm
The Art Institute of Chicago, Gift of
Mr and Mrs Leigh B. Block
(pl.111, p.145)

Colour Explosion 1945
Colour pencil on paper mounted on
plastic
20.5 x 25.5 cm
Bauhaus-Archiv, Berlin
(fig.74, p.115)

My Bed in the Hospital 1945
Pencil and crayon on paper
18 x 20.5 cm
Collection Hattula Moholy-Nagy
(fig.25, p.77)

Untitled 1945
Pencil and crayon on paper
28 x 21.5 cm
Collection Hattula Moholy-Nagy

Untitled 1945
Pencil and crayon on paper
21 x 27.3 cm
Collection Hattula Moholy-Nagy

Untitled 1945
Pencil and crayon on paper
21 x 27.3 cm
Collection Hattula Moholy-Nagy

Untitled (Night. Chicago) 1945
Pencil and crayon on paper
21.5 x 28 cm
Collection Hattula Moholy-Nagy

Double Loop 1946
Plexiglas
41.1 x 56.5 x 44.5 cm
The Museum of Modern Art, New
York, Purchase, 1956

Leda and the Swan 1946
Plexiglas
55.9 x 41.3 x 40 cm
IVAM, Instituto Valenciano de Arte
Moderno, Generalitat Valenciana
(pl.101, p.137)

Dual Form with Chromium Rods 1946
Plexiglas and chrome-plated steel rods
92.7 x 121.6 x 55.9 cm
Solomon R. Guggenheim Museum,
New York

Nuclear II 1946
Oil on canvas
130.2 x 130.2 cm
Milwaukee Art Museum, Gift of
Kenneth Parker
(pl.110, p.144)

Untitled 1946
Pencil and crayon on paper
28 x 21.5 cm
Collection Hattula Moholy-Nagy
(pl.107, p.142)

Untitled 1946
Pencil and crayon on paper
21.5 x 28 cm
Collection Hattula Moholy-Nagy
(pl.108, p.142)

Untitled 1946
Pencil and crayon on paper
28 x 21.5 cm
Collection Hattula Moholy-Nagy

Untitled 1946
Pencil and crayon on paper
28 x 21.5 cm
Collection Hattula Moholy-Nagy

Untitled 1946
Pencil and crayon on paper
28 x 21.5 cm
Collection Hattula Moholy-Nagy

*Untitled c.*1940
Pencil and crayon on paper
21.5 x 27.9 cm
Collection Hattula Moholy-Nagy

Untitled 1946
Oil on Plexiglas
22.2 x 45.4 x 7.6 cm
Whitney Museum of American Art,
New York, Gift of Mr and Mrs Marcel
Breuer
(pl.109, p.143)

BOOKS

Walter Gropius (ed.)
Internationale Architektur 1925
International Architecture
(Bauhausbücher, vol.1)
First edition, paperback
Private Collection

Paul Klee
Pädagogisches Skizzenbuch 1925
Pedagogical Sketchbook
(Bauhausbücher, vol.2)
Second edition, hardbound with
original wrapper
Private Collection

Oskar Schlemmer, László Moholy-
Nagy and Farkas Molnár
Die Bühne im Bauhaus 1925
The Bauhaus Stage
(Bauhausbücher, vol.4)
First edition, paperback
Private Collection

Piet Mondrian
Neue Gestaltung 1925
Neo-Plasticism
(Bauhausbücher, vol.5)
First edition, hardbound with original
wrapper
Private Collection

Theo van Doesburg
Grundbegriffe der neuen gestaltenden
1925
The Basics of Neo-Plasticism
(Bauhausbücher, vol.6)
First edition, paperback
Private Collection

Theo van Doesburg
Neue Arbeiten der Bauhauswerkstätten
1925
New Works from the Bauhaus
Workshops
(Bauhausbücher, vol.7)
First edition, paperback
Private Collection

László Moholy-Nagy
Malerei, Fotografie, Film 1925
Painting, Photography, Film
(Bauhausbücher, vol.8)
Second edition, paperback
Private Collection
(pl.33, p.31)

László Moholy-Nagy
Russian translation of *Malerei,
Fotografie, Film* 1925
Private Collection

Wassily Kandinsky
Punkt und Linie zu Fläche 1926
Point and Line to Plane
(Bauhausbücher, vol.9)
Second edition, paperback
Private Collection

J.J.P. Oud
Holländische Architektur 1926
Dutch Architecture
(Bauhausbücher, vol.10)
Second edition, paperback

Kasimir Malewich
Die gegenstandslose Welt 1927
The Non-Objective World
(Bauhausbücher, vol.11)
First edition, hardbound with original
wrapper
(fig.10, p.70)

Walter Gropius
Bauhausbauten Dessau 1930
Bauhaus Buildings in Dessau
(Bauhausbücher, vol.12)
First edition, hard bound

Albert Gleizes
Kubismus 1928
Cubism
(Bauhausbücher, vol.13)
First edition, hard bound with
original wrapper in original slipcase
Private Collection

László Moholy-Nagy
Von Material zu Architektur 1929
From Material to Architecture
(Bauhausbücher, vol.14)
First edition, paperback
All Bauhaus Books, Private Collection

The Street Markets of London
by Mary Benedetta
John Miles Ltd., London 1936
22.2 x 14.8
National Art Library

Eton Portrait
by Bernard Fergusson
John Miles Ltd., London 1937
25.5 x 19.8 cm
Collection Terence Senter

Oxford University Chest
by John Betjeman
John Miles Ltd., London 1938
25.5 x 19.6 cm
Collection Terence Senter

Vision in Motion
Paul Theobald, Chicago 1947
Second Edition
28.5 x 22.2 cm
Tate Library

WORKS BY STUDENTS

Thomas Flake
Geometric Drawing n.d.
Blue and black pen on tracing paper
41.9 x 29.5 cm
The Josef and Anni Albers Foundation

Wolfgang Tümpel
Teaball 1924
Silver
14.5 x 2.8 x 2.8 cm
Bauhaus Dessau Foundation, Germany

Wilhelm Wagenfeld
Plate for Teaball 1924
Brass, chrome-plated
14.2 x 5.8 x 5.8 cm
Bauhaus Dessau Foundation, Germany

Konrad Püschel
*Study on the Terms 'Structure, Facture,
Texture'* 1926/7
Tempera and Indian ink on paper,
mounted on card
58 x 44.5 cm
Bauhaus Dessau Foundation, Germany
(fig.12, p.71)

Konrad Püschel
*Three Plastic Space Balls Tucked Inside
Each Other* c.1926/7
Paper
16 x 16 x 16 cm
Bauhaus Dessau Foundation, Germany

Konrad Püschel
Equilibrium Study 1926
Watercolour on paper
58 x 44.5 cm
Bauhaus Dessau Foundation, Germany

Konrad Püschel
Material Study in Paper 1926/7
Paper
21 x 20 cm
Bauhaus Dessau Foundation, Germany

Konrad Püschel
*Photographic Composition with Plants
and Buttons* c.1926/7
*Photographic Composition with Flowers
and Cacti* c.1926/7
*Photographic Composition with Flowers
and Watch Chain* c.1926/7
Photograms
frame: 40 x 30 cm
Bauhaus Dessau Foundation, Germany

Rudolf Ortner
Small Money: Material Study 1932
Collage
58 x 44.5 cm
Bauhaus Dessau Foundation, Germany

Karl Marx
*Paolo Malatesta and Francesca da Rimini
– Two Eternal Lovers* 1932/3
Photomontage
58 x 44.5 cm
Bauhaus Dessau Foundation, Germany
(fig.13, p.71)

Robert D. Erickson
A Child Sees 1945–6
Exam paper for Master's Degree at the
Institute of Design
29 x 24 cm
Bauhaus-Archiv, Berlin

Students of the Institute of Design
Three Hand Sculptures c.1946
Glued tropical hardwood
17, 20 and 23 cm wide
Bauhaus-Archiv, Berlin

Student at Black Mountain College
'Free Study' Collage n.d
Coloured papers mounted on card
27.9 x 35.5 cm
The Josef and Anni Albers Foundation

Student at Black Mountain College
*Student Exercise '10 a. Illusion of
Transparence. A more developed
demonstration.'* n.d
Collage of coloured papers mounted
on black paper
6.9 x 34.2 cm
The Josef and Anni Albers Foundation

Student at Black Mountain College
Two Colour Charts n.d
Pencil and coloured paper collaged to
a white backing card
35.5 x 16.5 cm
The Josef and Anni Albers Foundation

Student at Black Mountain College
Texture Study n.d.
Leaves, dirt and moss painted white
17.8 x 14 cm
The Josef and Anni Albers Foundation

Student at Black Mountain College
Texture Study n.d.
Shredded twine on black coated paper
20.4 x 14 cm
The Josef and Anni Albers Foundation

Student at Black Mountain College
Texture Study n.d.
Dabs of white paint on black coated
paper
20.4 x 14 cm
The Josef and Anni Albers Foundation
(fig.51, p.98)

Student at Black Mountain College
Texture Study n.d.
Photographic paper with glued
sequins
17.3 x 24.1 cm
The Josef and Anni Albers Foundation

CREDITS

LENDERS

PUBLIC COLLECTIONS

The Art Institute of Chicago
Bauhaus Dessau Foundation
Bauhaus-Archiv, Berlin
British Airways Archive and Museum Collection, Hounslow
Hirshhorn Museum and Sculpture Garden, Smithsonian Institution, Washington, DC
George Eastman House, Rochester, New York
IVAM, Instituto Valenciano de Arte Moderno, Gerneralitat Valenciana
The J. Paul Getty Museum, Los Angeles
The Josef and Anni Albers Foundation
Joseph Albers Museum, Bottrop
Kunsthalle Bielefeld
Viktor and Marianne Langden Collection
Los Angeles County Museum of Art
Louisiana Museum of Modern Art, Humlebaek
The Metropolitan Museum of Art, New York
Musée national d'art moderne, Centre Pompidou, Paris
Milwaukee Art Museum
Museum Folkwang, Essen
The Museum of Modern Art, New York
National Gallery of Art, Washington, DC
National Art Library, London
Scottish National Gallery of Modern Art, Edinburgh
Solomon R. Guggenheim Museum, New York
Staatsgalerie, Stuttgart
Collection of the Theatre Studies Department, University of Cologne
Van Abbemuseum, Eindhoven
Victoria and Albert Museum, London
Westfälisches Landesmuseum für Kunst & Kulturgeschichte, Münster
Whitney Museum of American Art, New York
Yale University Art Gallery, New Haven

PRIVATE COLLECTIONS

Collection Hattula Moholy-Nagy
Private Collection, courtesy Annely Juda Fine Art, London
Private Collection courtesy Galerie Orlando GmbH
Ruth Silver and Michael Blacker
Collection of Katharine and Nicholas Fox Weber
Galerie Berinson, Berlin/ Ubu Gallery, New York
Private Collection, Courtesy Pace/MacGill Gallery, New York
Collection Terence Senter
James Hyman, London
Dana and James Tananbaum
Private Collection, Germany
Private Collection, Switzerland
Collection Angela Thomas Schmid
and all other private lenders who wish to remain anonymous

COPYRIGHT CREDITS

Albers: © 2006 The Josef and Anni Albers Foundation/ VG Bild-Kunst, Bonn and Artists Rights Society, New York
Moholy-Nagy: © 2006 Hattula Moholy-Nagy/ DACS

PHOTOGRAPHIC CREDITS

The Josef and Anni Albers Foundation pls.3, 15, 16, 19, 20, 23–7, 53–5, 57, 60, 62, 63, 64, 69–71, 81–90, 92–6, 113–14, 118–22, figs.2, 19, 22–3, 32, 51, 52, 59, 60, 63–8, cover (bottom), frontispiece (left)
Josef Albers Museum, Bottrop pls.31, 112
Photography © The Art Institute of Chicago pls.40, 111
© Bauhaus-Archiv, Berlin pls.22, 32, 33, 34, 35, 52, 66, figs.4, 7, 45, 49, 74, frontispiece (right)
Bauhaus Dessau Foundation pls.56, figs.12, 13
© Galerie Berinson, Berlin pls.29, 30, 37, 49
© British Airways Archive http://www.bamuseum.com pl.72, fig.37
© Christie's Images Ltd pl.98
© Bettman/ CORBIS fig.58
Photo CNAC/MNAM Dist. RMN pls.5, 6, 58, 100
© George Eastman House pl.105, fig.15
© The J. Paul Getty Museum, Los Angeles pl.45
© Solomon R. Guggenheim Museum, New York pls.75, 91, fig.43
Hirshhorn Museum and Sculpture Garden pls.2, 17
Courtesy of James Hyman, London pl.44
IVAM, Valencià pl. 47, 79, 101, fig.38
Courtesy Annely Juda Fine Art, London pls. 36, 77, 97, 99, 102, 103, figs.16, 41
Kunsthalle Bielefeld pl.9
Photograph © 2005 Museum Associates/LACMA pls.115, 117
Courtesy Langen Foundation pl.18
Louisiana Museum pl.50
© 1987 The Metropolitan Museum of Art pls.1, 28
© Milwaukee Art Museum pl.110
Courtesy of Hattula Moholy-Nagy figs.69, 70, 71, 72, 73
Museum Folkwang, Essen, pls.42, 51 figs.11, 17
© 2005, Digital image, The Museum of Modern Art New York/Scala, Florence pl.41, 43, fig.6, 31
National Gallery of Art, Washington/ Photo by: Rob Grove pl.116
Courtesy Galerie Orlando Gmbh pl.13
Courtesy Pace/MacGill, New York pls.38, 39
Private Collection pls.12, 73, 76, 104
Repro-photography: Retina/ Martien Kerkhof fig.30
Courtesy Andrea Rosen Gallery, New York pl.106
Scottish National Gallery of Modern Art, Edinburgh fig.48
Courtesy of Sotheby's pl.4
Staatsgalerie Stuttgart pl.59
Kevin Stearns, Valois Photography pl.61
Tate Photography pl.11, fig.56
Tate Photography Rod Tidnam pl.7
Courtesy of the Theatre Studies Department, University of Cologne pl.65, fig.9
Courtesy of Angela Thomas Schmidt pls. 10, 21, 74
Van Abbemuseum, Eindhoven pls. 8, 67
© Welti-Furrer Fine Art Ltd. pls. 14, 46, 48, 78, 107, 108, fig.25, cover (top)
Westfälisches Landesmuseum für Kunst und Kulturgeschichte fig.53
Whitney Museum of American Art, New York pl.109
© Victoria and Albert Museum, London pl.80
© Yale University Art Gallery fig.54

INDEX